PHOTO FAKERY

WITHDRAWN

Photo *Fakery*

THE HISTORY AND TECHNIQUES

Dino A. Brugioni

OF PHOTOGRAPHIC
DECEPTION AND MANIPULATION

BRASSEY'S
Dulles, Virginia

LIBRARY OF CONGRESS CATALOGING-IN-PUBLICATION DATA

Brugioni, Dino A.
 Photo fakery : the history and techniques of photographic deception
and manipulation / Dino A. Brugioni. — 1st ed.
 p. cm.
 Includes bibliographical references and index.
 1. Trick photography—History. I. Title.
 TR148.B78 1999
 778.8—dc21 99-36376
 CIP

ISBN 1-57488-166-3 (alk. paper)

Printed in the United States of America on acid-free paper that
meets the American National Standards Institute Z39–48 Standard.

Brassey's
22883 Quicksilver Drive
Dulles, Virginia 20166

First Edition

10 9 8 7 6 5 4 3 2 1

For Robert F. McCort

CONTENTS

PREFACE

This book aims to provide the layperson with a reference aid to determine photo fakery and photo manipulation. It is written so it can be understood by those who may never have examined a photo for possible fakery or manipulation. I have refrained from using many overly technical photographic terms, and where their use is necessary have attempted to make them understandable to a non-photographer.

As a senior officer of the Central Intelligence Agency's National Photographic Interpretation Center, along with its noted first director, Arthur C. Lundahl, I often had to determine whether photographs obtained through the CIA's sources were valid or faked. Over the years, a number of techniques were developed to determine the reliability of photos acquired.

My first experience with photo fakery began shortly after I was hired by the CIA in 1948. While waiting for security clearances, I was given the task of reviewing Russian still photos and newsreel films captured by the Germans during World War II. It became immediately apparent to me, even as a neophyte in the intelligence game, that the Soviets had embarked on a massive program of misinformation during the war years. On reviewing still photos, I found that the Soviets had used heavy brush techniques to delete details of their weapons. Care had also been taken to portray their leaders in the most favorable light. Reviewing Soviet newsreels, I found that many battle scenes had been deliberately staged; often, dramatic scenes of one battle would be superimposed to show up in films of other battles.

I also became aware that few intelligence officers at the time knew even the rudimentary methods of determining photo fakery. I subsequently wrote the first article published on the subject, titled "Spotting Photo Fakery," for the winter 1969 issue of the CIA's *Studies in Intelligence*. The article, which has recently been declassified, showed intelligence analysts the basic techniques to be applied to photos—received

primarily from Soviet, Communist Chinese, and East European Communist countries—to determine their truthfulness. Since my retirement from the CIA, I have maintained an active interest in photo fakery and manipulations, and have been called upon to inspect suspect photos.

There is still no manual for the layperson to use in discerning fake photography. Existing books on the subject deal primarily with the art of altering or retouching photographs. They are concerned almost exclusively with presentation techniques for enhancing the artistic or purely technical values of the photography presented.

Assembling any kind of documentary compilation, one frequently reveals personal preferences through the choices of photos selected. I have attempted to provide both an overview and an explanation to show why photography has been tampered with for more than one hundred fifty years.

It is misleading to claim that scientific advances and scholarly expertise can cause all photo fakes to be unmasked. Questions about authenticity remain. Many photos that once were considered genuine have recently been determined to have been faked. The authenticity of some is still being debated, and there are undoubtedly those that were so perfectly created that they have remained undetected. Some photo fakes have been done solely for the sheer joy of confounding the experts. It is my hope that because of this book, fewer nonexperts will be deceived in the future by photo fakery and manipulation.

Dino A. Brugioni
Hartwood, Virginia

ACKNOWLEDGMENTS

In preparing this book I am indebted for the help of many and I would like to thank the individuals, collections, and institutions named below. I am also indebted to the specialists whose talents were available and who consulted with me on this work. I must also acknowledge the many people who helped in locating valuable material. I was allowed to reproduce photos which I hope provide a panoramic overview for the over 150 years photos have been tampered with. I am deeply indebted to U.S. Senators John Warner and Charles S. Robb; Congressmen Herbert H. Bateman and John Paul Hammerschmidt; Benjamin J. Guthrie, Clerk of the House, U.S. House of Representatives; Dr Walter E. "Skip" Fischer; Lois Duncan Arquette; Louise Steinmetz; James Oberg; Janice Madhu, Barbara Puorro Galasso, Becky Simmons, Katherine Bassney, and David Wooters of George Eastman House; Charles F. Trowbridge, Jr., and Robert R. Sheetz of the Defense Intelligence Agency; Ann Shumard and Mary Panzer, Curators of Photography, National Portrait Gallery; Jonathan Heller, Still Pictures Branch, National Archives; Karl Kabelac, University of Rochester; Tom Desjardin, Gettysburg National Military Park; E. C. Finney, Jr., Photographic Branch, Naval Historical Center; Maya Keech, Jennifer Brathovde, Mary Ison, and Barbara Natanson of the Prints and Photographs Division of the Library of Congress; and Peter Kunhardt and Philip B. Kunhardt III of Kunhardt Production, Inc.

I also need to thank Lori A. Wiener, Photo Editor, The White House; Fred Pernell, Still Pictures Branch, National Archives; Carolyn Poe Gurley, National Press Photographers Association, Inc.; Priscilla L. Strain, National Air and Space Museum; Susan Hirschfeld, Guggenheim Museum; John E. Collingwood, Gene O'Donnell, Dean Fletcher, and Rex Tomb of the Federal Bureau of Investigation; Tony Cantu, United States Secret Service; Adrian Berry, science correspondent of the *Daily Telegraph*; Kenneth Garrett; Marvin Minor, Forensic Identi-

fication Services, Metropolitan Toronto Police; Elizabeth Kunreuther of the Carpenter Center for the Visual Arts, Harvard University; Christopher Sheppard, Brotherton Collection, Leeds University Library; Dr. Karol Ann Peard Lawson, of the Columbus Museum; Mick Varley of Airborne Industries Limited; John J. Graham, Charles Monbello, Teresa A. Schumacher, and Lenny LaFeir of the Eastman Kodak Company; Philip Greenstreet of Rosco Laboratories, Inc.; Dr. Andrew Biache, Jr., and Carroll Lucas of Autometric Incorporated; Bruce Bradshaw of Leaf Systems, Inc.; Jeffrey Lord of The Lord Companies; Chris Holt, Creative Services Manager, British Airways; Craig Kevghas of the Scitex America Corporation; Eric Hibbard, NASA AMES Research Center, Numerical Aerodynamic Simulations Division; Wesley Billstone, Heidi Woldt, Eric F. Pfeckl, and Bruce Best of ABC Photo and Imaging Services, Inc.; Richard Wahlstrom of Richard Wahlstrom Photography, Inc.; J. van le Linde of Minolta Business Equipment; Martin P. Kress and Patricia S. Newcomer of the National Aeronautics and Space Administration; Suni Chapman of New England Press, Inc.; Colleen Hanleyh of Spot Image Corporation; The Association for Education in Journalism and Mass Communication; W. P. Branham, The William Branham Evangelistic Association; Larry Hirsch of Larry Hirsch Advertising; Wayne B. Robbins, Director, Research Services Division of the Institute of Paper Science and Technology; Stuart A. Crown; and Don Bowden of AP Wide World Photos and Advanced Presentations.

I am especially indebted to Robert F. McCort, the most astute, caring, and understanding editor. We work so well together. Finally, this book would not have come about without the devoted concern and patience of my wife, Theresa.

PHOTO FAKERY

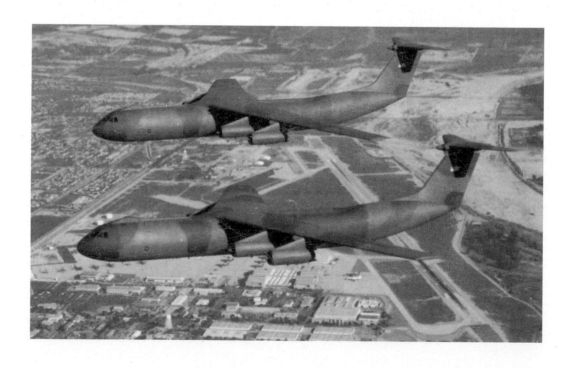

CHAPTER 1

Photo Fakery
Is Everywhere

Arthur C. Lundahl, the first director of the Central Intelligence Agency's National Photographic Interpretation Center, compared the invention of photography to the invention of gunpowder. He lectured that it was the most important tool for recording and communicating information, and a powerful and factual way of viewing and understanding the world. It was also the most literary of all the graphic arts. Its universal appeal allowed it to convey ideas across language barriers more quickly and concisely than the written or printed word. But Lundahl always cautioned that any photo that has been tampered with, when discovered, could have the impact of exploding gunpowder.

The term "fake" is from the German word *fegen*, to "furbish" or "clean up." "Photo faker" conjures up the concept of a craftsperson creating an image that will deceive an innocent or ignorant viewer, a person who can create a complex web of deceit. Nothing could be further from the truth. Anyone who has worked in a photo lab knows that many laboratory technicians, and now those in the digital environment as well, will experiment with various techniques of photo fakery.

It has been estimated that approximately 38,082,191 photos are

taken in the United States each day.[1] Of these, fewer than 3 percent are reproduced and fewer than 1 percent enlarged.[2] The Rochester Institute of Technology estimates that about one in ten color photos in print have been altered, indicating that something has been added, deleted, or removed.[3] Every indication is that these percentages will grow as newspapers, magazines, journals, and advertising organizations purchase new equipment to manipulate photos electronically.

The old adage "a picture is worth a thousand words" implied that the information contained in a photograph was inviolable. Photography has been seen as a medium of truth and unassailable accuracy and has been universally accepted as one of the most important means of communication. The potential of any medium depends on its credibility. Photography is graphically apparent and readily relatable and is taken *prima facie* as being the truth in court cases. Oliver Wendell Holmes, an amateur photographer and photo interpreter, stated that a photo serves as a "mirror with a memory." We all have a tendency to accept all photographs as being true representations of what they depict. The adages "The camera never lies" or that the camera "reproduces reality" or "seeing is believing" add additional believability to the photo—that what is shown was recorded truthfully and faithfully. Credibility is the photojournalist's most valuable asset. Photos are often so graphic that a reporter will allow them to carry a story.

NEWS PHOTOS

While the veracity of the printed word has been questioned over the years in terms of the credibility and integrity of its sources, photography generally is not subjected to such critical analysis. But with the age of computers and modern digital methods, photographs may not reveal what the camera saw at all. It is important to note that, today, photography is responsible for an estimated 97 percent of our visual information. Its ever-increasing importance as a means of communication and its contribution to our cultural life means that, if a photograph has been tampered with, false conclusions can be reached.

Because the photograph is an instrument of such powerful believability, the faking of a photograph for the purpose of deceit or deception is repugnant to most people; such photography defames and falsifies our understanding of the truth. When such attempts are discovered, they meet with disdain. Whenever a faked photograph is discovered, the perpetrator is held in contempt, accused of glaring bad taste, and roundly denounced in the print media. Fakery provokes feelings of anger and shame in those who have been deceived. The media, especially the print media, are intensely concerned about authenticity. There is a growing public skepticism, however, of the ability of the press to distinguish a

fake from a real photo. While some forgeries have been unmasked, most go unnoticed. Most people, including many professionals, cannot distinguish visual fact from fiction. I have spotted photo fakes in a number of prestigious newspapers and journals.

The "still" news picture has inherent properties that give it enduring strength and allow it to become a precise documentation of the time it was taken. The still photo can also strike the eye and shock the mind.

Most photographers and editors will readily agree that news photos should not be doctored or tampered with, yet in some instances organizations with strict rules against tampering have permitted alterations. Sharp debates have emerged among photographers—in darkrooms, newsrooms, at editorial desks, and in the publishing business—on not only the ethical but also the legal implications of manipulating the quality and content of photos. Where once a series of controls was imposed on the photo printing process, modern procedures have sometimes eliminated a series of checks and balances. Gone especially are the many craftworkers with their complex union rules that protected photography from adulteration. Some major newspapers such as *The New York Times*, *The Washington Post*, the *Los Angeles Times*, *Newsday*, the *Chicago Tribune*, *USA Today*, and smaller newspapers such as *The Providence Journal Bulletin*, *Asbury Press* (New Jersey), and the Associated Press have adopted guidelines or strict rules that bar altering any content in news photos.

The Associated Press has issued a written warning to all AP personnel: "The content of a photograph will NEVER be changed or manipulated in any way." The *Chicago Tribune*'s director of photography, Jack Corn, called electronic manipulation "Ethically, morally and journalistically horrible."[4] Robert Gilka, former picture editor of *National Geographic* magazine, stated that electronic retouching "is like limited nuclear warfare. There ain't none."[5] Stephen Isaacs, acting dean of the Columbia School of Journalism, told the Associated Press in 1994 that "To distort reality is a journalistic sin."[6] Charles Cooper, executive director of the National Press Photographers Association, was very blunt when he said: "What you see is no longer what you get. Photographs used to be the most accurate representation of reality, but you can't take that for granted anymore."[7]

Though the larger newspapers have developed strict policies, many smaller newspapers have not yet developed any. Some maintain that the essence of a photo should be kept, but complain that there has always been alteration of photos.

While early techniques for altering photographs were relatively simple, recent advances in computer technology have permitted greater refinements of old techniques, and have provided versatile and effective

One of the modern digital image retouching and processing systems that allow for the computer manipulation of photographs in "electronic darkrooms." *Scitex Blaze Workstation, Scitex America Corp.*

tools for deception. Because the computer can be programmed, it is infinitely malleable. Images can be combined or altered and smoothly melded into a new artistic medium.

THE ELECTRONIC DARKROOM

Traditional chemical darkroom procedures have not changed for over a century, and they are inefficient, demanding, and time consuming. As in so many other work areas, the application of computer technology has brought change. Yet the emergent science of image manipulation, like most innovations, is as controversial as it is promising. The advent of the computer has caused a revolution in photography as we have known it. The computer is a powerful new tool at the service of human imagination, yet it can also have detrimental effects.

In the future electronic images will no doubt replace light-sensitive film. The news and printing industries are heading toward an all-digital environment, a virtually filmless and chemical-free process. This is a highly cost-effective way to process photography to the printed page. Major camera manufacturers such as Nikon, Fujica, Epson, Konica, Minolta, Panasonic, Canon, Casio, Chinon, Eastman, and others have created and are touting the new Advanced Photo Systems (APS). For example, the new Eastman DC-200 electronic camera is priced at about $400.00, making it competitive with other cameras. There has been considerable criticism, however, that the photos are nowhere as sharply detailed as conventional 35mm photos.[8]

The more expensive cameras, such as the Nikon N90, with a digital back and costing a whopping $28,000, are capable of sending an image from the camera to a publisher's screen via telephone lines. Using these cameras may mean taking a risk of losing an original image. The magnetic storage disks for the images can be erased and recorded over, so that an original, permanent negative does not exist.

The latest stage of technology is a combination camera-modem-telephone where photos can be transmitted as they are shot. Two Canadian newspapers, *The Vancouver Sun* and *The Province*, have bought twenty News Camera (NC) 2000 digital cameras from the Associated Press. The camera was developed by Eastman Kodak and the Associated Press specifically for time-sensitive press coverage. The quality of the images is excellent, and using this equipment allows photographers to stay on a scene right up to deadline. The cameras range in price from $15,000 to $17,500; each has a compact storage drive that holds more than seventy-five images. The drive can be removed and then inserted into a photo transmitter to send images by phone lines or by satellite to the newspaper.[9] The images are captured digitally, and seconds later can be scanned on a monitor. Etching, stripping, and correcting the color of photos can be done on a computer screen. An image can be modified or manipulated to create special effects, or merged with other images. At the workstation, retouching and color corrections, as well as page assembly, can be done. These workstations are equipped with exceptional airbrush and copy capabilities to correct photographic flaws. Backgrounds and foregrounds can also be added or merged. Finished images can be easily incorporated into documents. Images can also be prepared for facsimile telecommunications.[10]

One of the most attractive aspects of computer composing is that the results can be seen and reviewed as each step progresses. One does not have to wait for the painstaking and time-consuming efforts of conventional retouching techniques, which can take hours or even days to accomplish.[11]

In addition to saving valuable processing time, such processing systems have both economic and ecological advantages. The system is digitally integrated so images can also be sent electronically to scattered branch plants of major newspapers. Because it is virtually chemically free, thousands of dollars can be saved in processing, and the problem of disposing of the chemicals disappears.

Among the leaders in the production of machines being installed in leading newspaper plants and magazine, advertising, and publishing companies are the Scitex America Corporation, Crosfield Electronics, and Hell Graphics Systems, Inc. These are expensive systems, but less expensive systems are being produced for newspapers with smaller cir-

culations. Amateurs and freelancers can use off-the-shelf software such as Adobe Photoshop.

The ability to alter photos through electronic manipulation has raised a host of legal, moral, and ethical issues. Defense officials have often been accused of exaggeration and manipulation to show the military in the best light. Concerned that possible manipulations might be detrimental to the image of the Department of Defense, John M. Deutch, as Deputy Secretary of Defense, issued strong guidelines. Noting that "photographic and video imagery has become an essential tool of decision makers at every level of command and in every theater of military operations" the department issued a policy on prohibiting the alteration of official photographic and video imagery. The directive states that imagery must be complete, timely, and, above all, highly accurate. "Anything that weakens or casts doubt on the credibility of this imagery within or outside the Department of Defense will not be tolerated."[12]

The directive, however, leaves some loopholes. It specifies that "photographic techniques common to traditional darkrooms and digital imaging stations such as dodging, burning, color balancing spotting, and contrast adjustment that are used to achieve the accurate recording of an event or object are not considered alterations." The directive adds: "The use of cropping, editing, or enlargement to selectively isolate, link or display a portion of a photographic video image is not considered alteration. However, cropping, editing or image enlargement which has the effect of misrepresenting the facts or circumstances of the event or object as original constitutes a prohibited alteration."[13] To ensure that the Department of Defense guidelines are followed, ethics will be an important part of a course in digital imaging taught at the Joint Defense Photography School in Pensacola, Florida. It will also be used in classes at the recently established Defense Information School at Fort Meade.

Although strict standards have been set by leading newspapers and magazines, there are still deep-seated concerns about possible abuses since it is known that news photos have been manipulated by editors. Some news organizations feel that it is permissible to "clean up" photography as long as that doesn't change the integrity of the image. Other organizations maintain the right to "clean up" a photograph that appears cluttered or messy by removing small elements in the photograph that are "journalistically irrelevant." For example, the *Saint Louis Post Dispatch* is known to have electronically removed a Diet Coke can from a 1989 Pulitzer Prize–winning portrait.

On Sunday, August 14, 1994, *The Washington Post* carried a front-page photograph of a young couple embracing at the 1994 Woodstock festival. In the background was a man whose T-shirt was emblazoned

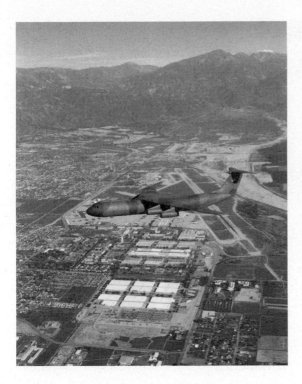

with a large phallic symbol. In a later edition, the symbol had been electronically removed. When confronted, Joe Elbert, assistant managing editor for photography, stated that the computer surgery was a clear violation of the *Post*'s written policy that no news photos should be altered. Elbert said a news editor had asked that the symbol be removed and that the picture desk had gone along.[14] *The Washington Post* earlier had also erased a second actress from a stage photo of Helen Hayes.

During the Gulf War, the dull sky during the Battle of Khafji appeared as brilliant blue on a *Time* cover. The October 1987 cover of *Newsday* carried a photograph of eighteen F-14 jet fighters taking off in formation. The image was created by taking a photo of a single jet and copying it seventeen times.

Recently, *Newsweek* was accused of straightening the teeth of Bobbi McCaughey, the mother of septuplets. In a number of published photos, it was obvious that McCaughey had crooked teeth, but on the *Newsweek* cover her teeth were straight and smooth. When confronted, a *Newsweek* spokeswoman said the magazine had attempted to lighten up a dark area in a news service photo and that it wasn't their idea to do inappropriate dental work.

Kenneth Lambert of the *Washington Times* photographed a naked man at the 1994 Woodstock festival. The picture, titled "Everything Old Is Nude Again," is a full frontal shot of a naked man sitting in a lawn chair receiving puzzled looks from several nearby women. The *Wash-*

The ease with which photos can be manipulated by modern digital equipment is demonstrated in these photos, where an additional jet transport has been added to the original photo by Autometric, Inc. The camouflage markings are exactly the same, which makes the photo immediately suspect. *Autometric, Inc.*

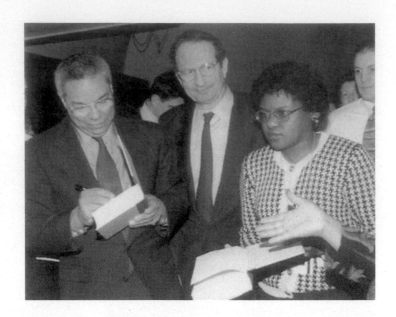

ington Times refused to print the photo for "taste reasons." Lambert subsequently entered the photo in the annual contest held by the White House News Photographers Association. It won a first-place prize for color feature photography, which set off a rhubarb among photographers. Some felt that the photo should not be displayed publicly in the Library of Congress; others felt it was a legitimate news photo that should be shown. Some hoped that the photo might be withdrawn by either the president or the Library of Congress. The White House News Photographers Association voted not to withdraw the photo on grounds of poor taste. The *Washington Post* did publish the photo, but with a manipulative black area deleting the man's genitalia.[15]

On October 6, 1995, Senator Edward Kennedy conducted a forum on Medicare. Both the *The New York Times* and the *Washington Times* carried photos of the senator with an oversize chart behind him. In *The New York Times* version the large letters on the chart, MEDICARE CUTS PAY FOR TAX CUTS FOR THE RICH, can clearly be seen. In the *Washington Times* version, the words seem to have been whited out, although other words on the chart are clearly visible. Francis Coombs, the *Washington Times*'s assistant managing editor for news, dismissed the idea that the picture had been tampered with. He stated: "It's probably just the printing of it that has been lightened [*sic*] it up."[16]

Many view the press, and news photographers in particular, in an unfavorable light. In a number of murder scenes, automobile accidents, funerals, or natural disasters, photos have been published that have brought strong reactions from readers. Charges of sensationalizing the news at the expense of the concerned families have been heard. These

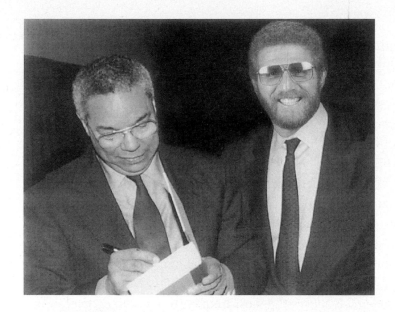

New computer technology allows for the complete changing of the concept of a photo. In the original photo, General Colin Powell is autographing his book. John M. Deutch, the Director of the Central Intelligence Agency, stands immediately to his left. In the second image, the young woman has been removed from the photo; Deutch's head has been removed and a lab technician has substituted his own; the background has been removed and the light and shadows on Powell conform with those on the lab technician. *Author's collection.*

photos, often referred to as "the ultimate grief photo" by photographers, are often tampered with. The blood in the scenes is either softened or removed, and facial expressions of the dead victims are changed. Some would say this is a matter of taste and sensitivity. Others believe that capturing the news in its most vivid form allows the reader to share in the tragedy. Failure to publish such photos, they argue, would amount to an act of censorship.

Perhaps Gary Bryant, a staff photographer for the Salt Lake City *Desert News*, stated it best when he wrote: "The media's credibility is under fire; we are not trusted anymore. Society feels that we are intruding past the line of decency. People no longer want to see pain and suffering of the human family, especially if the camera is focused on the pain of their neighbor."[17]

Each editor or art director determines how the computer will be used and each, it appears, seems to be setting his or her own standards. Concern has been expressed that new systems will prove too tempting for news editors to resist implanting their ideas "to improve photography." For example, in 1993, *Newsweek* combined a photo of Dustin Hoffman, then in New York, with one of Tom Cruise in Hawaii for a story on the film *Rain Man*. *Newsweek* editor Maynard Parker stated that standards were different for "celebrity photos."[18] Jann Wenner, editor of *Rolling Stone*, an ardent opponent of handguns, insisted that *Miami Vice* star Don Johnson's pistol and holster be removed electronically for a cover picture.[19]

Others feel that in "cleaning up" a photograph it is often difficult to determine where the line should be drawn. For example, an innocuous

change of color could have unexpected connotations. The issue of who is charged with these decisions is a tricky one. Some believe that a photographic editor should make these choices. Still others are concerned that the photographer in the digital age has faded too far from the scene where such decisions are made. More often than not, however, it is the editor—not the writer, and certainly not the photographer—who determines how the image will appear in print.

The faker's skill will be sharpened with the computer, and an ethical concern is growing in both academic and professional journalistic circles that the manipulation of one photo will destroy the credibility of all. A fear is being generated that photos in major newspapers will be greeted with doubt and suspicion since there is a growing public skepticism about the ability to distinguish truth from fiction.

Among television stations, the Radio-Television News Directors Association Code of Ethics is the most frequently adopted code of ethics with regard to television news reporting. The National Press Photographers Association (NPPA) has issued a call for guidelines for news photos. Their statement of principle:

> As journalists we believe the guiding principle of our profession is accuracy; therefore, we believe it is wrong to alter the content of a photograph in any way that it deceives the public.
>
> As photojournalists, we have the responsibility to document society and to preserve its image as a matter of historical record. It is clear that the emerging electronic technologies provide new challenges to the integrity of photographic images. The technology enables the manipulation of the content of an image in such a way that the change is virtually undetectable. In light of this, we, the National Press Photographers Association, reaffirm the basis of our ethics: Accurate representation is the benchmark of our profession.
>
> We believe photojournalistic guidelines for fair and accurate reporting should be the criteria for judging what may be done electronically to a photograph. Altering the editorial content of a photograph, in any degree is a breach of the ethical standards recognized by the NPPA.[20]

Some photojournalists do not favor a written code of ethics, maintaining that such codes only cover specific situations. Each case is different in their eyes, and photojournalists should resolve complicated cases as they occur; for example, to close a blouse or an open zipper is permissible. Because of the competition for newsstand sales, some photojournalists are tolerant of the manipulation of magazine covers to catch a customer's eye.[21]

Others advocate a new code of behavior—that a sort of truth-in-labeling-law be established: when a manipulated photo is used it should have a disclaimer or be identified as such. There are a number of sugges-

tions as to how to inform readers that a photo has been tampered with, such as marking an image with the word "illustration" or a large "I"; the word "Montage" or the letter "M"; or "photo manipulation" or the letters "PM." Others feel such markings hidden in a title page or credit can easily be overlooked by readers.

Some advocates draw a distinction between photo illustration and photojournalism. Since it is now possible to create realistic-looking images with computers, and because it may be impossible to tell that these are fiction instead of fact, these images should be so labeled. There has been a growing tendency among some newspapers to supplement traditional news photos with contrived illustrations to produce a more graphically appealing product. These appear especially in the food sections of the newspaper.

Probably no set of rules will ever cover all possible cases—the subjective judgment of a photo by the managing editor will always be necessary. This point is illustrated by the controversies surrounding some news photos involving the O. J. Simpson trial.

On a *Time* cover a reproduction of the grim police mug shot of O. J. Simpson was electronically manipulated to make Simpson look darker, and, some felt, evil.[22] The darkening of the photo made him appear to have darker stubble on his face. Some black journalists condemned the photo and saw it as a racial insult. Media critics argued that the darkened image reinforced the stereotype of the menacing black male. Benjamin Chavis, president of the NAACP, stated the photo made Simpson look sinister and guilty, "like some kind of animal." Although *Time* had labeled the cover as a photo-illustration, it brought a sharp rebuke from the magazine's rivals. "We as a matter of policy do not manipulate news photos," stated Merrill McLaughlin, co-editor of *US News and World Report*.[23] Richard Smith, *Newsweek* editor-in-chief, said, "We don't mess around with news pictures."[24]

In *Time's* next edition,[25] Managing Editor James R. Gaines would state in an apology to its readers that "no racial implication was intended by Time or by the artist."[26] While critics felt that the artist's work had changed the picture fundamentally, Gaines stated, "I felt it lifted a common police mug shot to the level of art, with no sacrifice to truth."[27] *Time* spokesman Robert Pondiscio indicated that the controversy did not prompt a change of policy for the magazine. He said, "The goal is not to set policy. The goal is to increase your sensitivity and be smarter about these things in the future."[28]

Pondiscio would later point out that *Newsweek* was not as virtuous as Richard Smith had indicated: *Newsweek* had manipulated the mug shot of Los Angeles patrolman Lawrence Powell on its April 26, 1993, cover.

Newsweek had changed the color photo to black-and-white and enlarged it, giving it the stark, grainy texture of a news photo. *Newsweek* editor Maynard Parker dismissed any comparison of the two covers: "We didn't manipulate the image to make it more sinister. We didn't add anything to that photograph. We blew it up. That photo looks like the reality of the event."[29]

Wired magazine took the cover portrait of a glowering O. J. Simpson from the July/August 1995 issue of *American Heritage* and created a blond, blue-eyed version of Simpson. This *Wired* issue also digitized a Nicole Simpson photograph into an Afro-American holding the white hand of the Simpson on the cover.[30]

When no news photograph is available, there is a growing tendency among American magazines to contrive a manipulated illustration. A *National Enquirer* headline read "Battered Nicole Photos Taken by Her Sister Show How O. J. Beat Her Up."[31] The photo of Nicole showed a half-closed left eye that was bloodshot and the left side of her face badly bruised and swollen. Her earlobe was also bruised, and scratches appear on her neck and nose. On the newsstand, the photo would immediately catch one's attention. On the lower right of the photo is a smaller caption: "Sister Describes Photos Seized by Cops—Computer Re-creation." The computer re-creation is based on Nicole's sister Denise's description of Polaroid photos she had taken, which had been seized by police from Nicole's safe-deposit box.[32]

A succession of hoaxes have achieved notoriety in the media. Widespread publicity always gives rise to additional hoaxes. This has been especially true in such cases as UFOs, the Loch Ness monster, and POW/MIA searches in Vietnam. For less than $200, a scanner can be bought as an accessory for a home computer. The scanner can be used to copy and manipulate photos. A number of articles on how to manipulate photos have appeared in photographic and computer journals. Photo expert Vicki Goldberg has stated that "Photography's power of proof derives from its unique and unbreakable bond with reality."[33] There is a veracity, sanctity, and uniqueness in a given photo, and to destroy these qualities is especially repugnant. Whether we like it or not, however, we've entered an era where photographic reality can't be trusted. Ms. Goldberg states: "We are in the middle of a revolution in visual evidence: photographs no longer necessarily repeat what the camera saw at all. The technology for digitization of photographs—whereby images are translated into computer language—is bringing about a transformation in the very nature of imaging that is as radical as anything since the invention of photography."[34] There are those who will say that images appearing in the press are as unreliable as words—that they can no longer be defensible as portraying criminal behavior or historical reality. Perhaps Frank

Van Riper, a Washington-based professional photographer and writer, stated it best when he wrote: "Should the day ever come when photographs in mainstream newspapers or magazines are greeted with doubt as to their content or origin, something terrible will have happened to our democratic free press in the name of higher technology."[35]

PHOTO FAKERY IN ADVERTISING

One of the richest markets for tampering with photographs is advertising, which has a long tradition of manipulation and fabrication, and where it is expected that artists and designers will rely on the computer's sophisticated altering techniques to produce appealing photos electronically. If a photo laboratory has botched the processing, or if there is something distracting in a photo, or if there are offending backgrounds, digital imaging can come to the rescue.

In glamour and fashion magazines, the key is to portray subjects as attractively and alluringly as possible. Analysis shows that facial or body complexions have been made flawless, and a female model's skin made hairless. In the industry, these maneuvers are referred to as "helping the model." If there is a scar or a mole, a pimple or a freckle, it is removed, along with any enlarged pores. Crow's-feet, wrinkles, blemishes, and stray hair are eliminated. Protruding veins are sublimated, teeth whitened and polished, lip lines corrected, eyebrows groomed, and shadows about the face erased so that a hyperclean look that seems freakishly flawless abounds. The white of the eye has a smooth finish and the eye color is enhanced. Busts may have been enlarged or lifted. Prominent navel rings can be erased. The all-important smile is always softened. The model tends to be a figment of the reader's imagination—providing escapism and inspiration—a fantasy. The model is the perfect embodiment of beauty. The process is often referred to in advertising as Scitexing or the Scitex Glow. Scitex is a leader in the image-manipulation field and has become a catchall term for computer enhancing systems.[36]

There may be, however, certain identifying marks—little imperfections—that give a model a definitive character. For example, Cindy Crawford has a mole, Patti Hansen a scar, and Stephanie Seymour a tattoo. Sometimes the Scitex operator goes overboard and eliminates that trademark. *Glamour* magazine, for instance, bonded all of Madonna's teeth together, closing in her famous "gap."

Nearly every cover on these types of magazines has been tampered with, and the cover face always has a scrubbed and polished look. The magazine cover is a marketing tool designed to sell the magazine. It has been said that magazines live and die by their covers on the newsstands. They must be perfect, if not truthful.

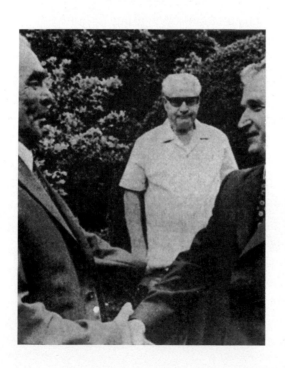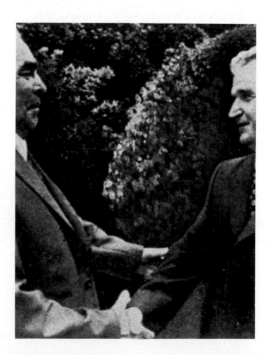

CHAPTER **2**

Types of Photo Fakery

There are four distinct kinds of faked photographs, recognized by the different techniques used to accomplish them: removing details, inserting details, photomontage, and false captioning. The fourth category, false captioning, differs from the others in that tampering with the photography itself is not a necessary ingredient of the fakery. The context of what the photograph is purported to convey is simply falsified.

DELETION OF DETAILS

The public of the nineteenth century had become accustomed to the flattering portraiture painted by artists, and expected the same from portrait photographers when they began to open studios. When photos captured all the blemishes and unflattering facial features of a subject, many people refused to accept them. Artists were hired to correct with a brush those features in portrait photos that the camera had captured too realistically. There is an old saying among retouchers: "If you can't remove ten years or ten pounds from a figure, you're not a good retoucher."

During their heyday, Hollywood studios hired a battery of retouchers to make the stars appear to be without blemishes, and their clothing

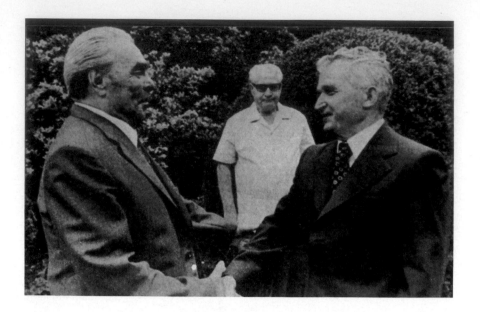

immaculate and without wrinkles. The seductive allure of movie stars and attempts to make them glamorous continue. For example, in the movie *Cleopatra*, Elizabeth Taylor has a vertical scar at the base of her neck, but in all of the ads for her Fragrant Jewels perfume neither the scar nor any of her wrinkles show.

To show what modern technology can perform, *McCall's* magazine took candid photos of Kirstie Alley, Jessica Lange, and Elizabeth Taylor and submitted them to digital Scitex enhancement. *McCall's* showed how eye and forehead wrinkles and sagging jowls were removed. Blemishes, stray hairs, and lipstick smudges were also retouched. Hairlines were enhanced, eyes were whitened, eyebrows groomed, skin tone evened, and shadows softened. The differences were startling.[1] In photos of other movie personalities, it is obvious that waists have been nipped in, hips reduced, arms and legs lengthened, cellulite removed, and all wrinkles removed from their clothing.[2]

Photographs are often used in attempts to rewrite history. We are all familiar with Communist countries that have removed from photos personalities who have fallen from grace. There are also many Soviet photos that I have categorized as the "Go away buddy, you don't belong" type. The Soviets were very conscious of rank and protocol; distinguished visitors to Moscow, were, of course, accompanied by interpreters and security personnel. It was common for the Soviets to brush out individuals in the photos whom they did not consider to be of sufficient rank to be recorded. For example, Romanian party leader Nicolae Ceausescu met with Soviet Premier Leonid Brezhnev in the Crimea; a Soviet photo was taken of their handshake and printed in the August 1981 issue of the

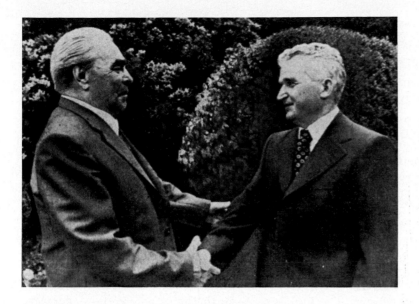

REMOVAL OF INFORMATION
The original photo shows Soviet
Premier Leonid Brezhnev meeting with
Romanian President Nicolae Ceausescu
in the Crimea, with a man, possibly
a security officer, appearing in the
background. In the revised image,
the Communist Romanian newspaper
Scinteia has removed the man. *Central
Intelligence Agency Presentation to Congress.*

Frankfurter Allegeine Zeitung. The two leaders are facing each other.
Between them, at a discreet distance, is a third grim-faced man in a
white shirt, probably an interpreter or security person. The photo also
appeared in the leading Romanian newspaper, *Scinteia*, on August 1,
1981. Close inspection reveals that the faces of Brezhnev and Ceausescu
have been spruced up, the wrinkles in their clothes smoothed out, and
the lone official completely removed. Leaves on the bushes where the
official had stood had been brushed in to fit his place.

INSERTION OF DETAILS

Details can obviously be deleted; a good technician can also add details
that were not in the original photo. An artist can add in features that may
be lacking on the photo. Facial features can be softened, or additional
color brushed into the eyes, lips, and cheeks to make the subject more
attractive. If a smaller waistline is considered to be more fashionably at-
tractive to a woman, a retoucher can brush out a part of the waist and
brush in small sashes or bows on her apparel. The cost of taking photos
for advertising purposes is extremely expensive. If there are minor im-
perfections in a given photo, it is often cheaper to hire a competent
retoucher than to restage the entire scene. There are a number of es-
tablishments in New York that specialize solely in retouching photos.
Retouch artists, especially those involved in color work, are generally su-
perb and realistic artists. Computer specialists are replacing these art-
ists, and photographs can now be retouched so the results are often not
immediately visible to the human eye.

Modern computer technology not only allows the insertion of small

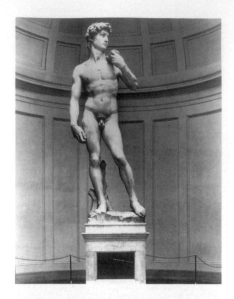

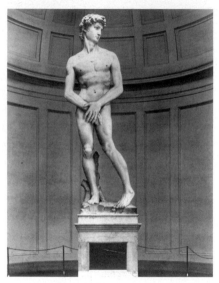

facial details but also can be used in some cases to change the depiction of the entire body. There is a certain, sometimes humorous, fascination in changing something well known to something that is entirely different. Minolta, for instance, changed Michelangelo's statue of the proud young David by moving his arms and legs to modestly cover his genitals.

PHOTOMONTAGE

It is perhaps necessary to distinguish a photomontage from a collage, since both can involve photo fakery. "Photomontage" designates a composite image in which all elements are photographic. Chemical, optical, or digital methods have been used for alteration. In a photomontage, it is common to rearrange the parts of the whole to produce a new work. The photomontage brings all elements into a single unified composition. Often snippets of the photos are rearranged for a new realism, or used to interject whimsy. The idea is to make the areas where the images are merged as nearly invisible as possible. This is done by shaping, scraping, painting over, or digitizing.

The art of collage, on the other hand, involves cutting one or more photographs into pieces and reassembling all or some of the pieces to form a new image. A collage often attempts to make expressive use of image pieces, shifting the spacing or arrangement, keeping all or eliminating some elements of the total image. Often photographs are combined with other materials, such as cloth, paper, and paintings. The composite result may be mounted on a flat surface or may form a three-dimensional piece. There usually is no attempt to conceal the edges or the parts of the juxtaposition and texture.

There is general agreement that there are three different types of photomontages. The first is often referred to as the "butt" montage, where two or more photos are simply butted up against one another. The second is the "on top" montage, where one photo is superimposed on another. The third is referred to as "composite," where two or more images are melded to create a new image. Great care is taken to conceal the fact that different images have been used. The photomontage in the past was created by cutting, pasting, or superimposing parts of separate paper prints and mounting them into a composite photo. The montage is widely used commercially for producing trick or artistic effects, murals, advertising and publicity, posters, and magazine covers.

In the past, the cut-and-paste method required no special laboratory facilities and the product was known as a "paste up" montage. This type of photomontage is usually retouched to obliterate joints, gains, or differences in texture. The resulting montage is usually rephotographed.

Today, a computer can be used to add one image to another by breaking down the photos into tiny electronic units called pixels (an abbrevia-

tion of "picture element"); each of the hues, intensities, and color saturations are recorded digitally on a disk or tape. An operator can then manipulate the pixels either singly or in groups and reassemble them into a different form to create a different picture that is nearly seamless in construction.

The montage has frequently been used in the international arena to demonstrate or buttress political, cultural, and military activity. Frequently, photography is integrated with other pictorial systems to produce a synergetic effect—a whole scene that was different from the sum of its parts.

The photomontage is often used in a humorous vein. An American business promoter purchased the London Bridge, had it dismantled, sent to the United States, and reconstructed in Arizona. Photomontages were subsequently created to show how other world-famous structures would look reconstructed in the United States. The Leaning Tower of Pisa was positioned in a mall in Minneapolis, Moscow's St. Basil's Cathedral in Washington, D.C., Big Ben and the Houses of Parliament at Disneyland, the temple of Abu Simbel at Mt. Rushmore, the Parthenon in Memphis, and Stonehenge at an art center in Minneapolis.[3] Similarly, Fred Ritchin, a former photo editor of *The New York Times*, created a computer photomontage showing the Statue of Liberty, the Eiffel Tower, and San Francisco's Transamerica Pyramid building in downtown Manhattan.[4]

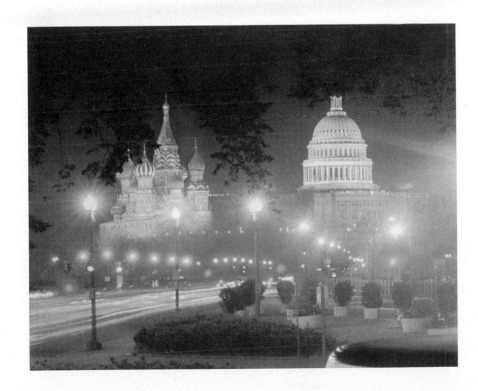

MONTAGE
Images of Moscow and Washington have been combined in this remarkable montage. *Data General, FCB Leber Katz Partners.*

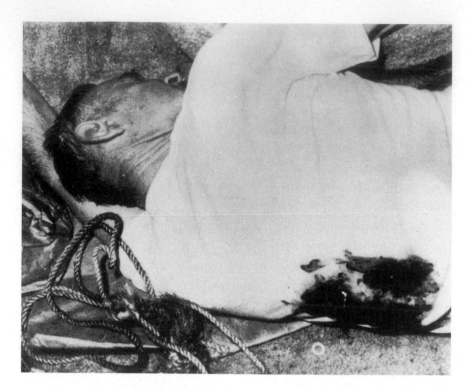

FALSE CAPTIONING

The falsely captioned photo differs from other groups of fake photos in that, although the photography has not been altered, the context of what the photograph purportedly conveys is simply falsified. Proper captioning of a photograph includes descriptive data regarding the "who, what, where, when, and why" of the subject or scene. In falsely captioned photos only one or more of these elements is usually mentioned. This type of fake is frequently used in criminal cases to trap defendants who have tried to silence witnesses from testifying against them.[5]

The trial of T. Cullen Davis, one of the wealthiest men ever tried for murder in Texas, involved what a number of newspapers termed a "fake" photo of the purportedly dead body of a judge. The judge was alleged to have been on a "hit list" that Davis gave to an FBI informant. But the photo itself had not been altered. It was instead a staged photo of an event that never happened—in other words, a falsely captioned photo. Davis, who had been accused of murdering two other people, was eventually acquitted.

In a similar case, Egyptian security officers tricked Libyan leader Muʿammar Qaddafi into believing that Abdul Hamid Bakoush, a former Libyan prime minister and a strong foe of Qaddafi, who was living in Egypt, had been executed by Qaddafi's assassins. Egypt's security and

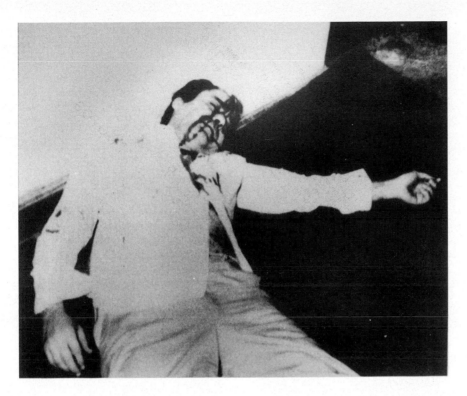

intelligence service had learned of the plot and the so-called assassins
were captured. A photograph was staged showing Bakoush dead and ly
ing in a pool of "blood." Egyptian intelligence had the leader of the "as-
sassins" write a letter to the head of Libya's embassy in Malta saying the
"execution" had been carried out. Egyptian security forces also saw to it
that the photo made its way back to Libya. The Libyan news agency
proudly proclaimed that Bakoush had been "executed" because he had
"sold his conscience to the enemies of the Arab nations and the Libyan
people." President Hosni Mubarak of Egypt then revealed that Bakoush
was alive and well and that the photo had been staged—much to Qad-
dafi's chagrin. The pictures of the "dead" Bakoush show him sprawled
on his back, apparently shot in the forehead. The "blood," instead of
flowing from the wound to the floor as gravity would have it, is shown
splattered down his face and on his shirt front. For this to have hap-
pened, Bakoush would have to have been kept standing after being shot.
Apparently, the Libyans were also poor photo interpreters.[6]

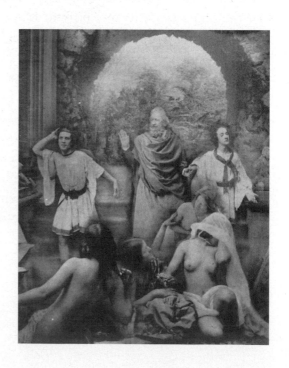

CHAPTER 3

The Beginning

The art of photo faking is as old as photography itself. The introduction of photography dates from January 1839 when both William Henry Fox Talbot and Louis-Jacques-Mandé Daguerre announced they had discovered, quite independently of each other, two different processes of fixing an image.

The daguerreotype was a silver-coated copper sheet that had been made sensitive to light, exposed in a camera, and developed with mercury vapors. The subjects had to remain motionless sufficiently long to permit the necessary minimum exposure. In the case of humans, brackets held the head and body in position for the long exposure. Since the long exposure made it impossible for subjects to keep their eyes open during the entire exposure, photographers would scratch the pupils of the eyes on the plate or emulsion.

In the early decades of photography, as previously stated, the public, accustomed to flattering portraits by artists, were shocked when they saw their portraits, because the camera had represented their countenance truthfully. Photographers soon realized that to sell portraits, they were obliged to flatter the sitter. Some of the first portrait photographers were artists turned photographers. When people wanted a more realistic

photo, artists were hired to hand-color the images. A variety of means were later used to add color manually to black-and-white photographs, including using watercolor and other paints and dyes. Hand-colored photos are to be distinguished from tinted ones. A tinted photo has a single overall color resulting from the addition of a dye or dyes to the photographic papers by the manufacturer.

Daguerre was the idol not only of France but also of the Western world. This adulation was responsible for the first false-captioned photo in 1840. A pioneer in French photography, Hippolyte Barnard, posed himself as a drowned corpse to protest the lack of recognition of his photographic process and saw to it that the photo received a wealth of publicity. In his "suicide" note he wrote: "The government which gave M. Daguerre so much, said it could do nothing for M. Bayard at all, and the wretch drowned himself."[1]

Before photography, paintings had occupied the prime spot for illustrating history. People came to know the characters in the Bible, as well as historic personages and battles, through paintings. Paintings were a window on the world and the culture of the ages was reflected in artists' renditions of famous events.

The first phase in the use of the camera was imitation. Photographers tried to use the camera in the same way that the artist used a brush. There were attempts to enlarge the sphere of photography and allegories were tried. In 1843, John Edwin Mayall made ten daguerreotypes to illustrate the Lord's Prayer that were widely acclaimed by the British press. In 1848, Mayall produced six plates based on Thomas Campbell's poem "The Soldier's Dream."

During the 1850s, there were attempts to depict scenes from literature or from the Bible. Renaissance art depicting religious scenes was also an inspiration to the artists-turned-photographers and they began plagiarizing religious paintings by staging and photographing religious art, taking great pains to achieve accuracy.

Technological advances improved the artistic value of photographs. In 1851, Frederick Scott Archer invented the wet-collodion process, which revolutionized the nascent photographic industry. Lens speed was also increased, making images with a finer grain, which, along with albumen papers, produced photographs of excellent quality.

Artists, however, still criticized the photo as a two-dimensional representation unlike an artist's painting, which could be three-dimensional. Artists also protested that photography could not expose innermost visions or feelings. Critics, comparing the artistic merits of photography with Old Master paintings, found photography seriously lacking. Artists told a story and depicted the incidents of their paintings with

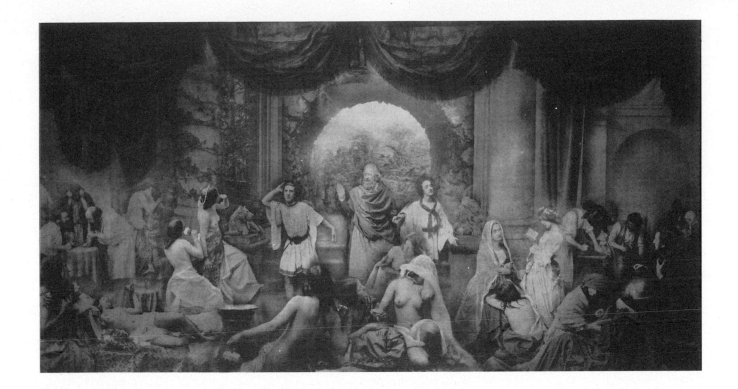

a minuteness of detail that could not be matched by photos. The photograph literally did not present the soul and had little or no effect on feelings or emotions. To rescue photography from such reproach, it was obvious that something had to be done other than the simple presentation of an individual photo, and thus the art of photo fakery was born. The merging of two or more negatives to create a new image was referred to as "composite" or "combination printing." Today it is known as photomontage. Photographers took artistic license to add or subtract details to suit their purposes. Yet as early as 1856, the *Journal of the London Photographic Society* wanted doctored photos banned from society exhibits.

New inventions followed one after another, year after year. There were also a number of hoaxes. For example, Levi Hill, a former Baptist clergyman who had given up his ministry to become a daguerreotypist, claimed to have invented daguerreotypes in color. He had written a manual of daguerreotypy and offered it for sale at $3.00 a copy. It is generally agreed that he worked his hoax by cleverly coloring his daguerreotypes by hand.

The cameras, crude but expensive, were hampered by the clumsy equipment and balky photographic processing. Despite the difficulties, photographers took their cameras to the countryside and photographed landscapes, buildings, monuments, and celebrities in their own locales. Later, many traveled to Italy, Greece, Turkey, and Egypt and produced

In 1857, Oscar Gustav Rejlander created a sensation with his allegorical photo *The Two Ways of Life*, made from thirty negatives. *The Royal Photographic Society Collection, Bath, England.*

remarkable photos of the monuments of ancient and classical civilizations. Albums of photographs were produced that found interested audiences in lovers of architecture and of the natural and visual arts.

Advances in photography also brought about a new profession—photojournalism. Roger Fenton loaded up his camera equipment and went to photograph the Crimean War. Reports from journalists told of the horrible living conditions, diseases, and the fighting in which many were dying each day. Fenton, however, never trained his camera on the scenes of carnage and did a disservice with his posed photos, published in Britain, that implied that all was well in the Crimea. His well-composed photos of military cantonments, of officers and men in dress uniforms consulting, resting, and relaxing with their wives, and of the Balaklava harbor filled with officers' yachts did not cover the primary subject matter of war—the actual fighting, the wounded, and the dead.

The first major artistic photomontage was created in 1857 when Oscar Gustav Rejlander combined some thirty negatives of separate figures and groups to create an allegorical composition, *The Two Ways of Life*, which represented two young men setting forth into life by different paths. One turns to religion, charity, and industry to form the good life; the other turns to gambling, drinking, and licentiousness. The large photo provoked heated discussions in photographic and artistic circles. Some questioned the moralizing content of Rejlander's photo, and others debated his erotic use of semi-nude models. Rejlander, however, had every reason to be satisfied with his photomontage when this first major photo fake was purchased by Queen Victoria for Prince Albert, who greatly admired it and hung it in his study. Later, from two separate negatives, Rejlander created an image of John the Baptist's severed head.

Rejlander followed *The Two Ways of Life* with the *Head of John the Baptist*.
George Eastman House.

Henry Peach Robinson, another artist who took up photography as a profession, felt that emotions and feelings could be demonstrated through photography. In 1857 he created *She Never Told Her Love*, a photo of a despondent girl. In 1858 he created *Fading Away*, made from five negatives. The photo showed a "dying girl" surrounded by her grieving mother, sister, and fiancé. Robinson intended the viewer to feel the sense of loss and tragedy, but some felt it was in poor taste to represent so painful a scene, while others decried it as maudlin. Artists attacked the photo for its "morbid content." Yet these photos tapped the rich vein of Victorian sentimentality and were popular with the public. Again, such manipulation of photography was given a boost by Prince Albert, who praised the photo and gave Robinson a standing order for a copy of every such photo he produced.

In his review in the Salon in 1859, French poet Charles-Pierre Baudelaire bitterly attacked photography: "By invading the territories of art, this industry has become art's most mortal enemy. If photography is allowed to supplement art in some of its functions it will soon have supplemented or corrupted it altogether."[2] He wrote in disgust that it was time for photography "to return to its true duty, which is to be the servant of the sciences and arts—but the very humble servant, like printing or shorthand, which have neither created nor supplemented literature."[3] Baudelaire acknowledged that photography had a role in photographing buildings and the like for historical purposes, but warned that if photography "be allowed to encroach upon the domain of the impalpable and the imaginary, upon anything that value depends solely upon the addition of something of a man's soul, then it will be the worse for us."[4]

Five negatives were used by Henry Peach Robinson to create the sentimental montage *Fading Away* in 1858. The joints of the various prints were subtly hidden. *George Eastman House.*

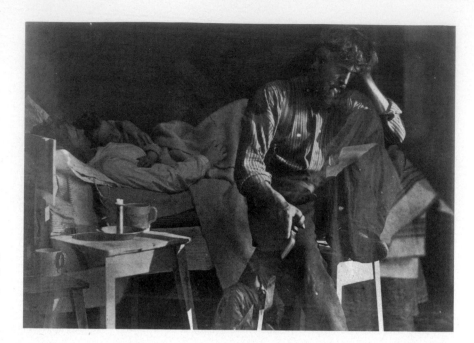

In 1860 Rejlander created the "spiritistical photo" *Hard Times* by deliberately double exposing photos. *George Eastman House.*

In 1860, Rejlander produced what is probably the first deliberately double-exposed photo in *Hard Times*, depicting a father's concern for the welfare of his family. This technique would later be used to show greater emotion than can be shown in a single print. (For more on double exposures, see chapter 6.)

Noted photographers such as Julia Margaret Cameron played on the sentimentality of the Victorian era. Photos such as *Pray God, Bring Father Safely Home, Seventy Years Ago, My Darling, Seventy Years Ago,* and her many religious and allegorical compositions won much favor with the British.

Photo fakery was also employed to portray news events that were impossible to photograph. On September 5, 1862, British balloonists James Glaisher and Henry T. Coxwell ascended in a hot air balloon to a height of 37,000 feet. The record-breaking ascent was hailed and the two men celebrated as heroes. Enterprising photographers Henry Negretti and Joseph Warren Zambra, using an aerial backdrop, superimposed the images of the balloonists in their basket and painted in the superstructure of the balloon.[5]

Queen Victoria and Prince Albert became avid photographic collectors and did much to encourage the spectacular rise of photography in Britain. They also used photography to commemorate major events in their lives and the gatherings of their large family. Their collection was wide-ranging and included a number of montages. Prince Albert became so fascinated with photography he had a darkroom built in Windsor Castle.

As photography progressed, combination printing involving "dodge, trick, and conjuration" became accepted as part of a photographer's art. Attempts to illustrate allegories, children's tales, poetry, and books accelerated. A first major effort, in 1861, was to illustrate Tennyson's romantic poem "The Lady of Shalott."

Defending photography as art continued. Many felt that photography was not an art and should not be exhibited in art museums. Others believed that any picture was the work of human ingenuity and that what artists and illustrators did was entirely creative. Artists began posing their subjects and photographing them to use the photos as a basis for their paintings. Photography also became a new tool for etchers and printmakers. Prepared glass negatives were used to make prints on photographic paper. The technology known as *cliché verre*, in which artists drew with a stylus upon a coated glass plate, scratching through the emulsion, was popular during this period.

The growing interplay between photography and art continued, with artists trying to determine whether photography was a threat or an ally. Artists were divided in their opinions of this new invention. Some looked upon photography as a purely mechanical and dull means of recording uninteresting events; others had strong feelings that photography could rival the combination of creativity and handiwork found in paintings.

It was not until the American Civil War that photos would bring home the full horrors of war. Mathew Brady's adventurous photographers, in special wagons fitted out for photographic purposes, accompanied units of the Army of the Potomac. They would chronicle not only the horrors and carnage of the battlefields but also the massive destruction left by the advancing and retreating armies. The photographers were not largely unrestricted and produced many close-up views of dead faces and bloated bodies on the field of battle.

Detailed examination of photos by Timothy H. O'Sullivan and Alexander Gardner, who worked for Brady, showed that corpses were sometimes rearranged for a more dramatic effect. Weapons were also moved to gain more special effects. Photo historian William Frassanito, after examining hundreds of photos of Gettysburg, in a comprehensive analysis brought several manipulated photos to light.[6]

An evocative photo of the Civil War taken by Alexander Gardner is of a dead Confederate soldier at Gettysburg. Some of Gardner's men saw the portion of the battlefield known as the Devil's Den after the battle and were struck by the photographic potential of the scene. Several photos were taken of a dead youth found lying beside a large boulder about forty yards from the Devil's Den. Seeing the potential of a photo of a dead sharpshooter in Devil's Den, the men put the body on a blanket and

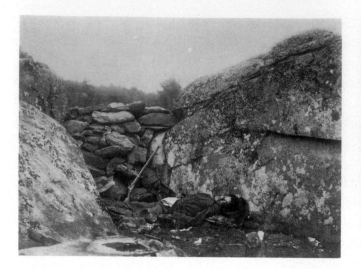 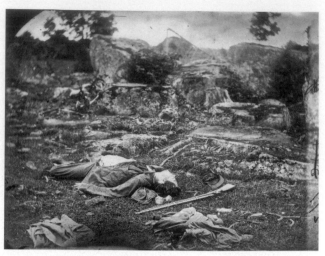

removed it to Devil's Den and rearranged it for dramatic effect. Two photos were taken and titled *A Sharpshooter's Last Sleep*. Gardner would write this caption: "Some mother may yet be patiently waiting for the return of her boy, whose bones lie bleaching, unrecognized and alone, between the rocks at Gettysburg."[7] Judging from the body's original placement, it is strongly felt that the soldier was not a sharpshooter but rather an ordinary infantryman. The rifle was not the type used by a sharpshooter. Also, a sharpshooter killed outright would be unlikely to have a knapsack propped under his head. Detailed research on the battle has revealed that there had been no sharpshooters in that particular area.

As it was not yet technically possible to print photos at the time, *Harper's Weekly* hired engravers to copy them. The engravers had artistic license to enhance photos, and often added additional bodies and debris in battle scenes.

After viewing photos of the battle of Antietam, Oliver Wendell Holmes, seeking knowledge of his son after the battle, wrote about the battlefield photos: "It was so nearly like visiting the battlefield to look over these views, that all of the emotions excited by the actual sight of the stained and sordid scene, strewed with rags and wrecks, came back to us, and we buried them in the recesses of our cabinet as we would have buried the mutilated remains of the dead they too vividly represented."[8]

Army generals and their staffs were often photographed during and after the war. A number of these photos were faked. Mathew Brady engaged in a bit of photo fakery in the photo *Sherman and His Generals, 1865*. General Frank P. Blair is not present in one photo, although his name is printed on the mounting. A separate image of Blair was pasted in later to complete the group.[9]

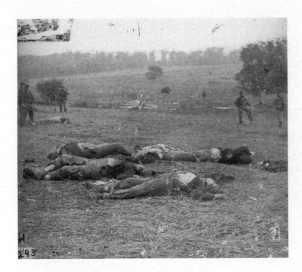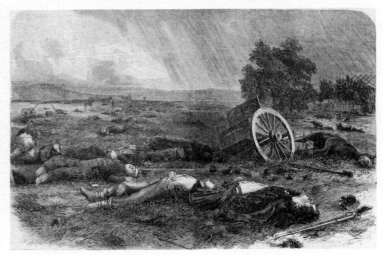

Careful examination of several Brady photos reveals retouching. For example, there are differences between the famous photograph of Lincoln and McClellan on the battlefield of Antietam and an enlargement of the same scene. Heavy smoke can be seen coming from a chimney in one photo and not in the other. In the enlargement, additional branches and leaves have been added to a tree.[10]

One of the most famous military photomontages was that of General Sheridan and his staff made by Gentile Studios of Chicago in 1877, well after the fighting had ended and far from the battlefield.[11] Individual photos of the general and his staff of sixteen were composed on a background containing a number of officers and field equipment in a military encampment. A cannon is also pictured blazing away.

When Abraham Lincoln was assassinated, Washington was awash with an aura of martyrdom and divinity. His death inspired an enormous literary outpouring and caused an immediate demand for photos of the slain president. In the files of the Prints and Photographs Division of the Library of Congress, there are a number of photos of Lincoln that are highly suspect. One eager entrepreneur combined Southern statesman John Calhoun's body with Mathew Brady's portrait of Lincoln to form a new standing portrait of Lincoln. On the papers on the table beneath Calhoun's hand, the words "strict constitution" were changed to read "constitution" beneath Lincoln's hand in the copy portrait. "Free trade" became "union" and "the sovereignty of the states" became "proclamation of freedom." Lincoln's head was also substituted on bodies belonging to Alexander Hamilton and Martin Van Buren. In Henry S. Sadd's engraving *Union*, the original version was published in 1852 with Calhoun, pen in one hand, with his hand on the Constitution. In a later version Lincoln's head has replaced that of Calhoun, and a number of heads

Above left: The dead at Gettysburg were photographed by Gardner to show the carnage on the battlefield. *Library of Congress.*

Above right: Artists from *Harper's Weekly* used the same photo and added more gruesome details in this engraving, entitled *The Harvest of Death*. More bodies were added along with dead horses and a damaged caisson. *University of Rochester Library.*

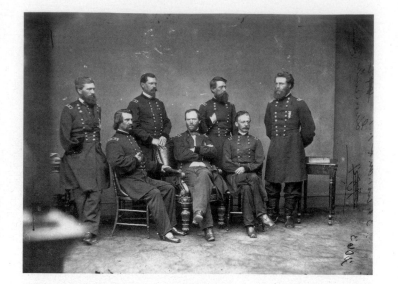

Mathew Brady took this photo
of Sherman and his generals. Although
General Francis P. Blair is listed on the
mount, he does not appear in the photo.
Library of Congress.

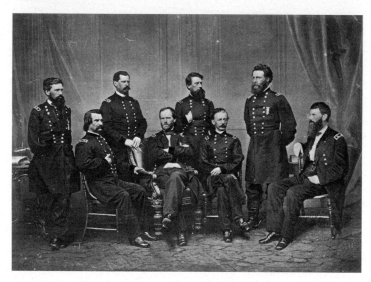

An image of General Blair
was later added to the photo.
Library of Congress.

of pro-Union politicians were inserted to replace those of 1852 politicians. There were even engravings of Washington embracing Lincoln.

As the Lincoln funeral train made its way from Washington, D.C., to Springfield, Illinois, Secretary of War Edwin M. Stanton gave special orders to Brigadier General E. D. Townsend, in charge of the funeral train, that no photographs were to be taken of Lincoln in his casket at various stops along the route. In New York a photographer managed to take photos of the dead Lincoln, although from some distance. An outraged Stanton ordered the glass plates broken and the prints destroyed. One print was sent to Stanton, who kept it among his papers. His son, Lewis, found the print twenty-two years later and offered it to John Nicolay, thinking he might use it in his ten-volume life of Lincoln. It was not used and remained among the Nicolay papers until it was found in 1953

at the Illinois State Historical Library. A number of photos have appeared of bearded men in caskets that were purported to be the dead president. Most can now be quickly dismissed because of the availability of the Stanton photo for quick comparison.

New vistas continued to open as artists began to use photography as a medium, and as a time and labor-saving device. In 1843 the Free Church of Scotland was formed, and the artist David Octavius Hill was commissioned to paint a gathering of its 457 founding members to commemorate this historic event. Sir David Brewster photographed the 457 members individually and arranged them into a photomontage. Using the montage, Hill painted *The Signing of the Deed of Demission*. Brewster's montage was one of the largest constructed up to that time.

The desire to portray in a photo that which could not be attained in a natural setting still persisted. The frontispiece of Walt Whitman's *Leaves of Grass* shows a butterfly perched on Whitman's index finger. It can easily be mistaken for a living creature. Some believed that Whitman had a unique magnetism for attracting small creatures, and he fostered this belief. An obvious question in examining this photo is how a butterfly would be available in a studio, and could be trained to sit on his finger. Close examination of the photo shows a wire from the butterfly wound about Whitman's finger. Among Whitman's personal papers and other effects, which were stolen from the Library of Congress and not recovered until fifty years later in 1995, was the paper butterfly. Justin Kaplin would remark: "The discovery of the paper butterfly was a slight deflation of the Whitman myth. This man was a great manipulator of what we now call image. He knew how to stimulate disputes, how to plant information, and he knew the value of photography before basically anyone else did. So the butterfly is really a symbol of image management."[12]

John L. Gibson of Philadelphia combined a series of photos in 1867 for an "action" shot of a racehorse named Dexter. Gibson took photos of Dexter "in motion," along with bystanding individuals, and pasted them on a prepared painting showing a race track, a hotel, and a building, in an attempt to portray the swiftness of Dexter.

A Philadelphia firm, the Bendan Brothers, produced and sold various background scenes on negatives that left the central part of the negative blank. Photographers could buy these background scenes, take portrait negatives on a plain background, and combine the two negatives to produce a new photo that would show an individual posed in a background he never visited.

It was a golden age of portraits. In each major city there was a well-known photographic studio that catered to notables and people in the public eye. Mathew Brady, for example, had studios in Washington,

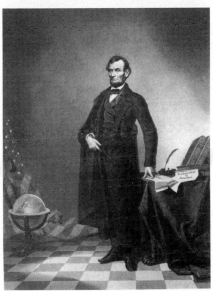

After Lincoln's death, the head from a portrait of Lincoln by Mathew Brady was reversed and placed on the body of John C. Calhoun to create a new engraving. *Library of Congress.*

D.C., and in New York. Photographic print stores sold portraits of such personalities as Abraham Lincoln, Queen Victoria, and Sarah Bernhardt. Around the turn of the century, the British developed an art form in which props played an important role in portrait photography. Portraits were increasingly theatrical and often gave hints as to how public personages used photography as a means of expressing themselves artistically. For example, William Lake, an artist, was shown with palette and paints working at an easel on one of his better-known paintings; Michael Faraday is seen holding a magnet; David Livingstone is shown holding a rhinoceros horn; and Henry Morton Stanley, in tropical clothes with pith helmet, has a gun at the ready. James Dewar is in his laboratory; Isambard Kingdom Brunel, a shipbuilder, was photographed before a background of massive breaking drum chains, which were used to let a ship down the slip when it was launched. Dickens is portrayed with book in one hand and baton in the other, giving a lecture; the soprano Adelina Patti is in the costumes of her various roles. Many portraits taken during this period were tinted, heavily retouched, or hand colored. Sir John Fowler, a railroad and railroad bridge builder, is portrayed on the parapet of a railroad bridge with a section of railway track at his feet; the studio background is of a village scene. A number of still-life objects were often displayed in a scene to give added details. Even though photographic portraiture had advanced, many clients were not pleased with

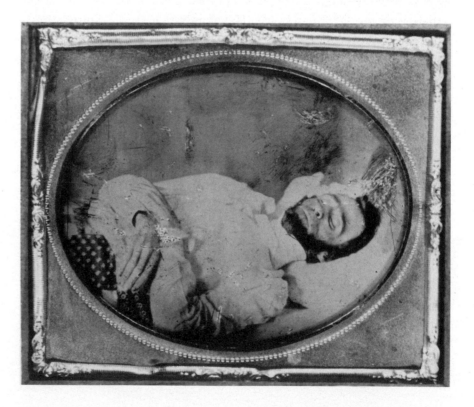

There are fraudulent photos or engravings of Lincoln. Among them is this photo of "The Martyr Lincoln," supposedly taken of Lincoln in his casket. *Library of Congress.*

the results. Thomas Carlyle, on receiving his portrait, wrote to noted photographer Julia Margaret Cameron: "It is as if it suddenly began to speak, terrifically ugly and woe-begone."[13]

The demand grew for portraits of families, wedding parties, children's graduations, and religious events. The task of the portrait photographer was, of course, to show each subject in the strongest and most flattering manner. Framed portraits became a popular Christmas gift. The demand for portraits became so great that almost every small town had a portrait studio. A softer light was being employed in portraits. Without artificial light many of the photos would not be possible; portrait photographers began to employ studios specifically designed for portraiture. In some cities, whole streets were devoted to portrait studios. Photographers often advertised that their photographs possessed "fidelity" and were "untouched." Each prominent studio also had a variety of portraiture backgrounds that could be used in photographs.

When landscape photographers first attempted to emulate oil or watercolor artists, they faced technological drawbacks caused by extremely slow film speeds. The collodion emulsion was overly sensitive to blue light, and, given the proper exposure to record a landscape scene, the blue sky was recorded on the negative as a solid tone—in other words, a white cloudless sky. The photographers desired to depict the beautiful skies seen in paintings, and more often than not they would brush in a cloud-filled sky. In order to get the proper cloud formations a photographer sometimes had to wait for extended periods. To remedy this shortcoming, a photographer would take a short exposure to record a sky scene, then take a longer exposure to record the landscape. The two negatives were then montaged.

Photography was still practiced almost exclusively by the wealthy professional photographers or scientists who could afford expensive cameras and contend with the complicated, laborious, and messy laboratory processes. Cameras were evolving from huge, cumbersome, manually operated machines into those that could be hand-carried. Photographers were recording momentous events in history, and large corporations hired photographers to record the construction of huge industrial developments. The Union Pacific Railroad, for example, hired several Civil War photographers to record both the construction and the famous linking of the transcontinental railway in Utah.

The period after the Civil War was an age of innovation in both the photographic and the printing industries. The presentation of news with sketches and etchings remained both slow and cumbersome. Cameras could be carried and taken to areas where newsworthy events were occurring. The problem of combining photography and printing would not be solved till the turn of the century.

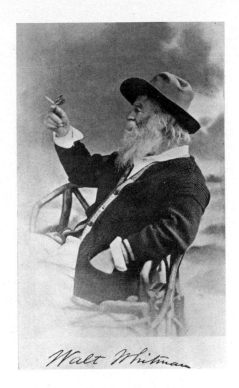

A studio portrait of Walt Whitman for the frontispiece to *Leaves of Grass*. Careful examination of the photo shows the "butterfly" is wired to his finger. *Library of Congress.*

4

The Media Years

The invention of the Eastman portable camera in 1888, followed by the box camera, opened photography to people in all walks of life. The first nearly automatic camera allowed the casual photographer to send exposed film back to the manufacturer for development and reloading. Eastman's slogan "You press the button, we do the rest" resulted not only in the mass marketing of cameras and film but also in mass production of photo printing. At the turn of the century, the Brownie camera, costing one dollar, revolutionized photography. It was something so simple the manufacturer promised that anyone who "could wind a watch" could master it. Now that photography was no longer a profession practiced only in studios, legions of camera enthusiasts began to record personal scenes, including photos of friends and families. Families separated by distance exchanged photos for nostalgia and to show longing. Photography also opened a means of self-expression and experimentation.

Although stereoscopic cameras were exhibited as early as 1841, they remained largely an oddity until Queen Victoria found the stereoscope a source of amusement. The stereoscopic camera employed two lenses, which were placed about two and a half inches apart. This distance is

the average space between the human eyes, from center to center. The camera created two images that were printed on one photo. An optical instrument called a stereoscope, with two prismatic eye glasses, was used to view the two images, which "fused" with one another to form a single three-dimensional image.

Oliver Wendell Holmes, the noted physician-author and an amateur photographer, invented the Holmes stereoscope, which was designed to hold two photos mounted side by side on a wooden shaft with a hood holding two lenses mounted at the other end of the shaft, allowing three-dimensional viewing.

Although stereoscopic prints were used during the Civil War, it was much later that they became a rage, and nearly every parlor had a stereoscope and an accompanying box or basket of prints. The stereoscope became the poor man's picture gallery. Photographers reacted quickly to the booming market for stereo pictures by scurrying to the ends of the earth lugging their double-lensed cameras to acquire photos. No human event was too monumental—or too insignificant—and no natural wonder was too inaccessible for the stereoscopic photographers. They made stately portraits of oceangoing yachts under sail, captured the frustrations of New York City's horse-and-buggy traffic jams, recorded scenes of domesticity, and even injected drama into scenic attractions by taking stereo pictures of a performer walking a tightrope over Niagara Falls.[1] Examination of many of these photos reveals heavy retouching, tinting, or hand coloring.

The pictures became much more intimate. Gazing into a stereoscope became a parlor rage, and also a form of voyeurism as stereoscopic nudes were introduced. Painted backgrounds illustrated love scenes with such titles as "Married Life and Its Pleasures," and "High Life and Low Life and were sometimes pornographic" Nudes were shown in exotic settings such as Turkish harems. Their eyes would be cast down or give a come-hither gaze. The stereoscope became the precursor of the motion pictures.

At the turn of the century, the invention of the half-tone photo reproduction method made possible the printing of photos in newspapers and magazines. A strong belief still existed that the camera never lied or distorted reality; photography was equated with the truth. Emile Zola expressed his feelings in 1900: "You cannot say you have thoroughly seen anything until you have got a photograph of it, revealing a lot of points which otherwise would be unnoticed, and which in most cases could not be distinguished."[2] Newspapers and magazines still had a tendency to sensationalize news and manipulate audiences in order to sell. The same tendency ushered in a number of photo fakes. Numerous composite portraits appeared and became a form of popular amuse-

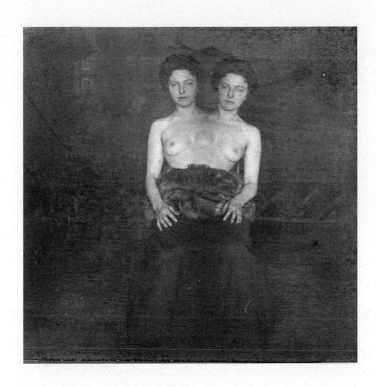

Stereo photos became a form of pornography. "Trick" photos of nudes were created for entertainment. *Library of Congress.*

ment. "The term 'composite photograph' came to be any study that emphasized typical attributes at the expense of individuality."[3]

The selection of emotion-provoking photos and stirring words became an effective manner of presenting social and economic conditions. Photos showed the horrors of slums, poverty, child labor, and the generally poor living conditions in large cities. Many of these proved to be montages. An adversarial, confrontational relationship developed between photographers and the upper class.

The term photojournalism was coined in 1924 by Frank Luther Mott, who was later dean of the University of Missouri School of Journalism. But photojournalism was really born around the turn of the century with the integration of words and pictures depicting world events and personalities in publications. There was heavy competition among the leading newspapers for readership, and most of them published illustrated Sunday editions. While photojournalism should have reflected reality without distortion, these newspapers competed for the purchase of still photos. When no photos were available on world events, they were often created in studios.

Exclusive photo and camera clubs, in the United States and abroad, became the most effective exponents for this type of photographic display. In 1896, a book on how to create montages, *Photographic Amusements*, was published, giving added impetus to photographic experimenting. Photographs exhibited as works of art raised the ire of leading

art critics. In 1888, P. H. Emerson published the book *Naturalistic Photography,* which dealt scathingly with the practices some of the pictorialists were guilty of. The British poet William Wordsworth, upset with this new form of journalism, penned a sonnet as an indictment of the pictorial press, which read in part:

> Now prose and verse sunk into disrepute
> Must lacquey a dumb Art that best can suit
> The taste of this once-intellectual Land.
> A backward movement surely have we here
> From manhood,—back to childhood; for the age—
> Back towards caverned life's first rude career.
> Avaunt this vile abuse of pictured page!
> Must eyes be all in all, the tongue and ear
> Nothing? Heaven keep us from a lower stage.[4]

In July 1898, the photographer Fred Holland Day, a leading representative of the New School of American Photography, created a sensation with a series of evocative photos that has since been called "the Crucifixion Series." Casting himself as Christ, Day starved himself to appear as Christ on the cross and also posed for the series "The Seven Last Words" of Christ. Many felt Day had stepped beyond acceptable boundaries to approach the sacrilegious. Janet Malcolm, noted critic and journalist, called the "Seven Last Words" of Christ "atrocious instances of posed photography." The critic Charles Caffin found "such a divagation from good taste intolerably silly." In another review Caffin added: "Surely claptrap and misapprehension of the province and mission of art can go no further." As late as 1981, writer Estelle Jussim claimed that Day's "sacred subjects turned out to be exceedingly bad art and worse photography."[5]

With the advent of impressionistic paintings, there was a desire to use the camera and printing techniques in the same manner. The impressionistic photo as a means of expression, however, reached the grotesque, abnormal, and even pornographic. It raised the ire of many leading critics who thought it should be condemned.

Photography had evolved in an inchoate, diffused, and unthinking manner. There were those who felt that photography, especially of nudes, had gone from an art form to erotica. Journalists, artists, and photographers were troubled by this new trend. Lady Elizabeth Eastlake felt that photography's legitimate business was "to give evidence of facts as minutely and as impartially as, to our shame, only an unreasoning machine can give."[6]

George Bernard Shaw in 1902 wrote: "When a photographer takes to forgery, the press encourages him. The critics, being professional con-

noisseurs of the shiftiest of the old makeshifts, come to the galleries where the forgeries are exhibited. They find to their relief that here, instead of a new business for them to learn, a row of monochromes are shown which their old jargon fits like a glove. Forthwith they proclaim that photography has become an art."[7]

After the turn of the century, Alfred Stieglitz, photographer, collector, gallery owner, and publisher of the influential magazine *Camera Work*, brought a new impetus to pictorialism and the art scene. In his magazine, published from 1903 to 1917, he was a tireless campaigner for the acceptance of the medium of photography as a fine art. He allowed many new, varied, and artistic methods of photographic expression. The debate centered about photographic honesty versus manipulation. His work and that of his students was displayed abroad and had a stimulating technical as well as artistic impact. Stieglitz commented: "It is justifiable to use any means upon a negative or paper to attain the desired end."[8] Stieglitz wrote of Paul Strand's photos: "The work is brutally direct. Devoid of all flim flam; devoid of trickery and of any ism; devoid of any attempt to mystify an ignorant public, including the photographers themselves."[9]

Sprays, air brushes, and other processes were used for enhancing the tonal delicacy of photographs. This was a time-consuming process taking days, even weeks. A transparency or print would then be rephotographed. Experiments in paper and processing techniques abounded. Most large city newspapers had a separate weekly pictorial section. Hardly a theme had not been tried with the camera. Each major newspaper had a battery of retouchers who highlighted details of less-than-perfect photos.[10] Sandra Weiner, the widow of a photographer, stated, "In that day and age, they would manipulate pictures in all magazines."[11] Edward Steichen, another famed photographer of the period, was also in favor of manipulation, maintaining that all photography was manipulated to a certain degree in the developing and printing of a photograph.

The long-held prejudice of the art world against photography subsided, and photographs were now displayed in museums alongside drawings, paintings, sculpture, and engravings. Artists were commonly painting from photographs of models. Frederic Remington often painted western scenes from photographs.[12]

Probably nobody recognized the value of the photograph more than William Randolph Hearst. The nation was heavily populated with immigrants who had problems with the printed word and little time to read. A photo could tell in moments a scenario that might require much more reading time to understand. Many of the extremely complex problems throughout the world could be portrayed simply with photos. Photogra-

GLOIRE AU ROI SOLDAT

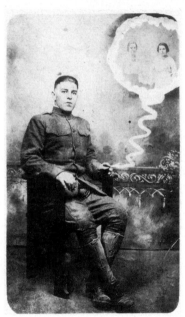

Top: Photography was often combined with artistic works to produce a more dramatic effect. During World War I, King Albert of Belgium was idolized as a soldier king. *Author's collection.*

Bottom: World War I photographers produced a variety of montages for servicemen who tried to express their loneliness and love for people back home. In this picture of a maternal cousin, the lady in the right of the smoke ring is the author's mother, the other his aunt. *Author's collection.*

phy heightened awareness, proved what had happened, and gave readers a feeling they had been there. An old journalism maxim states that the abnormal makes news. Hearst recognized that war, crime, murder, and other morbid and gruesome events, when shown by pictures, dramatically increased circulation. Photography created an impact where words often failed.

Large newspapers competed with one another for eye-grabbing sensational photos. The Hearst newspapers were especially guilty of violating ethical standards in promoting their newspapers. Cropping, dodging, lightening, burning in, and darkening portions of the prints were accepted practices. Objects were removed, cloned, deleted, or combined with other objects to achieve sensational photos. Harry Coleman, a veteran news photographer for the Hearst's *New York Journal,* chronicled the many methods he employed to please Hearst. Coleman admits that he and his fellow photographers violated every ethical and moral standard of their profession. He stated, "Original photos were painted over and adjusted to fit the general description of the subject. That was the incubation of picture faking."[13] He stated that on a homicide location, after carefully observing the victim, he would phone in a description of the deceased, stating a famous person he resembled to another photographer. A lab technician "would dig up a real photo of, say, John L. Sullivan, remove the ferocious mustache, paint a General Grant beard across his massive chin, and send it to the engravers as a legitimate picture of an unidentified body in a foul murder."[14] Photographers of this period also admitted to carrying a large rag doll or mannequin to throw into an accident or murder scene.

Spectacles, stunts, and events were covered, and if a photo couldn't be taken of an event, it was created. For example, a high point in aviation occurred when Lincoln Beachey became the first man to fly an airplane indoors, flying out of Machinery Hall at the San Francisco Exposition in 1914. Getting a photo of an aircraft in flight was extremely difficult. Yet a picture of that flight appeared in Hearst newspapers and caused an immediate sensation. Coleman would later write: "No one could figure how the remarkable action photo was made until we explained that it was really a time exposure and we had hung Beachey and his plane on a rope which was painted out on the photographic print."[15] The publishing of such photos and the public's reaction made newspaper publishers realize that such photos could be used to control public opinion.

As the market price of cameras and film dropped, the camera became an experimental and recreational tool for the general public. A number of books on "photographic amusement" and "amusing parlor tricks" appeared. A preoccupation with and refinement of photo fakery developed. It became known as "trick" photography, employing primar-

ily montages, and became a popular diversion. An infinite variety of montages was created for comic purposes, military mementos, Christmas cards, sentimental photos, and advertising photos.

The vast immigration to the United States during this period separated many families. To assure their relatives back in the old country of their well being, millions of people had portraits created. Montages were used to convey a deeper message than could be conveyed in a single photo.

World War I inspired montages of world leaders, which combined photography with artistic works to give a more dramatic effect. Honor, glory, and inner feelings could not be found in a single photo, but could be found in a combination of photography and art. King Albert of Belgium was portrayed as a soldier king whose heroic leadership inspired his men in the Battle of Flanders. During World War I a variety of montages were produced by photographers near military bases. Servicemen tried to express in photographs their melancholy, loneliness, and their longing for loved ones back home. This was often done by creating a photograph in which smoke from a cigarette contained an apparition of the soldier's loved ones.

Heavy meddling with photography in wartime again occurred during World War I. Photographs of "German atrocities" were found to have been heavily retouched. Photos of battle scenes were frequently inconsistent with battlefield history.

The Cottingley fairy photo also appeared during this period and cre-

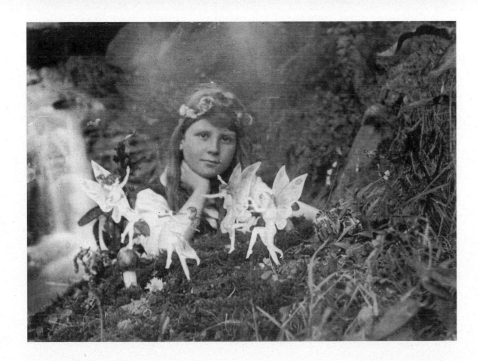

The famous Cottingley fairy photo fooled not only the British public but also the noted author Sir Arthur Conan Doyle. The fairies were cutouts from a children's book that were held up by hatpins. *Brotherton Collection, Leeds University Library.*

ated excitement in the British press. In 1917, two girls, Elsie Wright and Frances Griffith, had taken a photo supposedly showing a number of little fairies dancing in front of one of the girls. Not only large numbers of the British public believed the fairies were real but also Sir Arthur Conan Doyle, the creator of Sherlock Holmes. Doyle, an ardent spiritualist, enthusiastically endorsed the photo as genuine, although he knew the father of one of the girls was a photographer and had his own darkroom. It was later determined that the fairies were cutout figures from a children's book held up by hatpins.

Although the technique had long been used, the term "photomontage" was invented by the Berlin Dada group. Dada or Dadaism was an international literary and artistic movement begun in Zurich in 1916. It flourished during and after World War I in Paris, Berlin, and New York. Originally an antirationalist protest against established forms, it expanded as an instrument of ridicule of all human culture, the establishment, and the mass destruction resulting from the war and the disillusionment that followed. In developing new art forms to express negative and anarchic convictions, photographs and newspaper headlines were frequently used in collages and montages.

In Berlin, after the war, the Dada movement took on a political orientation, and John Heartfield, an artist and founder of the German Communist Party, pioneered the photomontage as a caricature of the political and social system. As the political and economic situation in the Weimar Republic grew more unstable, he used the photomontage for political propaganda to criticize living conditions, economic problems, and the threat of fascism. Others during this period who experimented with the photomontage as an art form were George Grosz, Raoul Hausmann, Johannes Baader, Hannah Hoch, Rickard Huelsenbeck, Franz Jung, Wieland Herzfelde, Herbert Bayer, Laszlo Moholy-Nagy, Eliezer Lissitzky, Karl Vanek, and Alexander Rodchenko. But it was Heartfield who developed it into a major art form that became aggressively political and used as a means of bitter social protest and political propaganda. Montages were constructed that juxtaposed and intermingled cutouts of political and familiar figures and news headlines. Heartfield's montages were carefully constructed, realistic mosaics with all irrelevant detail discreetly brushed out; they evoked a pointed thematic association with the specific view being espoused. The montage was carefully positioned with a sublimated or muted background with complementary tonal qualities. The montages were stark, bleak, and very lifelike. Most important in all of Heartfield's works, the montage kept a familiar photographic appearance and the lettering varied with the theme. There was always a carefully constructed caption, which created a powerful fusion of the montage and made the message immediately clear and direct.[16]

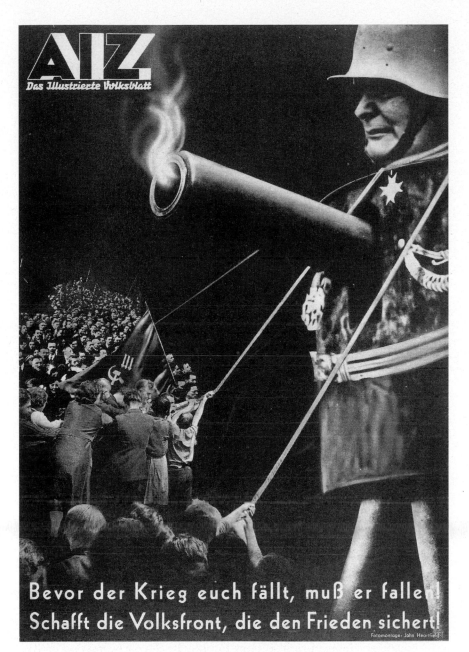

AIZ
Das Illustrierte Volksblatt

Bevor der Krieg euch fällt, muß er fallen!
Schafft die Volksfront, die den Frieden sichert!

Fotomontage: John Heartfield

John Heartfield pioneered the photomontage used to caricature a political and social system. An ardent anti-Nazi, he created numerous montages against the Nazi system. This caption reads: "Before the war brings us down, he must fall! Support the people's front in order to secure peace!"
George Eastman House.

In 1928, Heartfield created "A Face of Fascism," a skull-like face of Mussolini surrounded by his wealthy and powerful supporters along with starving and dead victims. It was used as a cover for the booklet *Italy in Chains*, which was issued by the German Communist Party and was widely distributed in the West.

When Hitler came to power, Heartfield used this form to its fullest potential to criticize Hitler and the Nazi Party. In 1932, he created a montage of Hitler swallowing gold coins, which could be seen accumulating in his stomach. The caption read "Adolf, the Superman:

Swallows Gold and Spouts Junk." These and other Heartfield montages incurred Hitler's wrath. Heartfield continued undaunted and used his montages to attack Joseph Goebbels, Hermann Göring, and the whole Nazi structure. Heartfield was about to be arrested in Germany when he escaped to Prague, Czechoslovakia. There he carried on his virulent campaign against Hitler, the Nazi intervention in Spain, and the increasing indications that the Nazis were preparing for a general war. Many of these montages were widely circulated in Western Europe and the United States. In 1938, Heartfield migrated to England and throughout World War II tried his hand with both Western and Communist political and economic issues, but never achieved anything like his initial successes.

Photomontages in the 1930s were often tied to revolutionary politics regarding industrial and technical programs and were widely used in posters, books, and magazines and in exhibitions. The Soviets made wide use of photomontages to promote Lenin's highly publicized electrification schemes. In 1928, with the inauguration of the First Five Year Plan, photomontages became effective weapons in the dissemination of Soviet industrialization efforts. Visual propaganda was an effective way of informing, educating, and persuading the people.

Mussolini used photomontages to promote fascist programs in Italy. During the Spanish Civil War, both sides used montages to espouse their causes. After World War II the photomontage fell into disuse as a political art form and was turned instead into a fine art form.

There had been a split in the Dadaists in the late 1920s between those who advocated photomontage as a political art form and those who advocated it as an expression in the fine arts. The use of the montage as a simulation of, or in combination with, painting and graphic arts had become a recognized art form in the 1920s. The leading advocates of this form were Max Ernst and Willi Baumeister. Ernst experimented with both collages and photomontages, combining photographs to provide a disorienting experience. For example, in *Here Everything Is Still Floating*, a ship and a skeletal fish float in a stormy sky. The ship is a transparent beetle lying on its back.

George Grosz, who had worked closely with John Heartfield in developing the photomontage as a political art form, also used the montage as a basis for his fine arts work. In the years following World War I, Grosz, Rodchenko, and Wassily Kandinsky infused their work with doomsday prophecies, much of which employed photographs of street scenes. In *The Great City*, painted by Grosz in 1916–1917, the effect of the photomontage can be seen in the portrayal of the collapse of political and economic stability. Rodchenko created photomontages of war scenes where cities were under attack from a variety of airborne weapons systems. In

his mixed-media work *The War of the Future*, beams from zeppelins rain destruction upon skyscrapers and large naval guns are pointed menacingly. Poison gas flows downward and several people are wearing gas masks and protective clothing. Grosz and others would later become leaders of the German Expressionist movement. When the Nazis came to power, the Expressionists were stripped of their teaching posts, and their art was confiscated and destroyed. Most of the artists went into exile in Switzerland, France, England, or the United States. The challenges such artists brought to the conventions of photography resulted in complaints that their work no longer had anything in common with photography. D. H. Lawrence would write "only the ugly is aesthetic today."[17]

Family photos maintained their importance and photos were often exchanged at Christmas. When families couldn't be united, a photographer would frequently combine several photographs taken at different times and locations to form a family photo. A number of montages of royal families were released. In a more modern example, an official White House photo released during the Bush-Clinton campaign supposedly showed three generations at a Bush family gathering. Analysis reveals it was a photomontage. The light is coming from two different directions and crop lines are clearly evident where the photos were joined. The scale of the photo is also off. The president and his immediate family are pictured smaller than the others.[18]

The advent of the automobile and the increase in tourism caused

Above left: *King George V. and Queen Mary with Their Children*. Because it was difficult to get families together, montages were often employed to create a family scene. Even royal families employed this method. *Author's collection.*

Above right: An official White House photo of "Senator Prescott Bush and His Family—Three Generations" is a photomontage. The light is striking George Bush and his family from their left while it strikes the rest of his family from their right. The lawn under George Bush's family is different from the lawn under the rest of the family and appears to have been brushed in. There also appears to be some brushwork on the president's sleeves. *George Bush Presidential Library.*

The Kind We Raise in
At MARION, OHIO.

A LOAD OF POTATOES FROM MAINE

398

Communities in the United States began to use exaggerations to attract attention to their products and vacation areas. *Author's collection.*

towns and states to expound on the advantages of visiting or touring their area. Postcard montages, some employing tongue-in-cheek humor, flourished. There were fish so large they had to be carried on a trailer truck or so large they could swamp a boat. Just a few potatoes from Maine filled a wagon, or an ear of corn from Marion, Ohio, required a railway flatcar.

Romantic magazines in the twentieth century employed photos with considerable success. *True Story Magazine*, for example, employed photos and many montages to illustrate love interests in the story. Noted author Fulton Oursler said it had the largest newsstand sale of any publication.

Opponents of the manipulated photograph continued to voice their objections. Paul Anderson wrote: "Let us use our instrument for the purpose for which it was intended: let us concentrate on doing the thing we can do best, and not prostitute our medium by trying to do what we can accomplish only in a lesser degree, but what other mediums do easily and well."[19] Alfred Stieglitz, who had advocated wide-ranging experiments in photography, changed directions. He began to give more time to his own serious photography, especially at his summer home on Lake George. He wrote his friend photographer Paul Strand about his earlier years: "There was too much thought of 'art,' too little photography."[20]

In the 1930s, as nations began to rearm, they desired to show their military strengths, and photo fakery was widely practiced. The Nazis doctored many photos of their armed forces to make them appear larger and more formidable than they actually were. Italian photomontages ex-

During the rearmament period of the 1930s, the military of many countries used montages to show their supposed military might. This photo of Martin bombers over Dayton is actually a composite of four separate photos. *U.S. Air Force.*

alted their air force, armed forces, and navy. Mosaics of marching troops and tanks with war planes overhead were frequently featured. The same was true in the United States. Photos of plane formations were often copied and repeatedly pasted into the same scene.[21]

In the 1930s, there was a resurgence in the graphic arts and, in an alliance with journalism, photography produced some of the finest images of the history of the period. Photojournalism flourished in the pages of mass-circulation magazines such as *Life*, *Look*, *Colliers*, and *The Saturday Evening Post*. The pages of these magazines were characterized by clear, crisp prints with good detail. A return to realism brought faultlessly detailed likenesses of the world's great men and women. The idea was to portray the intellect, power, wisdom, talent, and assertiveness of national and international leaders. Henry Luce said: "The photograph is not the newest but it is the most important instrument of journalism which has been developed since the printing press."[22] *Life*'s photographers especially covered world events and scientific advances. They also had an ability to dramatize normal life and capture the reader's attention with pictorial essays.

During World War II, montages were frequently used to advertise defense products and to rally support for the troops. After there were complaints that striking photography was not being used to promote the war effort, the U.S. Treasury Department commissioned an effort to use photos taken throughout the United States. Many were photomontages. The largest photo mosaic ever created was placed in Grand Central Station in New York City in 1941 to promote the sale of defense bonds and stamps. Seen by thousands daily, the mosaic was about 100 feet high and 118 feet wide.

In the 1950s, photo faking returned in the print media when a number of exploitation magazines, such as *Confidential*, began manufacturing faked photos, usually montages, to depict liaisons between high-profile people and to invade the darker side of society. Celebrities were displayed in unflattering poses or arm-in-arm with people they had never met.

In the 1960s, because of law suits and lagging sales, magazines began to curtail their exploitation efforts that used manufactured photography. But of course there was still an interest in unusual events. In the 1970s and 1980s, events such as UFO sightings became popular items in supermarket tabloids. As a renewed interest in the lives of the famous began, the tabloids printed articles on the lives of Hollywood and public figures. Over the years, however, the public has become immune to distortions and falsifications of photos in the tabloids designed specifically to enhance their newsstand appeal. Even the neophyte has become aware of outrageous and obviously faked photographs such as one a tab-

During World War II, photomontages were frequently created to back the war effort and to sell war bonds. The largest was created for Grand Central Station in New York. *Library of Congress.*

loid ran of an American World War II bomber on the moon. The public came to hold tabloid photos to a much lower standard of truth than those in the daily newspapers.

Yet there is a decided danger in this type of photography, as pointed out by Marvin Kalb: "More Americans get their print 'news' these days from *People* Magazine, the *National Enquirer, TV Guide,* or the *Star* tabloid than they do from *The New York Times* or *The Washington Post.*"[23] Any attempt to fake photos arouses a queasiness among those who require trust and objectivity in this medium. With the competition and rise of tabloid TV, it has also become increasingly tempting to make eye-catching images that would be totally believable. Kalb has also commented that "Americans get more 'news' or 'information' from programs

Tsunehisa Kimira, a Japanese graphic artist and designer, cuts and pastes photos to create surrealistic art that has substantial impact. In this photo, Niagara Falls was combined with the skyscrapers of New York.
Tsunehisa Kimura.

such as *Hard Copy* and the sudden eruption of talk shows than they do from the evening news on ABC, NBC or CBS."[24]

Advances in imaging technology have enabled a widespread application of digital imagery for representation of apocalyptic, nightmarish scenes of natural disasters, atomic destruction, and criminal violence, and raise the question of whether this is really photography or rather a competition to see who can create an image with the most stunning or unsettling effectiveness.

An artist who attempts to create with photography outrageous scenes of incomprehensible human and structural devastation is Tsunehisa Kimura, a Japanese graphic artist and designer hardly known outside Japan. He has created his own universe with scissors and paste, and with pictures taken from magazines worldwide. He produces his artwork by cutting up photographs into as many as forty parts, sorting them, cutting them, exchanging parts, retouching, and adding colors until his work takes on a surrealistic touch. The pictures are proportional and well composed and carry unnatural juxtapositions. For example, one of his works shows Coca-Cola bottles falling like bombs and creating destruc-

Photo fakery with a message has always played an important role in advertising. In an ad for a new laundry detergent, photographer Joe Steinmetz showed the amount of rinse water saved each month was equivalent to the weight of an elephant. *Courtesy of Lois Duncan.*

tion in a city below. Another shows a combination of Niagara Falls and lower Manhattan with a deluge of water falling from the tallest buildings. Still others show Noah's Ark under attack from fighter aircraft, or "Easy Riders" along a highway passing a couple engaged in the evening angelus.[25]

Another such composition by a French photographer shows Sacre Coeur Cathedral sinking into the sea.[26]

Advances in both laboratory techniques and cameras have allowed photo fakery with a message to play a prominent role in advertising. The emphasis is on clarity and simplicity, achieved by the skillful use of montages. When advertising agencies of repute required a photographer to illustrate their products with a picture standing out from the trite and commonplace, a leader in the field frequently called on was Joe Steinmetz. He was a stickler for careful conception and precise preparation. He also tried to show something statistical in his photos. One of his most famous photos for a laundry detergent had a housewife carrying an elephant in a laundry basket. The message was that there was no need to rinse clothes many times when this particular detergent was used. The

weight of the elephant symbolized how much water would be saved in a month by using the detergent.[27]

As previously discussed, if an art director is not satisfied with a photo and has neither the time nor the funds to send a photographer out for a second time, a retoucher is frequently called in to create the desired effect more precisely, more economically, and eventually, more satisfactorily. Often, there is a reverse process in the creation of a manipulated photo. For example, "Project Hunger" solicited the talents of Emilio Paccione for a television ad to show how a skeletal child gradually progresses to smiling, bright-eyed healthfulness. Paccione, regarded as a top retoucher, worked in reverse. He was given a photo of a healthy young boy and, by carefully bleaching and shading each print, he created a remarkable series of photos showing the progressive stages of starvation. These photos were used in ads aiming to promote the elimination of hunger in the world by the year 2000.[28] For *Esquire* Magazine, Paccione transformed an older gentleman into a remarkable likeness of George Washington.

Although the 1980s saw the advent of the personal computer and the rapid advances of the digitization of imagery, it has been called the age of parody.[29] Instead of exploring new avenues, images often embodied a fond look back at the past.

In Britain, footage of Gary Cooper in *High Noon* was combined with Griff Rhys Jones in a Holstein lager TV commercial. In the United States, footage from the John Wayne movie *Cast a Giant Shadow* was manipulated and used in a Coors beer commercial. In original film footage, Fred Astaire dances with a coat rack; the film has been altered so that he dances with a Dirt Devil vacuum cleaner. In one *Honeymooners* episode, Jackie Gleason is holding a kitchen tool; the tool has been digitally removed and replaced with a Braun blender. A segment in a *Drag Net* TV show has been used so that Jack Webb appears as a Lotus software promoter. Clips from the *Ed Sullivan Show* have been used to sell Mercedes Benz cars. In some cases, these parodies are done with a derisiveness that is bothersome to the older generation. The juxtapositioning of footage from Hollywood movies of the 1940s and 1950s with current advertising is regarded by many as a privatizing of history and art and a plundering and defacing of the past. Yet some say these parodies represent a rebellion against a growing stifling of artistic expression. Others claim that these ads are understood worldwide; Coca-Cola advocates that the American culture and commercials are inseparable.

Some complain that advertising agencies are using dead celebrities whose recognition far outshines those of today's movie or media stars. A spokesman for Coca-Cola stated that the use of dead stars interrupted and grabbed people's attention, and that the celebrities also added an

unexpected flair. Diet Coke reincarnated deceased movie stars Humphrey Bogart, Louis Armstrong, and James Cagney to cavort with the living in its first television ads. Because of their eye-catching appeal, Diet Coke unveiled a series of ads during the 1992 Olympics that pulled a series of Hollywood stars from old movies and combined them with Paula Abdul singing and dancing to the Diet Coke jingle. The blend of new and archival footage allows Abdul to electronically dance with Gene Kelly, has Cary Grant pour her a coke, and finally shows Groucho Marx, who not only dances but also talks to Abdul. The commercial was appealing and was talked and written about as a Madison Avenue masterpiece.[30] Old footage is frequently mixed with newly shot film and is made to look like the well-worn newsreel film clips of the 1930s and 1940s. In a 1995 TV presentation, Kelsey Grammer stands next to and trades jokes with Jack Benny. In the original 1964 film, Connie Frances did a comedy skit with Benny. Through modern computer technology Frances was removed and replaced with Grammer.[31]

Hollywood early on saw the capabilities of the computer to generate special effects. Some of the first movies to create such illusions were science fiction spectacles, such as *Star Wars* and the *Star Trek* movies. Filmed in studios with multi-million-dollar computers and electronic equipment, they captured the fancy of moviegoers.[32]

Most of us have imagined ourselves in a heroic fantasy. In many of these, a person assumes the antithesis of celebrity. Woody Allen's 1983 film *Zelig* recounts the imaginary life of an eccentric named Leonard

In Woody Allen's 1983 film *Zelig*, Allen in the title role is shown meeting with famous personalities of the 1920s such as Presidents Herbert Hoover and Calvin Coolidge. © *1983 Orion Pictures Company. All rights reserved.*

Now that's flying first class.

"The richest coffee in the world."

Top: In this clever ad for Colombian coffee, the trademark of "Juan Valdez" can be seen among the birds.
Courtesy of the National Federation of Coffee Growers of Colombia.

Bottom: In a Hewlett-Packard ad for their HP ScanJet Scanners, the caption reads "Tiny had the hard part. Scanning it was easy."
Richard Wahlstrom Photography, Inc.

Zelig, who can transform himself into virtually anyone. Allen plays Zelig and is shown convincingly in newsreels meeting with dignitaries of the 1920s. He is shown with Presidents Herbert Hoover and Calvin Coolidge, clowning and sparring with Jack Dempsey, and talking theater with Eugene O'Neill. He is on the platform in full Nazi regalia when Hitler is rallying his supporters in Nuremberg, and also in old newsreels with Babe Ruth and Pope Pius XI. Gordon Willis, the cinematographer of the film, successfully captured the grainy effects of old newsreels. Defiance is the theme of the movie, and, in other scenes, Zelig is shown defying gravity by standing on the walls while a doctor attempts to talk to him.[33]

In the 1994 film *Forrest Gump,* Tom Hanks, as the engagingly sweet-natured simpleton Gump, unwittingly stumbles into some of the most memorable historical moments of the past thirty years.[34] Like Zelig, he shows up not only in newsreels but also TV footage as a fleet-footed football star, a Vietnam hero, and a ping-pong champ. He meets the Black Panthers and appears on the cover of *Fortune.* He is digitally inserted next to George Wallace as he refuses to accept black students at the University of Alabama. He meets with President Kennedy and shows a war wound on his rear to President Johnson. In a meeting with Nixon, the President arranges to get him a better room at the Watergate Hotel. He also guest stars alongside John Lennon on the *Dick Cavett Show.*[35] To produce these films, researchers had to pore over thousands of feet of newsreel and television film at the National Archives. Charlie Puritano, production manager at Take Aim, who supervised much of the research, stated: "It was amazing the amount of effort that the filmmakers were willing to go through to ensure accuracy for a given moment of screen time."[36]

The Gump movie has other astonishing computer-generated special effects. Gary Sinise plays an embittered lieutenant whose legs had been amputated after an action in Vietnam. Digital computer technology was used to make Sinise's legs disappear. Vast crowds at a Washington antiwar rally at the Lincoln Memorial were also created electronically. About 1,200 extras were assembled at the Reflecting Pool, photographed, and then moved to various locations around the pool and photographed again and again. The photographs were combined to give the impression of thousands of people surrounding the pool.[37] Other amazing movie feats were accomplished by the Industrial Light and Magic Company, whose state-of-the-art effects were used previously in *Star Wars, E.T., Ghost, Raiders of the Lost Ark, Backdraft,* and *Terminator 2.*

Steven Spielberg's *Jurassic Park* and *Who Framed Roger Rabbit?* combined live action with animation. The movie *The Last Starfighter* had an unprecedented twenty-five minutes of computer-generated

rocket ships battling in outer space. The 1996 summer season featured *Twister, Eraser, Mission Impossible,* and *Independence Day.* Some have complained that stars, plot, and characters in some films are dwarfed by special effects. Hollywood is aware of the power of special effects and that technical razzle-dazzle will draw people to movies even if they are poorly made or poorly scripted.[38]

The digital revolution is seen almost daily in television commercials. The Merrill Lynch bull that walks along skyscraper girders and the DHL vans flying through the skies are among them.

The digital revolution has had a remarkable effect in advertising with a direct or hidden message. Benson & Hedges cigarettes began taking out ads making light of government smoking restrictions. Airline passengers are shown smoking on the wings of a jet in flight—"Have you noticed all your smoking flights have been canceled? Just wing it." People are shown at desks attached to the windows of their offices—"The length you go for pleasure."[39] In an ad for Colombian coffee, "Now That's Flying First Class," the "Juan Valdez" trademark appears as a flock of birds. Similarly, in ads for Bally Shoes, footprints can be made out in supposed photos of clouds and islands. In an ad entitled "Absolute Venice," pigeons in St. Mark's square form the outline of a bottle of Absolut vodka.

The capability of modern photographic technology is seen at its best in advertising. In a Hewlett-Packard ad for their HP ScanJet Scanners, an elephant is shown riding a bicycle. The caption reads "Tiny had the hard part. Scanning it was easy." The photo, beautifully composed and created by Rick Wahlstrom using advanced computer technology, is so realistic (down to the squashed bicycle tire) that the Hewlett-Packard Corporation received several hundred letters from irate animal lovers claiming that it was cruel to subject an elephant to such an arduous experience.

In a clever, eye-catching ad, "Colombian Coffee on Ice," Juan Valdez skates holding his donkey aloft. In another instance, ideas of bulk storage capacity (portrayed by an elephant) and speed (spots of the cheetah) were combined in an effective ad for the Maxoptic Optical drive.

The manipulation of photography through the use of computers has added new dimensions to advertising. The ads are appealing to the eye and thought-provoking. They have also made consumers more sophisticated about realizing that some of the photos can't be real.

"Colombian Coffee on ice."

The new Maxoptix 2.6GB MO drive. So big, so fast, it's a whole new animal.

Top: The capability of computer manipulation is apparent in this clever ad "Colombian Coffee on Ice." *Courtesy of the National Federation of Coffee Growers of Colombia.*

Bottom: Storage capacity (the elephant) and Speed (cheetah spots) are portrayed for the capabilities of the Maxoptix Optical Drive. *Larry Hirsch/Steve Wilson of Larry Hirsch Advertising.*

CHAPTER **5**

Spotting Fakes

Throughout history, photo experts have been forced by the forger's wiles to sift the real from the spurious. Photos have been doctored for many reasons: fraud, greed, malice, humor, profit, deception, education, and to sway public opinion, to rewrite history, to sow discontent, and to waste the time of many people. Then too, some forgers create fakes for the sheer joy of confounding experts and esteemed institutions.

Skill is necessary. Great forgers usually can execute their intentions. They must be masters of all techniques with the hope that their fakes will not be uncovered. The photo faker knows exactly what is necessary to secure acceptance: a photograph that looks remarkably true to the unsuspecting eye. Such fakes are inside the realm of possibility; questions about the authenticity of a photo are usually beyond the realm of those who are using it. Qualified professional experts will often disagree on a photo's authenticity. A variety of techniques, many computer assisted, has often made it difficult for a layperson to distinguish a true photo from those that have been doctored or faked. Unmasking a faked photo often requires opposing sets of skills. This volume is not meant as a technical tract, but rather attempts to show how forgers slip up on many of

the details that constitute a "perfect fake." Forgery detectives have many weapons and trained eyes to keep a fake from escaping detection. No matter how well-trained and experienced an expert may be, however, frequently he or she simply can't determine whether a photo is true or fake. Many a respected expert has been taken in.

The question is, what do experts look for? Suspicion can be aroused on many fronts. The most important thing is to understand the framework in which a possible deceit is being practiced. Why was a photo made, and what is most visually significant? It is quite difficult to establish criminal intent. The financial profits that can be obtained from some fakes are a powerful incentive.

The detector will be looking for false facts. The clever faker requires considerable knowledge, for many times experts from a variety of disciplines have been brought in to challenge the authenticity of a photograph. These might include photo interpreters, photogrammetrists, chemical analysts, paper analysts, subjective experts, and technologists. Each discipline has a variety of techniques of authentication.

Photo interpretation has been defined as "the art of examining photographs for the purpose of identifying objects and judging their significance."[1] The field is extensive and a number of tools can be employed.

In determining whether a photograph has been faked, the expert will look at a photo and consider the following:

1. Shape: the general configuration of an object.

2. Size: the dimensions, surface, and volume of an object.

3. Tone: the tint, shade, or hue of an object, and the relative lightness or darkness of the shades of gray in a scene.

4. Texture: the arrangement, size, and quality of the constituent parts of an object. For example, is it rough or smooth, firm or loose?

5. Pattern: the spatial arrangement of an object or objects.

6. Shadow: the condition wherein an intervening object prevents the sun's rays or indoor lighting from striking certain areas shown on the photos.

7. Site: the location of an object in relation to its environment.

8. Scale: the ratio of image size to object size.

9. Association: the interrelationship of objects observed.

The interpretation of photos involves determining how a photo was made, what lenses were used, the location of the camera in reference to the scene, and what lighting was used. The f/stop of the lens will often reveal the depth of field; the shadow cast by the sun will reveal the date

and time of day a photo was taken, and measurement of objects in a photo will reveal if it is a composite. Examination of the grain patterns in the negative will often reveal the type of film used.

It would be misleading to leave the impression that photographic expertise can solve all photo fakeries. Even among experts there can be intense debate as to whether a photo is genuine or a fake, and some photos remain unproved for long periods. In 1934, the famous photograph purporting to show the mythical Loch Ness monster was first published in a London newspaper and lay unproved until 1994.

There has been a spectacular proliferation of digital manipulations in photography. Some attempts at photo fakery are still amateurish and obvious, but the best work is subtle and sophisticated. Experts in forgery detection will subject each photo to an arduous gamut of inspection and analysis. They obtain information from faked photos when they study, interpret, or analyze the object imaged. Experts will also attempt to get as close to the original negative as possible. Specifications for the camera, focal length, film, filter, season, sun angle, scale, parallax, distortion, sharpness, tone contrast, and light and shadows will be investigated.

ONE IN A MILLION PHOTO

The "one in a million" so labeled by the intelligence community is the most difficult photo to prove false. Photos are spuriously released to cause reactions in the media or in the intelligence community. News agencies are frequently offered fabricated or staged photos and stories, often sold by foreigners or agents for funds, notoriety, or to perpetrate misinformation. Proving a photo valid or faked requires an enormous effort in research and analysis. The most sophisticated analysis often requires a variety of equipment and the searching of hundreds of files for a possible solution. One method is to compare suspect examples with prints of known veracity. Another is to consult libraries of photographic prints. It is also necessary to employ a higher level of analysis than that of the originators.

The release of any photo supposedly showing lost U.S. servicemen from the Vietnam War always stirs a wave of publicity. Dick Cheney, the former secretary of defense, once remarked: "I can think of no subject that stirs more emotion or generates more frustration and controversy than the subject of prisoners of war and missing in action, especially those lost during our operations in Southeast Asia."[2]

Nothing, in my opinion, is more cruel than to play on the emotions of families and friends of POWs and MIAs who cling to the hope that their loved ones are still alive. I served on U.S. Air Force General Eugene Tighe's Task Force Review of DIA PW/MIA Analysis in 1986.[3] It had

In July 1991 a photo of three middle-aged Caucasian men surfaced mysteriously. Relatives claimed the men were missing Vietnam War flyers Colonel John L. Robertson, Lieutenant Commander Larry Stevens, and Major Albro L. Lundy, Jr.
Department of Defense.

long been recognized that there are individuals who doctor photos and traffic in reports obtained from unnamed sources to invite publicity for their claims that American POWs are still alive in Southeast Asia. It was known that many hoaxes were being perpetrated by Southeast Asian bounty hunters seeking money from American families. To further their efforts, they claimed that their information was proof-positive of the U.S. government's ineptitude in covering up vital information relating to the POW/MIA problem.

In July 1991, a grainy photo was circulated of three middle-aged Caucasian men, smiling, appearing well-fed, grouped around a cryptic sign with the date 25 May 1990. The photo, allegedly taken in Cambodia, supposedly showed three American aviators who had been held captive for more than twenty years. The photo was first released publicly by Eugene "Red" McDaniel, a former prisoner of war and the director of the American Defense Institute. The Institute has long charged that missing American servicemen are still alive in Southeast Asia and has claimed that the U.S. government was suppressing evidence of this. McDaniel said he had received the photo by courier from an American aid worker who obtained it at a refugee camp along the Thai-Cambodian border. Two of the men in the photo were identified on an accompanying note simply as "Robertson" and "Stevenson." A Colonel John L. Robertson, USAF, had been carried by the Department of Defense as KIA/BNR (killed in action, body not recoverable) since his F-4 Phantom crashed and exploded. A Navy Lieutenant Commander Larry Stevens was listed as an MIA (missing in action) after his A-6 Intruder went down in Laos. McDaniel said that Colonel Robertson and Lieutenant Commander Stevens were being held by a Cambodian businessman, who was demanding $500 for anyone to see either of them at a Phnom Penh pharmacy. Soon after Mc-

Detailed research and analysis by Department of Defense personnel revealed the photo was a doctored reproduction of a 1923 photo of three Soviet farmers that had appeared in a 1989 issue of a Khmer-language publication. *Department of Defense.*

Daniel obtained the photo, the two servicemen were supposedly recaptured and returned to a prison camp in Vietnam.

The Pentagon had received the same photo the previous November from a naturalized American of Cambodian descent. Although skeptical about its authenticity, the Defense Department provided Colonel Robertson's daughter, Shelby Robertson Quast, the name of the man who had sent the photo to the Defense Department. Mrs. Quast met with the man, who gave her two contacts in Cambodia along with a handwritten note demanding $2 million for the release of two of the three men.

Mrs. Quast flew to Phnom Penh and met with one of the contacts, who maintained that he took the photo when he was a prison guard. At first, he said he would try to free the men, but at a second meeting stated he could not fulfill his promise.

There is an old saying, "if you want to believe, you will believe." The photo, in addition to Colonel Robertson and Lieutenant Commander Stevens, also supposedly showed Air Force Major Albro L. Lundy, Jr., according to Lundy's family. The families maintained unequivocally that the photo was authentic. They were utterly convinced that Robertson, Lundy, and Stevens were alive and in captivity somewhere in Southeast Asia. This belief prompted a yearlong odyssey by the Defense Department, using a variety of techniques and talents, to try to determine whether the photo of the three men was authentic. The Department of Defense sent a ten-member team to Thailand to discover the circumstances under which the photograph had supposedly been carried across the Thai border from Cambodia.

Interpretation and analysis of the photo showed a number of anomalies. The haircuts, round faces, and mustaches of the subjects were consistent with Russian or Eastern European appearances. The prisoners

looked unusually well nourished and showed no obvious signs of physical or psychological abuse. Their general muscle tone seemed good, and their faces appeared tanned, and they had full heads of hair. If the men were the American prisoners, they would probably have lost some hair over the years. The man on the left appeared to be holding the stocks of several rifles, but it would be doubtful that Americans held captive in Vietnam would be holding rifles.

The cryptic sign held up by the three men in the photo appeared to have been tampered with. The Department of Defense analysis revealed that the handwriting on the altered photograph and the method of alteration were similar to changes made to five other existing photos supposedly of other prisoners of war. One of the sources of a particular photograph had passed faked POW photos in the past. The originals of the five other photos had been found in Eastern bloc magazines. These photos did not show purported American prisoners of war but depicted a Soviet baker, military advisers, and workers. The clothes worn by the three so-called POWs in the photo were subjected to detailed analysis. The tunics and the buttons on the breast pockets were distinctly Russian. The high collar and the lack of epaulets were similar to a Soviet Cossack fatigue uniform adopted by the Red Army.

Further research by the Defense Department revealed that the picture was a doctored reproduction of a 1923 photo of three Soviet farmers carried in the December 1989 Khmer-language issue of a magazine called *Life in the Soviet Union*.[4] Mustaches had been added to the three men. A banner praising collective farming had been replaced in the photo by a message indicating the captivity of the three American POWs.

Although the Defense Department was satisfied with its interpretation, Mrs. Deborah Robertson Bardsley, daughter of Colonel John L. Robertson, who had visited Vietnam and Cambodia in search of further clues about her father's whereabouts, stated the Defense Department search methods and conclusions were still not acceptable.[5]

During the Cold War great emphasis was placed by U.S. intelligence agencies on strategic and tactical weapons developments. It was known that the Czech intelligence service was strongly influenced by the Soviets, and so it was not surprising that Czech photo faking capabilities and operations were second only to those of the Soviet Union. It was known by U.S. intelligence services that a number of Soviet advisers supervised the Czech intelligence service after World War II, making it a virtual replica of the Soviet service.

In the spring of 1947, the British sold twenty-nine Rolls Royce Nene and Derwent jet airplane engines to the Soviet Union. The Soviets

copied these engines and used the Nene copy in the MiG-15 and the Derwent copy in the YAK-23 fighter and in a Lavochkin experimental aircraft. Later, it became known that the Soviets had allowed the Czechs to copy these engines under license.

A photo of a purported Czech jet engine plant that appeared in a Czech publication in the early 1950s caused a stir in the Western intelligence community. The picture showed engines on assembly lines that had fourteen straight-through combustion chambers, like the Allison jet engine of the J-33 series made in the United States and unlike the Nene and Derwent engines, which had nine chambers. If the photo was true, it meant that the Czechs, and therefore the Soviets, probably had a jet engine to match the performance of the newest American jet engine.

The U.S. had not sold either the Soviets or the Czechs any such engines. The U.S. government was concerned that the Czechs or the Soviets might have stolen the plans or perhaps even an American engine.

U.S. intelligence officers, including myself, began comparing the Czech assembly-line techniques with U.S. practices, and thousands of photos of U.S. plants were reviewed. Imagine our surprise when we found a duplicate of the Czech photo. It was not, however, a plant in Czechoslovakia, but rather a production line at the Allison jet engine plant in the United States. The Czech photo faker had cleverly brushed in coveralls on one of the workers, painted a "No Smoking" sign in Czech on a pillar, and removed a tie from one of the workers. The ruse was detected only after thousands of hours of work.

• • •

A Czech publication showed photos of a supposed Czech jet engine plant (above left). Of great concern was the fact that the engine appeared to be a duplicate of the latest American engine. Research found an exact duplicate of one of the photos; it was of an Allison jet engine plant in the United States (above right). The Czechs in their photo had brushed in coveralls on one of the men and had posted a no-smoking sign in Czech on a pillar. A tie was also removed from one of the American workers. *Central Intelligence Agency.*

During the "missile gap" controversy, a Soviet photo (top) of a "large missile static test stand" turned out to be of the Rocketdyne facility at Santa Susana, California. *Department of Defense.*

The caption becomes an essential element in investigating each faked photo. Usually there are two types of captions: those that present information in a logical way (usually several sentences long), and those that allow readers to deceive themselves (usually brief). The function of the latter sort of caption is to mislead. It must convince a reader that what is depicted is undeniably true. It must match accepted convictions and conceptions, and it should encourage natural assumptions and beliefs. It can never express doubt.

The first Soviet test firing of an intercontinental ballistic missile (ICBM) occurred on August 27, 1957, and was widely publicized by the Soviets. On October 4, 1957, the Soviets launched Sputnik and reaped a whirlwind of publicity. In the United States, there were immediate charges that the U.S. was lagging behind the Soviets in missile technology, and the "missile gap" controversy developed between Republicans and Democrats. President Eisenhower asked the intelligence community to conduct an all-out effort to determine Soviet ICBM capabilities.

Naturally the Soviets were evasive, superficial, and did not publish any photos of their missiles or space boosters. A search was made of Soviet missile research and development literature. When a Soviet book on guided missiles did appear, it was regarded with great interest. One photo in the book was captioned "large missile static test stand." A careful analysis of the photo and a comparison with U.S. installations revealed it to be of the Rocketdyne test stand at Santa Susana, California. The Rocketdyne facility was designed to test large rocket engines for the U.S. Air Force and NASA space systems.

Similarly, as missile technology advanced, guidance and control of ICBMs occupied a prominent role in assessing the accuracy of the various Soviet ICBM systems. To tremendously reduce the size and weight of the electronic devices required in such systems, printed circuitry was developed by U.S. industry. Transistors, diodes, and integrated circuits were included in this new graphic technology. To produce such a complicated device required sophisticated engineering, photographic, and manufacturing processes. A key to Soviet progress in guidance and control was how proficient they were in the manufacture of printed circuits.

In a Soviet publication, there appeared in the late 1950s a picture of a young woman holding a printed circuit. This set off a detailed evaluation to see what the Soviet circuit could possibly be used for. Experts concluded it was probably for a television set. However, we knew that Soviet television sets did not employ printed circuits. We began to examine photos of American TV sets. There we found that the "Soviet" printed circuit was actually taken from an American television advertisement.

As these three examples of the "one in a million" photo show, deter-

mining whether a photo has been faked involves a lot of detailed, time-consuming work. There are also several methods that can be used to examine a photo, which are discussed below.

LIGHTS AND SHADOWS

When analyzing a photograph, nothing is as important as considering sources of light and shadows. Shadows of objects are present in most photos, and they must fall in the same direction and be consistent in relative size and shape with the object photographed. Detailed analysis of the direction of the light and the shadows being cast are key elements in the detection of a fake photo. The mere fact that shadows fall in more than one direction should make the photo immediately suspect.

When studio or indoor lighting is involved, of course, shadows might fall in more than one direction. By analyzing the highlights of illumination and shadows on such photos, it usually can be determined whether the lighting is natural or cast by a flash source.

The London *Sunday Telegraph* once created a digitized photo of Queen Elizabeth dancing with Fred Astaire.[6] Roger Tamblyn, the creator, merely removed the woman Astaire was dancing with and replaced her with an image of the Queen. I received the photograph with a challenge to see if I could find any faults with his efforts.

Detailed analysis of the photo revealed that the light sources on the Queen and Astaire are clearly from two different sources. The light source for Astaire is a soft one, probably stage lighting, and is coming from above and to the left of the photo. This can be confirmed from the light on his hair, ear, brow, nose, his extended arm, and his shoe. The light source for the Queen, on the other hand, is coming from her side and slightly to the right in the photograph. The intensity of the light, especially on her face, elbow, and gown, indicates the illumination was probably from a flash source at about her height, and at a relatively close range.

The lights and shadows on either the Queen or Astaire can be analyzed, and subsequent effects that the lights and shadows would have on each other. For Astaire, note the light on the crown of his head. The light on Astaire's brow is casting a shadow on his lips and chin. His jaw is clearly outlined and his neck is in shadow. To conform with Astaire's light source, the crown of the Queen's hair would have been highlighted, her cheek darkened rather than highlighted, and her jaw clearly outlined like Astaire's and her neck in a dark shadow like Astaire's. There would not be a shadow on the knuckle portion of her hand; it would have been highlighted.

There is a shadow on the back of Astaire's hand around the queen. Therefore, the entire length of the Queen's arm should be casting a

In the 1950s, printed circuitry was regarded as a new military breakthrough. When a photo appeared in a Soviet publication of a young woman holding a printed circuit (top), it drew the attention of the Western intelligence community. Research proved, however, that the photo came from an American television ad (bottom). *Department of Defense.*

shadow, but it does not. Astaire's shoe and leg are casting a shadow that continues under the Queen's gown. If this is true, then the Queen should be casting a shadow to the right of her gown in the photo. The Queen's gown should also be casting a shadow on the strap of her shoe. There is something fraudulent about the shadow to the left of Astaire's shoe. It is not consistent with the contour of his shoe or the shadow being cast by the tip of his shoe. The Queen's neck should not be casting a shadow on her stole, for, if the illumination is from the left and above, the top of her stole would be highlighted rather than in shadow. The folds in the Queen's gown would be showing fuller and more pronounced shadows. The shadows about the Queen's purse are neither true or consistent. The picture was obviously tampered with, probably to accommodate Astaire's hand about the Queen's waist. Looking for details, I noted with interest that the Queen's left hand is gloved while

LIGHT AND SHADOWS
Light and shadows are not consistent on Fred Astaire and Queen Elizabeth in this digitized photo created for the London *Sunday Telegraph*. The lighting on Fred Astaire is soft, probably stage lighting, and is coming from above and to the left of the photo. The light source for the Queen, probably from a flash, is coming from her side and slightly to the right of the photo. *Sunday Telegraph* (London).

the right one is not. The hands are also different in size. The pelts of the Queen's stole on her back are joined in a scallop effect; where the stole touches Astaire, the reverse occurs.

Also, if the Queen were dancing with Astaire, there would probably be a smile of pure joy on her face.

Lastly, historical photos of the Queen would show her as younger when Fred Astaire was dancing.

It is much easier to determine light and shadows in photos taken outdoors. Because the sun's rays are parallel, the shadows in photos taken in outdoor sunlight must fall in the same direction and be proportionate. In the early 1950s, there was a heightening of military tensions between Chiang Kai-shek on Taiwan and the Communist Chinese on the mainland. Of particular concern was the Communist Chinese navy, which consisted primarily of Soviet-supplied patrol boats. Concern was also expressed about former U.S. combat and support craft that the Chinese Communists had captured from the Nationalists when the mainland fell in 1947.

The photos the Chinese Communists published on their navy were carefully studied by U.S. intelligence. A photo of a former U.S. Landing Ship Tank (LST) supporting an amphibious landing was given most careful attention. It was determined that the photo was a carefully constructed montage. The Chinese forger had failed in one important detail—shadow fall. The shadow on the LST falls in one direction while the shadow on the amphibious tank falls in the other.

SCALE AND PERSPECTIVE

A legitimate photo must have proper scale and perspective. Scale involves the relative size of one known object or part of an object compared to another. Perspective is the spatial relationship of objects as they

would appear to the eye. Both are a function of camera focal length and the range of the camera to the target. In a photo, the objects nearer the camera seem larger and those farthest from the camera seem smaller, even though both may be the same size. Any kind of inconsistency suggests an insertion or deletion. Since all objects in a photo can be measured, if one subject in a photomontage appears to be too large or too small in comparison to another, the photo is probably faked. Inconsistent perspective angles should be immediately checked for scale. The proportions, relationships, direction of light, and fall of shadows should be studied in detail.

A widely distributed Soviet photo, meant to intimidate by showing Soviet missile size, was subjected to detailed analysis. In a photo of men and missiles certain assumptions had to be made. It was assumed that the men and the middle missile were approximately the same distance from the camera and of the same scale. It was known that the average height of the Russian male was 5 feet 6 inches. When this height was compared with the measurements of the missiles it was found that the missiles were 51 feet 9 inches long. The actual length of the missile shown, an SA-2, however, is 35 feet. If we were to take 51 feet as being the actual length of the missile, then the men in the photo would only be 3 feet 9 inches tall.

Another Soviet photo showed several MiG-15 fighters flying over a Skoryi destroyer. Through photogrammetric analysis, it was determined that the middle plane is positioned symmetrically over the destroyer. The wingspan of the aircraft is 37 feet 6 inches. If this same scale is applied to the destroyer, the destroyer's length would be 161 feet. The actual length of such a destroyer is known to be 420 feet. This image is clearly a montage.

DEPTH OF FIELD

If objects in the near foreground of a photo are in perfect focus and objects in the distance are also in perfect focus (or not in the same degree of focus with objects in their immediate vicinity), it's a good bet the photo has been tampered with. Depth of field "refers to the extent to which the space surrounding a subject appears to be sharply defined, both the space beyond the subject and between the subject and the camera. If foreground, middle ground, and background all seem to be in focus, the work can be said to have great depth of field. Technically, depth of field is dependent on the focal length of the camera lens, the size of the camera aperture, and the distance of the camera from the subject."[7] Lenses usually are designed so that objects at different distances from the camera will be in different degrees of focus. There is a point, called

SCALE

Top: In an early Soviet publication detailing the progress of one of their construction projects, the workers are clearly out of proportion with the apartment buildings below. *Department of Defense.*

Right: A photo must have proper scale and perspective. Since the average height of Russian men was 5 feet 6 inches, these SA-2 missiles would have to be 51 feet, 9 inches long. Their known length is 35 feet. *Central Intelligence Agency.*

Below right: This Soviet photomontage shows several MiG-15 fighters flying over a Soviet Skoryi destroyer, which is known to be 420 feet long. Photogrammetric analysis determined that the destroyer would have to be 161 feet long to be in the juxtaposition pictured here. *Department of Defense.*

the plane of focus, where everything is at optimum sharpness; in front of and behind that point is increasing blurring. The difficulty of constructing an image of interlocking snippets arranged to appear as a single photo is extremely difficult. In color film, for example, objects seen at a distance are generally more blue than those in the foreground.[8]

CROP LINES AND TONES

The final product of combining two or more photos will often reveal that the result often does not possess quite the same texture or tone of objects appearing in the original. Thus a "paste-up" montage will often appear flat or gray compared with the original photograph. A montage made from negatives, while retaining much of the quality of the originals, still presents problems to the technician's attempts to blend tones and combine textures. On negative montages, certain images tend to stand out from other images in the photograph. For example, in both paste-up and digital montages, trees present problems; if the forger attempts to place an image with trees in a new environment, he or she must either round out the tree's leaves, which then are unnatural-looking, or retain all the branches, which requires delicate cutting of the photo or elaborate dig-

DEPTH OF FIELD
This beautifully crafted montage carries a message about efforts to clean the air around a steel plant. We can tell it is a montage because of its depth of field. When objects both near and far are in perfect focus, it is a good bet that at least two photos were involved in the creation of an image. *Bethlehem Steel Corporation.*

itizing in the computer. In the latter case, looking at the corners of images under magnification will reveal the match or join lines. If there was improper illumination during the copying of a paste-up montage, crop lines are often detectable.

The skills of the photo forger have been enhanced by the computer. Digital image processing is a computer-assisted method of faking a photograph. A negative, transparency, or photograph is put into a scanner, which optically looks at a very small area of the photograph and determines the lightness of it. In more technical terms, numbers are assigned to the lightness and these are fed into the memory of a computer; the photograph is broken down into pixels, which can be stored. Once the data has been stored, it can be manipulated; the contrast or lightness can be increased or decreased. The computer, however, can also be programmed to look for edges or lines.

HEADS ROLL

Sometimes in creating a new news photo, the desire of an individual to be included in a photo has resulted in the head of one person being inserted onto the body of another. A *Texas Monthly* cover shows Texas governor Ann Richards sitting on a Harley Davidson motorcycle. The image was created to illustrate a story on the governor titled "White Hot Mamma." The credit lines did not indicate it was a computer manipulation with a head shot of the governor combined with an image of a female model on the motorcycle.[9] In the November 25, 1998, issue of *Weekly World News*, a photo of Attorney General Janet Reno's head was placed atop the body of a beauty-pageant contestant. A framed copy of the photo was sent to Reno, who remarked that she liked it.

On a 1989 *TV Guide* cover, Oprah Winfrey's face was combined with Ann-Margaret's body. The deception was uncovered when Ann-Margaret's husband noticed a familiar ring on one of "Oprah's" fingers. *Spy Magazine* combined Hillary Rodham Clinton's face with a buxom

TONES
When cosmonaut Yuri Gagarin was launched into space in April 1961, the Soviets made efforts to conceal the details of his spacecraft and equipment from Western eyes. An original photo clearly shows people in the background. In another photo, the background tone has been lightened. A sharp tonal change in a third photo clearly indicates tampering. *Department of Defense.*

The cover of the August 26–September 1, 1989 issue of *TV Guide* featured Oprah Winfrey, whose face was superimposed on actress Ann-Margaret's body. The illustration was not identified as a composite. In the world of magazines, the use of digital manipulation has launched a furious debate over the ethics of digital imaging, pitting artistic freedom against image control. *AP/Wide World Photos.*

leather-clad body. In the motion picture *In the Line of Fire*, a photo of a young Clint Eastwood was imposed on a Secret Service agent's photo during the Kennedy motorcade in Dallas. When the actress Demi Moore appeared very pregnant in a cover photo in *Vanity Fair, Spy Magazine* substituted the head of her husband, Bruce Willis, on her body. The actor Leslie Nielson's face is imposed on a very pregnant body with the inscription "Due This Month" in an ad for the movie *Naked Gun 33¹/₃: The Final Insult. Colors Magazine* combined a photograph of Queen Elizabeth with a similarly posed black woman to create a black queen.

A Washington-based photographer, Frank Van Riper, showed how easy it is to alter a photograph. At a dinner honoring his friend, Democratic Party chairman Paul Kirk, Van Riper took a photo of Kirk in an animated conversation with Ted Kennedy. In less than thirty minutes a computer technician electronically transported the head of Walter Cronkite, from a picture taken at a different function, to Kirk's head.[10]

Whenever a group picture is taken with the President, there is often jockeying or elbowing among participants to get as close to the President as possible. In an official White House photo, William P. Brennan, president of the National League of Postmasters, was standing fourth from the President's left while the President was signing a bill the participants had pushed. In the November 1994 issue of *Postmasters Advocate*, however, Brennan stands beaming behind Clinton's left shoulder. His head had been electronically grafted onto the body of Virgin Islands Delegate Ron de Lugo. The manipulator failed to remove the member-of-congress lapel pin from de Lugo's suit.[11]

Europeans, especially the French and Germans, love to make fun of celebrities in photos. *Die Welt* took photos of President Carter, Senator Ted Kennedy, and then-Governor Reagan and showed how they would look with beards and mustaches.[12]

BODIES MOVE

The advances of computer technology allow for one photo to be merged with another with relative ease. This often happens with personalities in the news when photos of an event are not available. The September 1985 cover of *Picture Week* headlined "Nancy Meets Raisa" showed Nancy Reagan and Raisa Gorbachev seated side by side. In fact, the pictures were taken in Washington and Moscow, respectively. Though two photographers received photo credits, there was no mention that the photo was a graphic illustration.

Similarly, Bjorn Borg and John McEnroe were photographed days apart and in different locations and appeared in dueling costumes on the cover of *World Tennis Magazine*. In 1993, *Newsweek* combined a photo of Dustin Hoffman, then in New York City, with one of Tom Cruise in Hawaii for a story on the film *Rain Man*. In a picture taken of President Bush and Prime Minister Margaret Thatcher, several shrubs, trees, flowers, and a long watering hose were removed and Bush was moved closer to Thatcher to make it appear that he was planting a lecherous kiss on her.[13] When the marriage of Princess Diana and Prince Charles was reported to be on the rocks, the German magazine *Bunte* ran a picture of Diana with a large tear in her eye; a dry-eyed version of the same photo appeared at the same time in *Paris Match*.

HEADS ROLL
Above left: To satisfy the desire of an individual to be included in a photo, his or her head can be inserted onto the body of another. In this group picture of postal officials taken with President Clinton, Walter P. Brennan, president of the National League of Postmasters, is standing fourth from the President's left *Official White House Photo.*

Above right: On the cover of the November 1994 issue of *Postmasters Advocate*, Brennan's head was electronically grafted onto the body of Virgin Islands Delegate Ron de Lugo. De Lugo's shirt was whitened, but his congressional pin was not removed. *Postmasters Advocate.*

During the Nancy Kerrigan–Tonya Harding controversy, New York *Newsday* printed a full-color cover photo of the Olympic rivals skating side by side. Although there was a disclaimer in the caption stating that it was a photo illustration, the doctored photo had a single background, which made it deceiving.[14]

Sports Illustrated for Kids took an old photo of Lou Gehrig and Babe Ruth, removed Babe Ruth, and substituted Cal Ripken.[15] A ledge was built at about the same height as the wall that Lou Gehrig was leaning on in the photo. An editor struck the same pose as Gehrig and a photo was taken that showed Ripken leaning on the editor with his arm around the editor. The two photos were combined and the composite photo appeared as though Ripken and Gehrig were the best of friends. When *Spy Magazine* celebrated its fiftieth anniversary, its feature article was "Life Really Is Like High School." Its illustrative cover showed General Schwarzkopf holding Madonna on his shoulders.

During Ripken's attempt to break Gehrig's consecutive games record, Ripken was shown holding a bottle of Coca-Cola in a photo that had been updated by Coca-Cola. The Coke bottle was digitally placed in the photo because Ripken originally had been posed with a different Coca-Cola product, PowerAde.[16]

Esquire showed a photo, which it jokingly claims to have found in Johnny Cochran's locker, of O. J. Simpson with his arm on Mark Fuhrman's shoulder on the seventeenth hole of the Bel Air Country Club.[17] In a *New York Times* photo, Groucho Marx replaces Joseph Stalin at the Yalta Conference with Roosevelt and Churchill, while Sylvester Stallone adds a Rambo presence behind Roosevelt.[18]

Foreign magazines love to portray national leaders in a humorous light. The *London Sunday Times Magazine* showed a naked French President François Mitterand. The German magazine *Stern* published a cover photo of a nude Helmut Schmidt posed as "The Thinker."[19] *The New Scientist* showed a picture of John Major chatting with Albert Einstein on the steps of No. 10 Downing Street.

The New York Times published a photo of Saddam Hussein, taken on August 8, 1990, that had been combined with one of Secretary of State Baker with Foreign Minister Raul Manglapus, taken on July 23, 1991. It shows Baker with his arm about Hussein.[20] Similarly, in 1988, when Yasir Arafat and the Israelis were at odds, *Life* magazine published a composite photo of Chairman Arafat warmly greeting then Prime Minister Yitzhak Shamir under the approving gaze of President Ronald Reagan.

The cover of *Scientific American* combined photos of Marilyn Monroe and Abraham Lincoln to create one of Monroe hugging Lincoln.[21] In an ad for the Elton John Aids Foundation, Elton John is combined with Judy Garland, Bert Lahr, and Ray Bolger in a *Wizard of Oz* poster.

During a visit of the Reagans to England, the British press attempted to show that Queen Elizabeth was not as clothes-conscious as Nancy Reagan. In an effort to persuade the Queen, who was the same height and weight as Nancy Reagan, to become more stylish, *The London Daily Mirror* used digital imaging to transpose the clothes of the two women to show that the Queen could use some of the First Lady's fashion flair.[22]

There appears to be no limit on how far editors will go in tampering with photos concerning images, taboos, or offensive materials. In the past, the catalogue for the Victoria's Secret lingerie line showed models posing in sheer brassieres or gauzy underwear in which their nipples were clearly discernible. In recent catalogues, the nipples have been eliminated, prompting a number of tongue-in-cheek articles.[23]

Digitally altering images has turned into an art form. A Mexican photographer, Pedro Meyer, has created a series of digitally altered photos in an exhibit titled *Truths and Fictions: A Journey from Documentary to Digital Photography*. There appears to be no limit as to what can be done to heighten an impact. In a photo of an amputee in a swimming

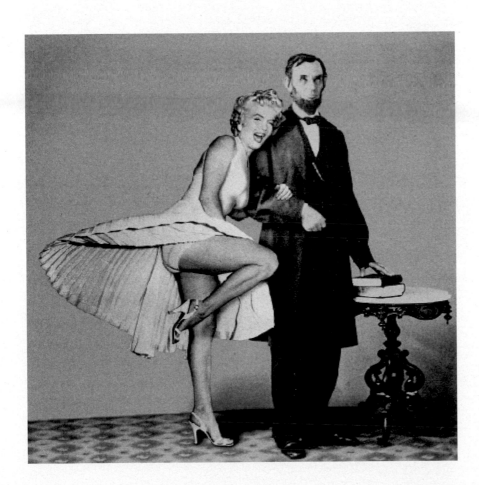

Photos of Marilyn Monroe and Abraham Lincoln were combined for a magazine cover. Scientific American *cover created by Jack Harris; Lincoln photo from Corbis; Monroe photo from Personality Photos, Inc.*

When NASA released a photo taken during its moon explorations, the NASA U-2 unit had some fun with their colleagues in the manned space program.
National Aeronautics and Space Administration.

pool, Meyer digitally removed another of the man's limbs to "heighten the dramatic effect."[24] Other works of Meyer's display a biting commentary on the lives of Mexicans in the United States.[25] In an Austrian company's brochure, a photo of a man and another of a horse were merged into a centaur.[26]

In an article "Is It Real or Is It . . . ?" Kathy Sawyer showed how easy it was to create a photo that simply isn't true. In a White House Rose Garden photo, Ray Charles is seen between the President and Hillary Rodham Clinton. In another photo Elvis Presley is pictured with President Nixon. Charles is replaced by Elvis so that President Clinton is seen shaking hands with Elvis.[27]

Photomontages have often been used as vehicles for humor. Humor

magazines have frequently featured them. They have also often been used by people and organizations having a little fun with one another. Such was the case when NASA personnel concerned with U-2 operations sent their astronaut space brothers a photo of a U-2 on the moon.

ACTION AND REACTION

Sir Isaac Newton's third law of physics—for every action there is an equal and opposite reaction—can frequently be applied to detect a fake photo whenever motion is depicted. If an auto is speeding down a dusty road, one should see dust trailing behind the auto. If a submarine launches a missile while submerged, one should see a wave when the missile emerges from the water. The photo technician frequently forgets about such details, thereby permitting detection of a fake photo.

Throughout the Cold War, the Soviets held air shows to display Soviet aircraft along with flypasts of their newest aircraft. These shows garnered a wealth of publicity for the Soviets and photos of the events were released by TASS, the Soviet news agency.

One of the photos displayed was of the Yak-24 "Horse" helicopter which, according to the Soviets, was capable of carrying forty troops or a variety of vehicles and guns. In examining the photo, I noticed that not a single person is looking up at the helicopters and that no downdraft was being created by the rotors. Certainly, the noise and downdraft from these helicopters would have commanded attention from the crowd below. It was obvious that the photo was a montage.

PHOTOGRAMMETRIC ANALYSIS

There were a number of criticisms of the Warren Commission's investigation of the death of President John F. Kennedy. In September 1978, special hearings were conducted before the Select Committee on Assassinations of the House of Representatives. The committee demanded a detailed analysis—photogrammetry—be performed on all the photos concerned with the assassination. Photogrammetry has been defined as "the art, science, and technology of obtaining reliable information about physical objects and the environment through processes of recording, measuring, and interpreting photographic images."[28]

On November 22, 1963, the day of President Kennedy's assassination, Dallas police detectives obtained a warrant to search the home of Ruth Paine in Irving, Texas, where Oswald's wife, Marina, had been living. In the garage where the Oswald possessions were stored, detectives found two different prints and a negative of one of the prints of Oswald holding the rifle. In addition, an Imperial Reflex camera was confiscated. Marina Oswald claimed she had used that particular camera to take the pictures of Oswald in the backyard of their home on Neely

ACTION-REACTION
Top: The launch of a missile from a submarine should create waves. The sea is perfectly calm in this Soviet montage. *Department of Defense.*

Bottom: For every action there should be an equal and opposite reaction. There are three large Soviet Yak-24 helicopters overhead but not a single person is looking up. Neither is there any downdraft being created by the helicopters. *Central Intelligence Agency.*

Street in Dallas. The photographs have come to be known as the "back-yard photos."

On the evening of November 23, Captain Will Fritz of the Dallas Police Department showed an enlargement of one of the photos to Oswald at the Dallas Police Department Headquarters. Oswald denied repeatedly that he had ever seen the photo, and claimed that someone had superimposed his head onto another body.

On the cover of its February 21, 1964, issue, *Life* used one of the backyard photos. It showed Oswald with a holstered pistol strapped to his waist, holding a rifle in one hand and copies of *The Militant* and *The Worker*, both Communist publications, in the other. To enhance its quality, the photo had been retouched in several areas, a common practice in the magazine world, especially on cover photos. The photo was widely disseminated. After the release of the Warren Commission Report, there were a number of claims that the photo of Oswald holding his rifle had been tampered with. Arguments ranged from shadow inconsistencies, conflicting body proportions, and variances in Oswald's chin and a supposed line that suggested montaging of Oswald's head. Critics maintained that a horizontal line appearing across Oswald's chin was evidence that a photo of his head had been grafted onto a different body. Still others claimed that Oswald's chin structure did not correspond with its shape depicted in earlier photos. Others charged that the heads were identical in the pictures, but that the length of the body differs and, finally, that the shadows cast by the nose were not consistent with those cast by the body.

The Select Committee on Assassination of the House of Representatives[29] sought to lay the matter to rest by having the photos subjected to the most detailed analysis ever made. In 1978, the Committee convened a panel of photographic and photogrammetry experts of varying backgrounds, with experience in photogrammetry, analog photographic enhancement, digital image processing, photo interpretation, and forensic photography. The Committee told these experts to use the most advanced technology available to determine whether the photos were authentic or fakes. Analog enhancement work was done by experts at the Rochester Institute of Technology, while image processing experiments were performed at the University of California, the Los Alamos Scientific Laboratory, and at the Aerospace Corporation.

The Select Committee on Assassination also located a third photo of Oswald with the rifle from Mrs. Genevese Dees of Paris, Texas, whose husband had been employed by the Dallas police at the time Oswald was arrested and who had kept the photo.

Knowing the sophistication required to fake a photograph, it seems foolish that someone trying to frame Oswald would provide experts with three photos to examine. Faking three photos would dramatically in-

Labels on image: HAIRLINE · OUTER EYES · TIPS OF EARS · INNER EYES · PUPILS · NOSTRILS · JAWBONE · LIPS · CHIN

crease the chance of being detected. Anyone faking a photo would certainly not allow the original negative to be subjected to detailed analysis. Also, it would have been very unwise to allow the camera to fall into the investigators' hands for analysis. With the photos, the negative, and the camera available, twenty-two of the nation's foremost photogrammetrists, photo scientists, and photo interpreters performed a myriad of examinations.

A number of measurements of Oswald's face were taken from all three photos, and they were all consistent. The conclusion of the nation's foremost photogrammetric experts was that the photos were real.

Although the best-known application of photogrammetry is the compilation of maps and charts based on information derived from aerial and space photos, the same techniques, sometimes called triangulation, can be applied to photographs taken from points on the ground. Similar topographic principles can be applied to the measurement and analysis of specific objects in any photograph. Just as a field or forest in an aerial photo can be precisely measured and the topographic features mapped, so can a face and body be mapped. To do this, measurements should

be made of the outer eyes, inner eyes, pupils, nostrils, lips, cheekbones, jawbone, ears, teeth, and hairline in relation to one another. Additional measurements, such as height, chest, waist, length of arms, legs, etc., can also be accomplished. Facial features can be accurately plotted to show warts, freckles, moles, and wrinkles. Proof of photo fakery can also be determined photogrammetrically by establishing discrepancies in the ratio of spatial relationships between objects in the image.

It should be noted that with aging, there is a diminution of the elastic skin tissues, which causes a sagging of the chin and jowls. This was especially true in a comparison of pictures of Lee Harvey Oswald taken at various ages. In some of his younger pictures, his chin appeared more pointed than it does later on when he developed a cleft in his chin. This phenomenon is usually accompanied by an increasing deposit of fatty tissue in the neck and face. In women, the diminishing elasticity of the tissues is frequently reflected in facial and neck wrinkles. In men, an increase of hair growth in the nose, ears, and eyebrows is common with age. In both sexes, elongation of the earlobe is also common with the aging process.

Probably one of the best examples of the use of photogrammetric analysis of an important event came during the Korean War. When Major General William F. Dean took command of the U.S. Army's 24th Division in Kokura, Japan, in June 1950, he was fifty-one, graying, slightly over 6 feet tall, and weighed 210 pounds. On July 21, he was captured and spent the remainder of the war as a prisoner of the North Koreans.

PHOTOGRAMMETRIC ANALYSIS Questions arose about whether the emaciated individual in this North Korean photo was General William F. Dean, missing for over a year during the Korean War. His face was measured with "triangulation" methods used in map making. CIA photo expert Arthur C. Lundahl assured President Truman that the individual was indeed General Dean. *Eastfoto.*

The North Koreans did not reveal his capture immediately. There were a number of reports that General Dean had been killed in action, but since there was no proof of his death, he continued to be reported as missing in action by the U.S. Army. For over a year and a half, the Western world knew nothing of his fate.

Then, on December 19, 1951, his name appeared on a prisoner of war list issued by the North Koreans, who also released a photo purported to be of the general. The man in the photo was estimated by U.S. medical doctors to weigh about 150 pounds. The photo was slightly out of focus and there were indications of retouching. The man purported to be General Dean had a brush haircut, but the hair was entirely black, with no evidence of graying at the temples. His eyes were closed and his face looked youthful, with no wrinkles. Doubts were expressed whether the individual pictured was actually General Dean.

President Truman asked if it could be determined whether this was indeed General Dean, and why the Communists had waited so long to announce the capture of such an important prisoner. Provided with pre-capture photos of General Dean and the Communist-released photo, Arthur C. Lundahl, the dean of American photogrammetrists, began a time-consuming and detailed analysis and measuring of the General's face on the various photos. Lundahl placed special emphasis on measurements of Dean's eyes, the distances between his eyes, his ears, and precise measurements of his nose and lips. Lundahl said he had "triangulated" Dean's face as one would survey a field. After comparing his measurements, derived from sophisticated mapping instruments called comparators, with those in the pre-capture pictures, Lundahl was able to make a firm judgment that General Dean was indeed the individual pictured in the North Korean photo. President Truman was so notified.

Later, the North Koreans released a second photo that showed Dean with wrinkled skin, graying temples, and a gaunt and pale appearance. General Dean eventually was interviewed and photographed in North Korea by Wilfred Burchett, a correspondent for the French left-wing newspaper *Le Soir*. In the Burchett photos, General Dean appeared to be much heavier than in the previously released photos. Why were there such discrepancies in the General's weight? After his release, General Dean provided the answer. The first photo was taken shortly after his ordeal of evading capture, at a time when he was suffering from dysentery. The Burchett pictures were taken on December 21, 1951.

PARALLAX

Parallax is an apparent displacement or difference in apparent direction of an object, as seen from two different points not in a straight line with the object. When you move sideways, even if you just move your head a

few inches, the relative positions of near and far objects change. If you focus on a foreground object, the background appears to move in the same direction you are moving. If you focus on a background object, the foreground appears to move in the opposite direction.

The concept of parallax is normally taught in colleges and universities using a simple experiment. If you hold a photograph up in front of your eyes, and hold a finger up between your eyes and the photo, and gaze at the finger while shifting your head from side to side, and the finger will appear to move from side to side with respect to the photo. The closer the finger is to your eyes the greater the shift. The apparent motion of the finger is called parallax and is due to the shifts in the position of observation. Overlapping photos will obtain a record of positions of images at the instant of exposure.

DATE-TIME-SHADOW SUN ANGLE ANALYSIS

Some photographic fakes are exposed by using advances in scientific techniques. It is generally unknown to the faker that photos taken outdoors can be dated to the day and hour. In order for this type of analysis to be done, the shadows should begin and end within the frame of an uncropped negative or print. There must be a horizon to determine the orientation of the camera. True north must be determined, and knowledge of the focal length of the camera is helpful.

If the precise location of a photographed scene (its coordinates in longitude and latitude) and the year when it was taken are known, the date and hour can be determined through photogrammetric means. If the azimuth and elevation angle of the sun can be determined from shadows, there are only two periods each year when the sun would cast such a shadow—when the sun is moving north and when the sun is moving south. The time of day can be determined from the azimuth and the time of year (month and day) from the inclination angle. The position of the sun in the sky at any given date or time is published annually in the Air Almanac, by the U.S. Naval Observatory, and by Her Majesty's Stationery Office. From this information, it is possible to calculate the angle and inclination of the sun for any given position on the earth and thereby compute the size of the shadow. It is nearly impossible to fake natural shadows in photographs.

Commander Robert E. Peary's claim to have been the first to reach the North Pole on April 6, 1909, was engulfed in controversy for about eighty years, largely because of the competing claim of Dr. Frederick Cook, who claimed that he had reached the Pole a full year earlier. There were also questions about Peary's navigation records and the distances he claimed to have accomplished. A monumental and exhaustive study was undertaken in 1989 by the Navigation Foundation on over 225 cubic

DATE-TIME-SHADOW
SUN ANGLE ANALYSIS
A question remained about whether
Commander Robert E. Peary had
reached the North Pole using his
navigation instruments. A detailed
study using modern photogrammetric
methods was conducted. By knowing
the focal length of his camera, locating
the horizon on the photos, analyzing
and measuring the shadows cast by
individuals, and the dates the photos
were taken, the angle of the sun was
computed. By consulting published sun
angle tables, it was possible to determine
that the sun angle of the photo taken by
Peary was 6.8 degrees. The actual sun
angle of the sun on the date the photo
was taken was 6.7 degrees. It was
determined that Peary was as close to
the North Pole as could be ascertained
"within the limits of his instruments."
Victor R. Boswell, Jr., © National
Geographic Society.

feet of papers in the Peary collection at the National Archives, along
with other collections of information and the instruments Peary used on
his trek.

The photographs taken during that expedition were key to the photo-
grammetric analysis as to whether Peary reached the Pole. Shadows are
clues in a technique called photogrammetric rectification, a process of
finding the sun's elevation when the various photos were taken. The fo-
cal length of Peary's camera was known. On one photo, the horizon
could be delineated and the camera tilt determined. Shadows cast by in-
dividuals were evident, and the angle of the elevation of the sun was
computed to be 6.8 degrees. The 1909 National Almanac gave the el-
evation of the sun at the Pole on April 7, 1909, when the photograph
was taken, to be 6.7 degrees, allowing the Foundation to conclude that

"Peary was at the Pole or as close as his instruments could measure and that the pictures were taken very close to the Pole."[30]

To confirm that Peary reached the Pole, William G. Hyzer, a noted photogrammetrist, set up the problem on a tennis court. An artificial horizon was constructed by using poles topped with ping-pong balls. Hyzer then applied the process of photogrammetric rectification to the white sticks and the shadows they cast to determine the angle of the sun above the horizon.[31] His analysis supported Peary's claim.

A photograph of myself taken in Rome in 1944 was given to Richard Dere, a photogrammetrist, for analysis. I was in the service at the time and was standing in front of the Victor Emmanuel Monument. I was wearing a summer uniform, so the season was obviously summer. The geographic coordinates of the monument are 41 degrees 54 minutes and 30 seconds north, and 12 degrees 17 minutes and 30 seconds east. My height was 5 feet 9³/₄ inches. The ratio of the sun's shadow to an object's height will result in a determination of the sun's elevation angle, which was 53 degrees. The sun's azimuth was 117 degrees, and from tables the sun's declination was 20 degrees north. Consulting the sun's declination in 1944 tables, the date computed by the photogrammetrist for the photo was July 21. A leave pass shows that I was in Rome on that day.

MICROSCOPIC ANALYSIS

One of the best weapons against the photo faker is the microscope. Pixels invisible to the naked eye can be seen under a microscope. Micro-

scopic analysis of a photo can reveal to the experts things not visible to the naked eye. Here too, experience and a keen eye for detail will often uncover a fake.

Under the microscope each potential telltale mistake by the faker is carefully analyzed. Individual silver particles in the film are examined. For example, in the Oswald photo previously discussed, the fine line across Oswald's chin was diagnosed as the edge of a water spot, which is common in photo processing. Detailed examination of the photo showed water spots on other areas of Oswald's body.

There is a large market for old photos, especially daguerreotypes, which were enormously popular in the mid nineteenth century. From time to time old photographs will appear on the market. Respected experts have authenticated daguerreotypes of historic personalities or science. In the 1990s daguerreotypes purported to be made by Albert Southworth and Josiah Hawes, a mid-nineteenth-century Boston-based portrait photography team, appeared on the market. These portraits were thought to be quite valuable until microscopic evaluation revealed printer's dot patterns which did not exist when daguerreotypes were produced. Daguerreotype images were made from a silver-coated copper sheet and would have continuous tones.

VANISHING POINT ANALYSIS

All artists, engineers, and photographers are well aware of the terms perspective and vanishing point. Lines that in actuality are parallel ap-

MICROSCOPIC ANALYSIS
The photo fake detective's best friend is the microscope. Detailed analysis of a negative can be conducted for spurious lines and changes in the negative that would indicate photo montaging. None were apparent in this photo of Lee Harvey Oswald. *National Archives and Records Administration.*

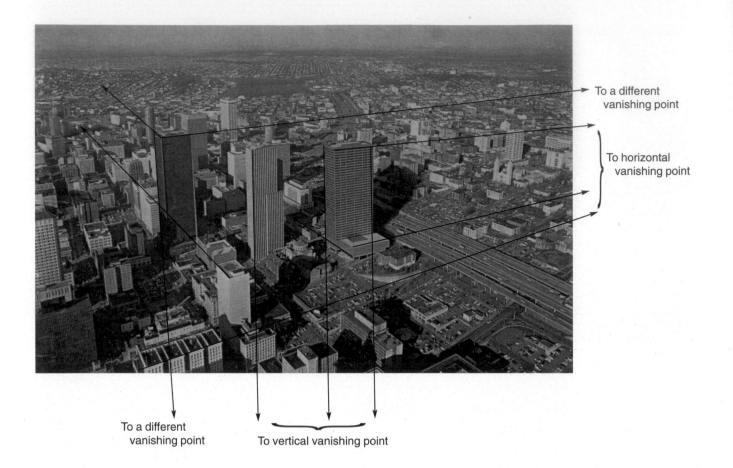

To a different vanishing point

To horizontal vanishing point

To a different vanishing point

To vertical vanishing point

VANISHING POINT ANALYSIS
A building was placed in this photo. Through vanishing point analysis it was quickly found. The tall dark building is 2 degrees off vertical and 8 degrees off horizontal, and its vanishing points are different from those of the other buildings. *Industrial Photography.*

pear to converge in perspective photography, just as they do in human vision. In drawings and paintings the lines are drawn or painted so that an object depicted disappears in the distance. For example, a photograph of a railroad line will show the empty tracks converging at a far point in the distance, yet it is well known that they do not. An artist will determine the proper proportioning of objects in a painting by drawing lines from the outside of the objects being painted back to vanishing points that define the horizon. The artist, therefore, mimics the railroad tracks and various converging lines and angles tie the images together and give the painting a three-dimensional effect. It is often possible to detect a photomontage through the examination of this perspective phenomenon; in a faked photo, vanishing points frequently are inadvertently or deliberately displaced.

The sun is so distant from the earth that in analyzing an outdoor photograph the light source can be considered as infinity. If a line is drawn from an object in a photo to its shadow in a number of points in the scene, all of these lines will converge at a point (the camera lens). If lines converge at several points, then one has a sure indication that the photo has been faked. This type of analysis is called vanishing point

analysis. When the Oswald photos were subjected to vanishing point analysis, all of the lines converged, indicating that the three photos of him were true and not tampered with.[32]

CROPPING

The photographer generally aims at the center of visual interest, and can accept or reject information that falls along the perimeter of an image. Cropping is the alteration of what appears in the original negative. The cutting off of peripheral detail or unwanted parts of a photograph has long been a standard practice in photojournalism. Photo editors routinely re-size and crop photos appearing in their newspapers. Cropping can be performed by cutting the edges of a print or blocking out portions of a photo during the enlarging or printing process. Photos are often edited to move subjects closer together to make the photo fit a layout. Often editors will rearrange elements of a composition for greater visual impact. Unless the uncropped print or negative is available, cropping is usually undetectable.

The *Time* magazine cover of April 4, 1994, showed an apparently worried President Clinton with his head bowed and his hand on his forehead. A concerned George Stephanopoulos stood nearby. On the cover was the caption "Deep Water. How the President's men tried to hinder the Whitewater investigation." The impression conveyed by the photo was that the President was irate at Stephanopoulos's phone call to a Treasury official complaining of the appointment of Jay Stevens. The caption inside the magazine failed to note that the picture was taken at a routine scheduling meeting on November 9, weeks before Whitewater became a major concern to the President. *Time* had also cropped out Dee Dee Myers from the photo. She complained to the press that the photo was taken out of context and would probably mislead readers.[33]

STRETCHING

Photographs are often stretched horizontally or vertically to fit a layout. This can easily be done with computers. Models are often made to look taller and more slender than normal. If done in small percentages, stretching is hard to detect. Gross stretching, however, will appear to "fatten up" or lengthen subjects and is usually detectable.[34]

BACKGROUNDS

Whenever two photos are merged, background details are often not considered. There's usually an attempt to blend the background data of one photo into the other. One of the first things I try to determine is whether the background is consistent with the rest of the photo, or whether clues show that the photo has been tampered with or that the photo is a photo-

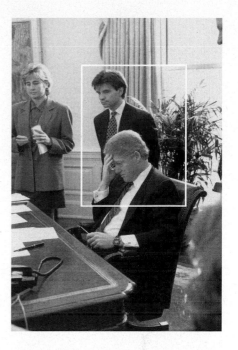

CROPPING
Cropping is performed by cutting out portions of a photo or blocking out that portion during the enlarging or printing process. A photo taken of a worried-looking President Clinton during a routine scheduling meeting on November 9, 1993—weeks before the Whitewater investigation became a major issue—was cropped by *Time* on its April 4, 1994, cover about Whitewater. The cropping is indicated by the white lines. *Barbara Kinney, The White House.*

montage. When photos are combined, the backgrounds are often harsh or flat. For example, when photos of Raisa Gorbachev and Nancy Reagan were merged, it was obvious that the backgrounds were different. Richard Stolley, *Time* Incorporated's editorial director, admitted, "We tried to blend them together so it wouldn't be so harsh. But you could tell from the backgrounds that the two women weren't sitting together in the same room."[35] When *Newsweek* combined photos of *Rain Man* stars Dustin Hoffman and Tom Cruise in a single image, it was apparent that distracting backgrounds had been eliminated.

MIRROR IMAGES

A mirror image is the reproduction of an optically formed photographic duplicate, usually to the same scale and format as the original image. Frequently, however, the duplicate image has been enlarged or reduced in scale. Close inspection of some photographs often reveals that the

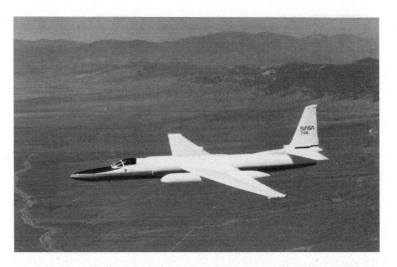

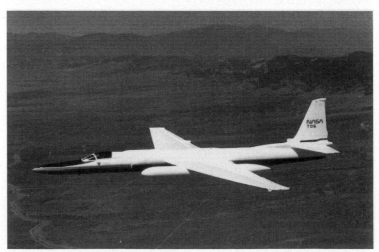

STRETCHING
Top: Photos can be stretched vertically, horizontally, or both to fit a layout. This photo of a U-2 spy plane is the original.
National Aeronautics and Space Administration.

Bottom: In this photo the image of the plane has been stretched horizontally. One can readily see or measure the distance it has been stretched.
Photomanipulation by Advanced Presentations.

same image will appear several times in the photograph. Such mirror images are often used to depict a scene as larger than it was in reality. For example, to enlarge a crowd at a particular event, images of the crowd scene will be spliced so that it is difficult to ascertain that it has been done. In photos of Russian military exercises, it can be seen that the rotors on helicopters are in the same position, a sure sign of mirror imaging.

HALATION

Halation is the fog or halo in a photograph around the image of a highly reflective surface or light source. Unlike ambient light, halation comes from a directed or reflected light source, and causes a "bloom" effect on the image. It occurs in the negative when excess light from a brilliant object is reflected back from the emulsion-support elements. For example, halation is caused by lights in a night photograph, or by reflectors or curved surfaces imaged in bright sunlight. In examining night photos, looking for halation can be very important. A faked photograph may show halation around one object and not around similar objects oriented in the same direction with respect to the sun or a light source.

During Mao's Great Leap Forward, the Communist Chinese were publishing photos showing the rapid progress of their industrial schemes. They published many night photos that would be difficult for a layperson to interpret. To show that they were becoming independent of foreign oil, a photograph of a Chinese oil field at night was printed in one of their propaganda journals for foreign consumption. Close analysis of

the halations in that photo revealed not one but a number of mirror images. Lights about the plant, storage tanks, and refinery equipment appear again and again in the montage.

AMBIENT LIGHT

Ambient lighting is the light emanating from the area surrounding an object imaged in a photograph. It is most often nondirectional and frequently does not cast a shadow. This light usually highlights the object. For example, ambient lighting will highlight loose hair, since the hair will capture and reflect the light, often causing a glow. The ambient light effect is difficult to recreate and, if such an attempt is made, it is very easy to detect.

PHYSICAL SEARCH

Through training and experience, a photo interpreter has catalogued in his or her memory thousands of images and concepts. Even after submitting a photo to intensive technical analysis by both laboratory and photogrammetric technicians, he or she may still be unable to determine whether a photo is true or forged. As a good detective visits the area where a crime has been committed, so too there are times when it becomes necessary for an interpreter to personally examine a specific individual or area where a photo purportedly has been taken.

A POW photograph, supposedly taken in Laos, surfaced in 1991. It showed a young Asian and a gray-haired, balding, and bearded man with Caucasian features who was identified by Betty and Dan Borah of Olney, Illinois, as being their son, missing Navy Lieutenant Daniel V. Borah.

Lieutenant Borah had been shot down over enemy-held territory in 1972. In support of their claim, a non-government forensic anthropologist positively identified the person as Borah. The individual was supposedly being held as a slave worker somewhere in Laos.

The photo was analyzed from every angle, including the individual forest plants in the photo. The flora and fauna were determined to be tropical and common to Southeast Asia. The Department of Defense, with the help of Laotian officials, was able to locate the older individual, who turned out to be a seventy-seven-year-old Laotian highland tribesman. The Army Central Identification Laboratory sent Sergeant First Class Frank Napoleon into the Laotian countryside in July 1991. He interviewed, photographed, and fingerprinted the man. Family members were still not convinced, and insisted on seeing the individual themselves. They made a trip to Southeast Asia accompanied by a Department of Defense investigator. Only an interview with the tribesman convinced them that he was not their missing son.

EXAMINATION OF A NEGATIVE

An old adage in photo fakery detection says, "Get back as close as you can to the original negative." With each copying or printing of a negative, there is loss of detail. Tonal qualities become degraded and detail is lost in both the highlights and shadows. But the original negative or duplicate negative is rarely available to determine a suspect fake photograph. If a negative is available, it can easily be determined whether it is the original by looking at the format edges. Under microscopic examination, the granular structure of the various parts of the image can be examined for discrepancies, along with checking the separation between sprocket holes, fiducial markings, and other manufacturer's markings. Brushlines and toning, along with any crop markings for montages, are often apparent.

A negative consists of an emulsion of gelatin upon which crystalline grains of silver halide are spread. This can be compared somewhat to the grains of abrasives on a piece of sandpaper. Fine-grain film records more information than coarse-grained film. As the exposure or the development time increases, grains at increasing depths in the emulsion coating are reduced to silver. An analysis of the grain pattern can be done microscopically or digitally. Upon enlargement, the image will break up and grains of a processed film will appear very roughly as spheres, cubes, and octahedrons.[36] Since the photographic image is made up of grains of silver halide, these grains are distributed evenly throughout the film. If there is either an extraction or insertion of an image, there could be disparities either in the grain size or in the distribution of the grains. A difference in grain sizes or film edges of the insertion would indicate a

PHYSICAL SEARCH
Top: A photo surfaced in 1991 of an individual identified by the parents of Lieutenant Daniel Borah as being their missing POW/MIA son.
Department of Defense.

Bottom: The Department of Defense sent Sergeant First Class Frank Napoleon to Laos to locate the individual. He turned out to be a Lao tribesman.
Department of Defense.

montage. We would also expect to see an edge under microscopic examination that would indicate a montage. If the negative has been tampered with—for example, scraped or another placed over it—this can be detected through the use of a phase-contrast microscope, which detects very small changes in the thickness of the negative.

Upon a request from the Congressional House Select Committee, a thorough examination of the Oswald photo's negative was conducted by experts. Detailed analysis of the grain patterns in the emulsion proved they had not been disturbed. If the photo were a montage, there would have been a discontinuous line, but the lines in the negative were continuous. Using a densitometer, a specialized photometer used to measure photographic densities, the negative was scanned for any differences in the individual grains of film above and below the middle of the chin. According to the report: "As photographic scientists, we found nothing remarkable about the grain pattern. This was the same type of grain pattern."[37]

There was also an attempt to locate any line or edge that would indicate an insertion of a second negative. A scientist reported: "Likewise, edges here are traced out by the computer, and with this analysis, the computer was unable to see any spurious lines across the chin and not able to see any spurious lines leading into the chin from the outside."[38]

In the digitized world, however, there may not be a negative to examine. In advanced photo systems, there are magnetic storage disks. These disks can be erased and used over and over again, and therefore a previous image can be recorded over, leaving no original or permanent archival negative.

Digital image processing is a computer-assisted method of faking a photograph. A negative, transparency, or photograph is put into a scanner which optically looks at a very small area of the photograph and determines its lightness. For example, numbers are assigned to the lightness, and these are fed into the memory of a computer. A photograph is thus broken down into pixels, which can be stored and manipulated. Under microscopic examination, the displacement of pixels is often evident.

COMPARISON OF GROUND TRUTH
WITH AERIAL OR SPATIAL PHOTOGRAPHY

If topography is required as important evidence in examining photos, aerial or spatial photography can be used to show whether a relationship exists with a ground photo. Financial profit obtained by a fake photograph is a powerful incentive for many during major news events.

The great concern about the Chernobyl nuclear disaster in Russia prompted TV networks to scramble among themselves to place informa-

tion about the disaster on the screen. An enterprising foreigner sold a video to several American TV networks that purported to show smoke rising from the affected Chernobyl reactor. Looking at the film, one could tell immediately that it wasn't Chernobyl. There was a mountain range in the background; Chernobyl lies along a river plain. The film showed a fairly large city; Chernobyl is a small town. The housing pictured was distinctly European, not Russian. I immediately called Ted Koppel's office, with which I had worked on early 20/20 presentations and on *Nightline* programs involving reconnaissance. I informed his office that the film was a hoax, explaining that any competent analyst comparing the film with commercial satellite imagery would have discovered the hoax. After being informed by Italian sources that the film was actually of Trieste, the TV networks acknowledged the error with some chagrin. Meanwhile the hoaxer had received a fairly substantial sum from the networks.[39]

DENSITY

The precise measurement of the amount of light reflected from or absorbed by a particular area of a photo is characterized as the density of a photo or negative. In the case of a negative, it is the amount of light

COMPARISON OF EVENTS WITH
AERIAL OR SATELLITE PHOTOS
The TV media reported that two reactors
had melted down at Chernobyl. They also
showed purported film of a reactor on
fire. The satellite photo here clearly
shows that only one reactor had melted
down. The TV film was fake. *Space
Imaging EOSAT, Thornton, Colorado.*

transmitted through an area of the negative. Density depends on the
amount of silver deposited in a particular area of the photo during the
development process, which determines the depth of tones in the photo.
In the nineteenth century, density was inexactly measured by the eye.
Today, there are a variety of optical, electronic, and/or digital devices
that can be used in comparison of photos suspected of being faked. One
of the principal weapons in the arsenal of photo fakery detection is digi-
tal image procession, which is a computer-assisted evaluation. In order
to use this technique, a conventional picture has to be transformed from
a continuous tone format into a digital format. Essentially, this means
transposing the gray tones in the pictures into numbers on a magnetic
tape or a floppy disk. This digitized information, in turn, can be input
into a computer for analysis.

There are a number of methods for evaluating conventional photog-
raphy. A preferred method is to use an instrument called a microdensi-
tomer. This instrument will record the varying light intensities in the im-
age and output the digital image into a tape or disc. The tape or disc will
contain the image in numerical form with 0 representing black, 255 rep-
resenting white, and various middle-level grays represented by numbers
in between. These "tracings" can detect minute variations, far more than

the normal eye, which can discriminate a minimum of about 32 shades of gray to a maximum of about 64. If time is of the essence or the image is in print form rather than a transparency, a digital videoscanner system can be used to digitize the image. This system is capable of digitizing the image in a matter of minutes, rather than the hours it takes with a microdensitometer. The image quality, however, will be diminished. As with the microdensitometer, the digitized image is then fed into a computer.

If the image is an analog image such as a TV image, then still another system, called the video quantization system, is employed. This system converts the video signal from a videotape recorder to digital form, which is then fed into a computer. The computerized data can then be played back into a viewing device.

Detailed analysis of the numerical data could show if the photo has been tampered with. The computer will define edges and look for discrepancy lines or pixel anomalies. If one photo has been imposed on another, the computer is a far superior system for spotting spurious lines or pixel anomalies.

FLORA AND FAUNA

One of the critical ways to determine whether a photo was taken in a particular area is to carefully analyze the flora and fauna that appear in the photo. To capture dramatic wildlife scenes on film requires a lot of patience, because it is a long and painstaking process. To have the camera positioned in the proper place and in proper focus where and when the split-second action occurs requires a detailed knowledge of animal habitats and of the peculiar and particular habits of the specific animal when it springs into action. With the advent of television, a number of films of wild animals shown on television were actually staged on movie locations. There were many complaints by experts regarding the authenticity of these films, with a plea that staged scenes should be identified as such for viewers. Experts had little trouble distinguishing the real from the staged scenes. For example, it was relatively easy for experts to identify films made in California because the flora and fauna particular to California could be seen in the background. Equally easy was the identification of the California terrain, especially in areas where the major studios are located.

There is always a demand for photo stories of rare and exotic animals, particularly of these animals in their natural habitat. The panda has always had a special appeal. The August 1981 issue of *Geo*, a reputable geographical magazine, had as its cover story what were alleged to be the first photos of pandas roaming their natural habitat in "the wilds of China's Sichuan Province." The photographer alleged that these panda photographs were taken in the animal's "natural setting."

The *Geo* article described the work of Dr. George Schaller, a zoologist who was at the Wolong Nature Preserve in Wuyipeng, Sichuan Province, filming pandas in their natural habitat for *National Geographic*. The "exclusive pictures" of pandas in the wild were no sooner published in *Geo* than their authenticity was challenged by Schaller. The photographer was immediately questioned by *Geo* publisher Peter Diqamandis. He eventually admitted that the pictures were made in a large fenced enclosure, and was fired.[40]

USE OF MODELS IN PHOTO FAKERY

In the 1930s, there was a renewed fascination with the air battles of World War I. Movies of the period, such as *Dawn Patrol*, heightened this interest. Although the number of air battles fought were many, there were few good authentic photos depicting the action. A book entitled *Death in the Air: The War Diary and Photographs of a Flying Corps Pilot* was published in 1932.[41] Mrs. Gladys Cockburn-Lange, supposedly the widow of a British World War I pilot, had presented the publisher with a manuscript and accompanying combat photos she said were taken by a pilot during the war who had been killed in combat. There were over fifty aerial combat photos bearing such dramatic captions such as "Just as he left the burning plane," "Jock—snapped a Hun as it was trying to shoot a burst at him," "Beautiful example of correct place to arrange your Hun before shooting him," and "A good picture."

Although hailed by *The Illustrated London News* as "the most extraordinary photographs ever taken of air flights in the war," experts were suspicious. One of the first things that made the book suspect to aviation buffs was that no author was identified and no link between the pilot and the author could be established. There were no service unit designations, no squadrons, no last names of individuals, and no place names. Although the book is written in diary fashion, no specific dates were given, only the days of the week. No data were given on the camera, only that it had been taken from a downed German plane and used by the British pilot. Mrs. Cockburn-Lange refused to identify the photographer or anyone who could authenticate the photos or the manuscript.

In the early 1950s, historians from the U.S. Air Force Museum brought copies of the photos to Arthur C. Lundahl for inspection. Consulting his library of German World War I cameras and films, he found a number of inconsistencies in the photos. For one thing, he expressed some doubt that a camera mounted on World War I aircraft could produce such sharp pictures. Airplanes, especially at the time, are vibrating, bouncing platforms—not exactly ideal for taking such photos. To dampen camera vibrations, a variety of makeshift suspension systems were devised, some using sections of inner tubes, sponges, and even ten-

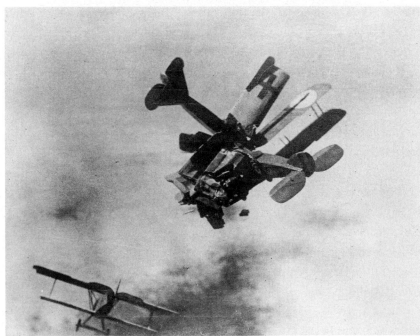

USE OF MODELS
The famous Cockburn-Lange photos of supposed dogfights during World War I were hailed as "the most extraordinary ever taken of air flights in the war." They turned out to have been taken of models.
U.S. Air Force Museum.

nis balls. The film speed in those days was extremely slow and could not have captured action traversing the track of the camera without some blurring.

Nor did the World War I cameras have the depth of field needed to capture action over miles of sky. In one photograph, there is a dogfight scene in which fourteen aircraft are shown in various flight attitudes—all in perfect focus. Also, all of the photos were taken against clear or solidly overcast skies, and thus did not provide photogrammetrists any reference points for measurements. Although the planes appear proportionate and the shadows properly aligned, Lundahl was suspicious that the source of light was not the sun. Lundahl further reasoned that if a pilot had been in the heat of such action for some time and produced such a cache of photography, it would undoubtedly have been known to others in his unit and certainly to the Royal Air Force. Lundahl concluded, "Although there is a certain cleverness about the photos and there is no doubt that the person who perpetrated these fakes knew something about the aircraft and also about photography, I believe that this was done in a studio and that the aircraft are models."

The U.S. Air Force, the Royal Air Force, and the Imperial War Museum demurred at displaying the photos until their authenticity was proven. Mrs. Cockburn-Lange was pressed to give additional details to vouch for their authenticity, but she remained evasive. In 1979, experts in the Time-Life Laboratory studied the photos and deemed all of them fakes.[42]

The fact that models were used in the photos was not proven until 1984, when the memorabilia of Wesley Archer and his wife were presented to the Smithsonian Air and Space Museum. Experts reviewing the records revealed that Gladys Maud Cockburn-Lange was actually Archer's wife, Betty. To bring the episode to a close, their memorabilia also included photos of Archer working on aircraft models scaled to blueprints in a specially equipped photo studio.[43]

Another area of great photographic interest has been the "monster" of Loch Ness, a 750-foot-deep lake in northern Scotland. The earliest known description of a monster in the lake was by Saint Columba, the industrious Irishman who converted Scotland to Christianity and was said to have encountered it in A.D. 565. Although descriptions have varied over the years, the gray creature supposedly had flippers, one or two humps, and a long, slender neck, and was from twenty to fifty feet in length. The monster supposedly swims at high speeds and seems leery of boats and noises.

A new highway under construction on the lake's northern shore in 1933, which was being built to make the lake more accessible to tourists,

led to a rash of reports of sightings of the monster, nicknamed "Nessie." In July 1933, a businessman and his wife reported that an elephant-colored creature with a long neck and a body crossed the road in front of their car and disappeared into the Loch. Although many of the sightings were by people of unquestioned probity, there was much skepticism about the sightings. There have also been a number of hoaxes. Shortly after the announcement of the elephant-colored creature, there were reports that the monster's tracks had been found along the lake's shore. These turned out to have been made by someone who used an umbrella stand made from the hind leg of a hippopotamus. There is a wide disparity between eye-witness sightings and a number of photos obtained over the years. The monster has been the subject of many articles and several books.[44]

The most famous photograph of the monster supposedly was taken on April 1, 1934, by Lieutenant Colonel Robert Kenneth Wilson, a London gynecologist. The All Fools Day date given for the photo had not gone unnoticed by serious researchers. It supposedly showed the monster just before it dived out of sight. This photograph probably has been more closely analyzed than any photo ever taken with arguments advanced pro and con about its authenticity.

Several other photos of the monster surfaced after Wilson's. In July 1955, P. A. MacNab, a London bank manager, photographed a partially submerged "monster" with two humps in Loch Ness. In 1960, Tim Dinsdale, a British engineer, made a short film of a dark shape moving through the lake. The film was shown on television and attracted widespread attention. Experts at the United Kingdom Joint Air Reconnaissance Intelligence Center concluded that the film showed "probably an

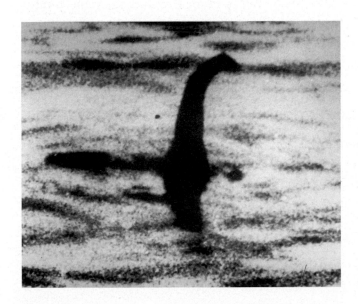

USE OF MODELS
The famous 1934 photo of a "monster" in Loch Ness became one of the most closely analyzed and debated photos in history. The debate ended when one of the seven men involved in the hoax declared on his deathbed in 1994 that the monster was actually a fourteen-inch toy submarine fitted with a serpent head. *AP/World Wide Photos.*

animate object."[45] In 1972, a photograph of a fin in the lake was taken by Doctor Robert H. Rines, a Boston attorney. In 1977, Sir Peter Scott, one of Britain's leading naturalists, used all of these photos and information from sightings to paint *Courtship in Loch Ness* which showed a horned, bulbous reptile resembling plesiosaurs believed extinct for sixty-five million years. Highly organized teams employing the most sophisticated tools of modern science, including hydrophones, submarines, and a gyrocopter, have been used to try to authenticate the monster. Divers and undersea cameras have failed to produce any new acceptable evidence of Nessie's existence, although sightings continue to be reported.[46]

There have been many explanations advanced for Wilson's 1934 photo, from its being a plesiosaur to a beaver, an otter, a seal, a deer, or a lovesick sturgeon.[47] Because of the limited food supply available to any animal, estimates have been made of the largest possible weight that Nessie could attain. Still others maintain that the monster was just a piece of driftwood or a mirage.

A conclusive photo of the Loch Ness monster has yet to be obtained. Experts who have analyzed the many existing photos have questioned their reliability. There is little analytic evidence in them to relate to—no shoreline, foliage, or objects. Analysis of the waves on the photos indicates that they are more typical of something having been thrown into the water than of something being thrust up from below.

Wilson himself was very evasive concerning the photo and his youngest son ultimately stated that his father's picture was fraudulent.[48] In 1994, London's *Sunday Telegraph* conducted in-depth research on the famous Wilson photo. It reported that Christian Spurling, the last of seven men involved in the ruse, confessed the fakery before dying at the age of ninety in November 1993. He claimed that the photo had been fabricated by Marmaduke "Duke" Wetherell, a filmmaker and big game hunter hired by the *Daily Mail* to find the monster. Spurling, Wetherell's stepson, stated the monster had actually been a fourteen-inch toy submarine fitted with a sea-serpent head made of plastic wood.[49] His story proved once again that even professional scientists can be fooled by chicanery.[50]

INCONSISTENT INFORMATION (FAKER'S GOOF)

In looking for indications of photographic fraud, Arthur C. Lundahl would always stress looking for any kind of inconsistency that would suggest an insertion or deletion. "Details, details, details," he would emphasize when inspecting a possible faked photo—always looking for details the perpetrator may have overlooked. If an image was removed, did it leave a shadow? Is the shadow consistent with the time of day it was supposedly taken? And so on.

There are times when the photo faker makes a mistake and fails in his

creation of the fake—for example, by leaving small bits of vital information that should have been removed. When individuals are removed from photos, sometimes parts of their bodies remain. In published East Bloc photos, the feet of individuals removed from the photos often remain.

The "Bomber Gap," for instance, became a national issue in the late 1950s, with the Democrats claiming that the Soviets were far ahead of the United States in bomber production. While we had U-2 photos of many of the Soviet aircraft plants, we needed information as to what was happening inside the plants. All photos in Soviet aviation publications were carefully screened for photos of the interiors of plants.

When the Soviets began producing a new bomber, they would often produce a commercial aircraft version of it. Such was the case with the Tu-20 (later Tu-95) Bear long-range bomber. The commercial version was labeled the Tu-114 (Cleat) and was used extensively in the travels of Soviet foreign leaders abroad. A Soviet photo of the interior of the aircraft plant producing the Cleat was published. Although the photo is meant to show one Cleat airliner under construction, analysis of the photo shows the tails of two other Cleat airliners, giving an idea not only of construction methods but also of the numbers of Cleats rather than Bears being produced at a given time. Detailed analysis of the photo also showed that equipment on the forward end of the building had been masked out.

SUPERIMPOSITION

If two or more pictures of the same person or scene are being considered, there is generally information implicit in the differences that would not be considered when viewing a single photo. Methods for de-

FAKER'S GOOF
While attempting to conceal the capabilities of this Soviet factory, the retoucher of this photo failed to remove the tails from two other aircraft on the assembly line. *Central Intelligence Agency.*

SUPERIMPOSITION

Superimposition of two or more photos can confirm if the individual or scene is the same. These photos of the author were taken twelve years apart. Note how closely they register. The major difference is in the author's neck, which had gone from a size 16½ to a size 17.

Author's collection.

termining if a photo is valid can include the "transparency," "image comparison," "change detection," and "superimposition." Attempting to ascertain differences by direct visual inspection with the images placed side by side is very unscientific and tedious, and usually only gross differences can be readily identified. By comparing markings directly, the unaided eye cannot discern subtle differences in gray scales (tones) or accurately determine the sharpness of the lines. Then, too, there are often different lighting conditions and variations in photo processing or printing that must be considered. But through a variety of methods, information that was invisible when viewing separate photos can be uncovered when using image comparison or change-detection methods.

One of the easiest methods for determining photo fakery is through the use of transparencies. If there are two photos at the same scale, duplicate positives of each can be made in the photographic laboratory. On a lighted table the two images can be compared by overlaying them. If there are differences, they can be studied under magnification. Often, to make comparative processes more apparent, one of the transparencies can be printed in a different color. If there are sharp edges in the print, the comparative process is relatively easy. In the world of photo interpretation, this is often done and is called change-detection. If the edges of images are not readily discernible (soft), the comparison process, of course, becomes increasingly difficult. When examining facial features, the outside and inside edges of the hair, eyebrows, ears, nose, nostrils, chin, and lips are carefully compared.

To superimpose the head of one individual onto another to determine whether they are the same individual requires a considerable and sophisticated effort. In the past, matting was the principal method. Matting in-

volved the use of masks and a pin-register system so that the new face could be precisely superimposed. This was done by cutting out a mask about the face to be imposed and then to eliminate as much as possible the background of the area in which the face was superimposed.

Digitized imagery allows the flipping, scaling, and juxtaposing of photos. Facial photos that are looking in different directions can be flipped and then scaled, usually by giving them the same distance between the centers of the pupils or between individual teeth if they are showing. There is a big danger in using this method in that, in an attempt to prove a point, photos may be forced, thereby emphasizing similarities and minimizing dissimilarities.

About the same time that the previously discussed photo of the three supposed downed flyers in Vietnam was released, a grainy colored photo of a smiling middle-aged man supposedly taken in Laos in 1990 surfaced. Jack Bailey, a retired Air Force colonel and POW activist, said he obtained the photo from "close Laotian government officials" in Laos in 1990. The photo, purporting to show a missing POW in a Laotian prison camp, bore a striking resemblance to Special Forces Army Captain Donald G. Carr, missing in action since disappearing inside Laos in 1971. Family members positively identified the man as Captain Carr.

In October 1991, Secretary of Defense Cheney met with Bailey at the request of several members of Congress. According to Cheney: "During the meeting, Bailey promised to give our investigators access to his subsources and introduce us to the individual who took the photo."[51] Cheney dispatched a Department of Defense team to accompany Bailey to Southeast Asia. According to Cheney, "Bailey was unable to provide the access or information he had promised. After the team arrived in Bangkok, he also disclosed that the photograph—instead of having been taken in Laos as he previously indicated—may actually have been taken in Burma or Thailand. In fact, our investigators have identified the place where the photo was taken—in Thailand, just outside Bangkok."[52]

Michael Charney, a forensic anthropologist, used the superimposition method to compare the Laos photo with a wedding photo taken of Carr in 1961. He concluded that the Laos photo was Carr. It should be noted that the wedding picture of Captain Carr he used had been heavily air-brushed and acne scars on the lower right of the left cheek had been removed.[53] The Los Alamos National Laboratory, using superimposition, also concluded that: "In our view, a strong possibility exists that the subject is an aged Captain Carr. However, this assessment is not conclusive."[54]

This, despite the fact that physical differences between Captain Carr and the photo subject were apparent. The spacing and shape of the eyebrows were markedly different; no hair was observed on the chest of the

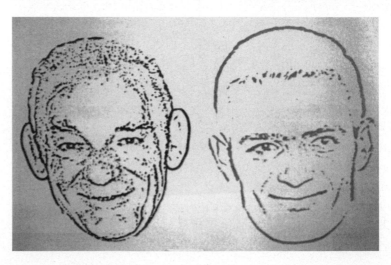

Top left: A photo purporting to be of a missing POW in a Laotian prison camp was brought to light by Jack Bailey, a retired Air Force colonel and a POW/MIA activist. It was supposedly of Special Forces Captain Donald G. Carr. *Department of Defense.*

Top right: Captain Carr had been missing in action since disappearing in Laos in 1971. This is his wedding photo, taken in 1961. *Department of Defense.*

SUPERIMPOSITION
Middle left: Several experts claimed that the individual in the prison camp photo was missing Army Captain Donald G. Carr. The author had the two photos superimposed, and they revealed a number of anomalies. While the brows and eyes show similarities, neither the ears nor the inner ear configurations match. The prison camp individual has a dimple and Carr does not. The lips do not match and neither do the eyebrows and cheeks. In addition, it was known that Carr had a hairy chest and acne scars while the prison camp individual does not. It was later found that the prison camp individual was Gunther Dittrich, a German national serving a sentence in Germany for importing exotic Asian birds. *Department of Defense.*

Middle right: A second photo of Captain Carr was also analyzed which also revealed additional dissimilarities. *Department of Defense.*

SKETCHES
Right: Sketches made from the two photos highlighted glaring differences in the ears, nose, brow, and chin. *Department of Defense.*

subject; there are differences in eyefolds; the acne and facial scars on Carr's face were not visible; and there were vagaries in the color of the hair of the photo subject.

The quest continued until the man in the photo was identified as a German national named Gunther Dittrich. Department of Defense investigators interviewed Dittrich in a German prison, where he was serving a sentence for illegally importing exotic Asian birds and confirmed he was the man in the photo.[55] He had been photographed in Thailand catching birds.

DATES OF THE PHOTOGRAPHS

Probably one of the most common misuses of photographs is to illustrate an article without revealing that the photo has nothing to do with the story being conveyed. One of the first actions in looking at a possible fake photo is to try to determine when the photo was taken or published. Shortly after the Cuban Missile Crisis of October 1962, Senator Kenneth Keating of New York charged that Soviet missiles and launching equipment were stored in caves and tunnels in Cuba. Other reports of the Soviets continuing to hide missiles in Cuba deeply disturbed President Kennedy. Charges persisted in the press and media that the Soviet missiles remained in Cuba, even though the CIA had photographed and counted the forty-two MRBM missiles the Soviets admitted sending to Cuba as they left the island.

The CIA had a file on every sizable cave in Cuba, and each cave was checked out against aerial photography for activity outside the caves; there was no evidence that missiles had been stored. A published photo of Castro supposedly inspecting missiles in a cave caused additional con-

cern. Detailed research, however, revealed that the photo had been taken shortly after Castro came into power and had been previously published in tourist brochures promoting caves in Cuba for speleologists and tourists.

After the Cuban Missile Crisis, the Cubans extolled the virtues of communism over capitalism in a published article juxtaposing a photo of a celebration in Moscow with one of an armed soldier marching in front of the White House. The pictures were to show that while there was always harmony in the Soviet Union, the reverse was true in Washington. The soldier is wearing a World War I–type helmet and the truth is that the last time there were armed military guards with World War I helmets around the White House was during the early days of World War II.

Major personalities can also be fooled, as was Secretary of State Alexander M. Haig, Jr., in 1982. A photograph published in early February in the *Figaro* magazine, a weekend supplement to the French daily *Le Figaro*, bore the caption "The massacre of fiercely anti-Castro Miskito Indians last December." On February 19, 1982, Haig showed leaders of the AFL-CIO in Bar Harbor, Florida, the *Figaro* photos. He claimed that the photos "showed the most atrocious genocide actions that are being taken by the Nicaraguan government against their Indian populations." Much to Haig's embarrassment, the photograph shown to him had been taken four years earlier during fighting against U.S.-supported Nicaraguan dictator Anastasio Somoza, and actually depicted bodies being burned by Red Cross workers as a hygienic measure.[56]

COMPARISON OF IMAGES

When a problem arises about the veracity of one photo, the answer can often be found by searching for other photos of the same subject or

DATE OF PHOTOGRAPH
In a Cuban publication extolling the virtues of Communism, a photo showed the harmony in Moscow; the caption of another stated the reverse was true in Washington. However, the soldier in the photo is wearing a World War I–style helmet. The picture was probably taken during the early days of World War II, when soldiers did patrol the White House wearing such helmets.
Central Intelligence Agency.

event. Such was the case during the O. J. Simpson civil trial. A photo taken by photographer Harry Scull of Simpson at a Buffalo Bills football game against the Miami Dolphins in September 1993 showed Simpson wearing Bruno Magli shoes, the same high-price shoes that FBI experts claimed tracked bloody size 12 footprints away from the bodies of Nicole Brown Simpson and Ronald L. Goldman. Simpson had sworn that he had never purchased and would never have worn such "ugly" shoes. The defense called upon Robert Groden, an amateur photo analyst, who claimed that there was "a high likelihood of forgery." He claimed that someone had doctored the negative to show Simpson's lower legs and the Bruno Magli shoes. Simpson had also insisted that the picture was a fake.

Everything suddenly changed several weeks later when a second batch of photos arrived. Photographer E. J. Flammer had taken thirty photos of Simpson at the same game, and Simpson was wearing the same shoes and clothing. Caught off guard by the evidence, defense lawyer Dan Leonard objected to showing the pictures to the jury. Even with this overwhelming evidence, however, Groden stuck to his opinion of the original photo, although he did say that if the new pictures were authenticated and the shoes were proven to be Bruno Maglis he would probably reconsider his conclusion.

Both the CIA and Department of Defense used this technique extensively during the Cold War. Soviet photos of their new aircraft were closely studied in the United States to determine if a plane was in series production. Of particular interest was Soviet production of seaplanes. The United States had given up production of seaplanes shortly after World War II. The Soviets produced the Beriev M-2 maritime reconnaissance plane, known in NATO circles as the Mail. A single Mail was displayed publicly for the first time in the 1961 Soviet aviation day flypast at Tushino Airport near Moscow. It was later flown over Leningrad. The first photo received from Soviet sources showed ten Mails flying over a guided-missile patrol squadron. The second photo showed only four. Close analysis of the photo with ten Mails clearly shows that a number of the Mails were mirror images.

POSED OR PREPOSED PHOTOS

Manipulation of a scene by posing people, re-enacting scenes, or rearranging objects to obtain desired effects has often been done by news photographers. The question then becomes one of accuracy.

Photos of those in power have shaped our views since the invention of the camera. In the past century, there has been a subtle and complex agreement between the press and those in power not to show those in power in an unfavorable light. For example, the press went out of its way not to show President Franklin Roosevelt in a wheelchair. He was always

CHECKING OTHER PHOTOS OF THE SAME EVENT
Four Soviet "Mail" seaplanes were photographed over Leningrad. In another photo of the same event, ten Mails are seen. Analysis revealed that at least six were mirror images. *Department of Defense.*

carefully posed when standing, and photographers always waited until he was fully erect. According to Henry Allen, "political photography has been an ongoing war of poses."[57] We remember people in power through a photo which, in many cases, was carefully posed or staged. In the early days of photography, settings were often choreographed—books, globes, maps, or new inventions on tables in the background suggested knowledge and enlightenment. Fiorello La Guardia made it a fetish to be seen in a variety of poses—reading comics on the radio, dressed in fire-fighting gear, holding a baby at a ribbon cutting, and so on. Theodore Roosevelt posed in a steam shovel during the digging of the Panama Canal. Photos have also shown those in power appearing in a less serious mode—President Calvin Coolidge was posed in an Indian headdress and in a cowboy hat.

Hoaxmaster P. T. Barnum never missed a chance for publicity and used photography widely for promotional purposes. A star of his show was the midget Tom Thumb. In a widely circulated photo, Tom was shown with his wife Lavinia and what was said to be their one-year-old baby girl, who weighed seven pounds. The couple, however, never had any children. The infant was borrowed for the photo.

Often, a visually significant photo captures an event that epitomizes the history of a period. The photo not only captures the event but also the feelings of a nation. The flag-raising on Iwo Jima was such an event. It has been praised as the greatest combat photograph of World War II. It was the most reproduced photo of the war, served as a symbol for a War Loan Drive, was used on a postage stamp, and served as a model for the Marine Corps war memorials in Washington and Quantico, Virginia.

Some have indicated that the photo was too perfect and hid the fact that this was not the first flag-raising at Iwo Jima. Photographer Joe Rosenthal was accused by the late Time-Life correspondent Robert Sherrod of having staged the photo. Some time later, Sherrod would admit he was wrong, but the rumor persisted.

Sergeant Louis Lowry, a photographer for *Leatherneck* magazine, took several photos of the marines raising the first flag on Mt. Suribachi's peak, and told Joe Rosenthal of it when he was coming down from the peak. When Rosenthal reached the peak, he found the marines taking down the smaller first flag and preparing a larger flag to take its place. When the second flag was raised, Rosenthal took the most memorable photo of World War II. Marine commanders had decided to replace the small flag with a larger one; Rosenthal was merely fortunate to have been there when it was raised.[58]

The most famous photo taken during the Spanish Civil War was Robert Capa's 1936 image "Fallen Soldier" or "Death in the Making." A Spanish soldier has been shot in the head and is shown falling back from

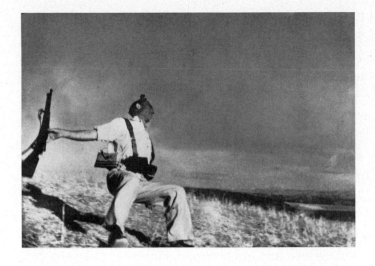

This famous Spanish Civil War photo taken by Robert Capa has been questioned by several skeptics as being a posed photo. Recent research, however, reveals the falling soldier to be Federico Borrell Garcia, killed on September 5, 1936, the day Capa was photographing the battle. *Copyright Robert Capa, Magnum Photos.*

the impact and dropping his rifle. It was first published in the September 23, 1936, issue of *Vu* and later in *Life* in 1937, with the caption "Robert Capa's camera catches a Spanish soldier the instant he is dropped by a bullet through the head." When the photo was published in *Vu*, it was accompanied by another photo of a soldier in a further state of collapse on the ground but apparently not shot in the head.

Skeptics contended that the two photos were taken in sequence and that the falling soldier had simply slipped. This view that "Death in the Making" was a misrepresentation was given further impetus by Phillip Knightley in his book *The First Casualty*. There were also allegations that Capa was not present when the photo was taken. Other critics later contended that the fallen soldier appeared alive in a later frame on the same roll of film.[59]

Close examination of the two photos published in *Vu* reveals a number of anomalies. The falling soldier wears a light shirt open at the collar and light civilian-type trousers, which supports the fact that he was from a militia unit. The individual in the second photo wears a dark military uniform. There are differences in the cartridge belts the two are wearing. The falling soldier appears to be taller.

New developments lend credence to the argument that the Capa photo was indeed a true one. There had been no attempt to identify the falling soldier, because his facial features were not clear and were in shadow. Mario Brotóns, a soldier who had fought in the battle, began a painstaking search through local records and in the military archives in Madrid and Salamanca. He found that, while many had been wounded in the battle on the Cerro Muriano near Córdoba, only one death during the fighting had been recorded. The falling soldier was identified as Federico Borrell, a twenty-four-year-old mill worker. Brotóns found that

records listed Borrell as being killed on September 5, 1936. He also met with Everisto, Federico's younger brother, who had fought in the battle, too. When he returned after the battle, he told his wife to be that his brother had died instantly on that day. He also said that some of his friends saw Federico fling up his arms and immediately crumble to the ground after being shot in the head. Analysis of the sequence of Capa's photos proved that he was at Cerro Muriano on September 5, 1936.

One of the most renowned photos of Albert Schweitzer is a montage. According to Jim Hughes, biographer of W. Eugene Smith, who created the photo, Smith was faced with an inferior negative that had a fogged lower-right-hand corner. To solve the problem, and to add to the symbolism of the image, Smith processed elements of another negative onto the original photo negative to create a photomontage. It was published by *Life* as if it were a single image.[60]

News photos are often affected by improper lighting, angles, and composition. A photo that captured the hearts of America in 1925 was Harry Warnecke's "Mother Cat Stops Traffic." Warnecke, a photographer for the *New York News*, liked animals, and when told that a mother cat with kittens was carrying them back to her home nearby, he hurried to the scene. The cat, with a kitten in her mouth, was trying to cross the street. A policeman, seeing her predicament, stopped cars to allow the cat to pass. Warnecke, not pleased with his first effort to capture the event, appealed to the policeman and pedestrians to restage it. He set up

POSED PHOTOS
A number of famous photos were posed. A photo that captured the hearts of Americans was Harry Warnecke's "Mother Cat Stops Traffic." Warnecke asked for and got cooperation from the police officer and the pedestrians for this photo. *Elsie M. Warnecke.*

the photo again. He asked the policeman to stop a car closer to the inter-section as the mother cat crossed and got the pedestrians to cluster closer to the cat. A classic photo was made.[61]

Photographers, often sensing what would make a good photo, will at-tempt to stage it. Such was the case of the famous "Dewey Defeats Tru-man" photo. Having just defeated Tom Dewey in the 1948 presidential election, Harry S. Truman was asked by photographers to hold up an early election edition of the *Chicago Tribune*, whose headlines blazoned "Dewey Defeats Truman." Among the photographers were Acme's Frank Cancellare, Al Muto of International News Photos, and Byron Rollins of the Associated Press. All three photographers made almost identical photos that have become classics in the political arena.

John Pierpont Morgan, the international banker, had an intense dis-like for news photographers. In 1933, he was called to Washington to testify before the Senate Committee on Banking and Currency. A hear-ing was to take place in a large Senate caucus room. A Ringling Brothers Circus representative came in with two midgets and introduced them to several members attending the hearing. It is not known who performed the feat, but in a fraction of a second one of the midgets was lifted onto the staid Morgan's lap. The photo taken made the front pages of a num-ber of major newspapers. It was sweet revenge for photographers on a man who detested publicity.

The authenticity of some of the most famous press photos has been questioned. The 1973 Pulitzer Prize photo of a screaming, naked Viet-namese girl running in terror from a napalm attack during the Vietnam War was questioned by General William C. Westmoreland. He said an official investigation determined that the girl had been burned in an ac-cident with a hibachi, an open cooking grill commonly used in the area. Westmoreland steadfastly maintained that had she been hit by napalm she would not have survived.[62] Huynh Cong Utt of the Associated Press, who took the picture, has steadfastly maintained that it resulted from a napalm attack. The little girl, now grown and living in the United States, confirmed she was hit by napalm.

In viewing Soviet battle films, I was always impressed that scenes of some battles often appeared in films of others. It was also very apparent that some of the battle scenes were reenactments. One giveaway to re-enactments is the clarity and focus of the scene; the other is that shells supposedly bursting close to individuals do not wound or kill them. Cin-ematographers and photographers usually take their time and set up well-directed scenes from desirable angles. Many scenes from Russian battle films were later reproduced in books as real photos, with no indi-

cation that they had been taken from a film. There have also been a number of famous reenactments, such as the battle of Dien Bien Phu and the Communist Red Chinese Long March.

More recently, *Time* magazine, in the June 21, 1993, cover story[63] published photos and a story of two alleged boy prostitutes and their adult pimp in Moscow. Although warned by American photographers in Moscow that the photos had probably been concocted by Russian photographer Alexey Ostrovskiy, *Time* went ahead and published them. The photos depict the pimp giving the boys a home and selling them on the street. This story set off efforts by other news agencies to verify the photos. One of the boys was found, and he and his family told Western journalists in videotaped interviews that he was neither homeless nor a prostitute.[64] *Time* would later apologize for running the pictures and acknowledged they had been staged.[65]

ILLUSION

Visual deception tricks the mind as well as the eye. The eye can be deceived, as magicians are well aware, and a number of photo fakery innovations have been introduced to do so.

There are times when altering reality is a means of getting attention.

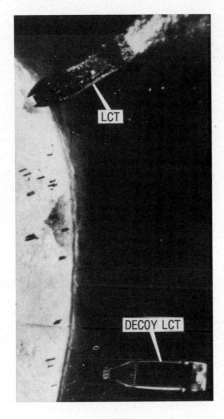

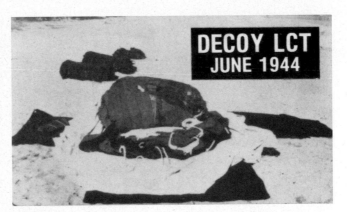

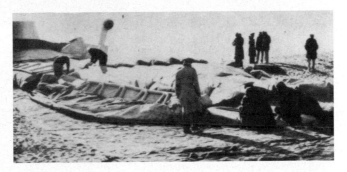

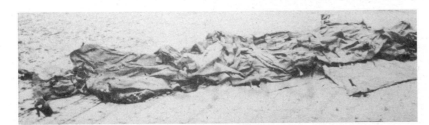

DECOYS

In preparation for the Normandy invasion during World War II, Landing Craft Tank decoys were placed among the real ones.
Department of Defense.

DECOYS

During World War II, inflatable tank, truck, and artillery decoys were deployed to fool the enemy. Photos at left show a decoy tank before and after inflation.
Department of Defense.

CAMOUFLAGE
Because of the fear of a Japanese
air attack on the west coast, the
Lockheed aircraft plant in Burbank,
California, was camouflaged to appear to
be a continuation of an adjacent housing
development. A photo interpreter would
have noted the airplane near one of
the "houses" at the lower left.
Lockheed Aircraft Corporation.

MODERN DECOYS
Top left: The sophistication of modern
technology makes it extremely difficult to
identify decoys. On the left is an M1
Abrams main battle tank, and on the
right is a decoy. *U.S. Army.*

Bottom left: A variety of HMMWV
decoys, including both rigid-frame and
inflatable designs, are shown. A real
HMMWV is on the right. *U.S. Army.*

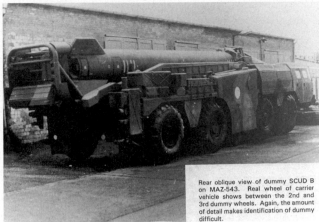

Rear oblique view of dummy SCUD B on MAZ-543. Real wheel of carrier vehicle shows between the 2nd and 3rd dummy wheels. Again, the amount of detail makes identification of dummy difficult.

Highway workers, for example, are at risk from speeding motorists while doing maintenance on heavily traveled roads. Placing actual patrol cars or law enforcement personnel at such sites to reduce the threat is costly and a drain on law-enforcement resources. One answer is to replicate the appearance of a police car with a high-resolution computer-generated photograph mounted on a panel. This decoy, which comes in a kit, can easily be set up where maintenance work is being performed. Tests show that it is effective in slowing down traffic.[66]

Nowhere is the art of illusion a more widespread and effective practice than in the military. The advent of modern reconnaissance systems has made it necessary to construct new concealment and simulation facilities. The history of scientific and technological camouflage, concealment, and deception efforts is a relatively short one, but has come to connote activities intended to blend, disguise, cover, screen, hide, confuse, trick, deceive, mislead, or falsify. The whole idea of camouflage, concealment, and deception activity is to surprise an enemy and reduce losses in manpower and materiel.

The introduction in World War I of the airplane and highly mobile wheel-and-tracked vehicles accelerated the need for camouflage, concealment, and deception efforts, especially when preparing for attack. But decoys of military equipment first achieved widespread use during World War II when a variety of them were deployed to simulate individual soldiers, tanks, aircraft, and even ships.

Since the war, a new dimension has been added to camouflage, concealment, and deception practices—making the decoys so real that they will momentarily baffle aircrews or will also fool the photo interpreters who have more time to view aerial photos. The construction of decoys has proceeded in such a fashion that even expert imagery interpreters

MODERN DECOYS
Above left: These British-manufactured ZSU-23 and T-72 main battle tank decoys could easily fool pilots flying fast aircraft. Photo interpreters, however, would quickly note that they had left no tracks. *Airborne Industries Limited.*

Above right: This Soviet dummy of a mobile Scud missile launcher is highly detailed and would be extremely difficult to detect by either pilots or photo interpreters. *U.S. Army.*

cannot distinguish the real from the fake. The effects are so outstanding and realistic that air crews have attempted to land on fake airfields.

Science and technology, along with experience in the use of decoys, has advanced to such a point that the United States has developed a series of credible decoys simulating tanks and other combat vehicles. Pneumatic decoys have also been made of the F-15, F-16, and A-10 aircraft. Photo interpreters always look for creases in improperly inflated decoys so generators have been added to keep the decoys fully inflated. The U.S. Air Force has deployed decoys on decoy airfields.

Successful camouflage, concealment, and deception activity boils down to quality equipment and discipline. If the decoys are inadequate or if attention to maintaining the ruse is lax, imagery interpreters will discover the deception, often with tragic results.

But not always. Lundahl always loved to tell the story that the British

MODERN DECOYS
Top: On the left is an F-15 decoy, and on the right an operational F-15. *U.S. Air Force.*

Bottom: A decoy hardstand contains F-15 and F-16 decoys along with a decoy fuel truck. *U.S. Air Force.*

discovered a German decoy airfield in North Africa during World War II. They subsequently sent a lone bomber over the field, which dropped a wooden bomb.

FILM CREATION DATE

Each company that produces film has methods by which it codes each batch of film produced. The code is incorporated into the edgeprint legend of almost all films, and the code can be deciphered by the producing company. The code designates the year and batch number of the film. Eastman Kodak Company used a circle, triangle, square, and cross system to designate the year of their film manufacture. Eastman also had a dot system that designated the plant of origin. The dot was incorporated into either the word KODAK or SAFETY.

Eastman Kodak, for the most part, has now abandoned the old

MODERN DECOYS
Top: A decoy F-16 is parked on a fake taxiway. Note the sandbags used to hold down the taxiway. *Department of Defense.*

Bottom: Two decoy F-16s are parked on a fake taxiway. A photo interpreter would note the bags of sand along the taxiway along with the fact that there are no oil stains or tracks on the strip. *Department of Defense.*

Kodak Film Codes

Year	Code		Year	Code		Year	Code	
1965	■	●	1984	▲ ■	▲	2003	● ▲	●
1966	▲	●	1985	■ ●	▲	2004	▲ ■	●
1967	■	▲	1986	▲ ●	▲	2005	■ ●	●
1968	+	+	1987	■ ▲	▲	2006	▲ ●	●
1969	+		1988	+ +	▲	2007	■ ▲	●
1970	▲	+	1989	× +	▲	2008	+ +	●
1971	●	+	1990	▲ +	▲	2009	× +	●
1972	■	+	1991	× +	×	2010	▲ +	●
1973	+	▲	1992	■ +	▲	2011	● +	●
1974	+	●	1993	+ ▲	▲	2012	■ +	●
1975	+	■	1994	+ ●	▲	2013	+ ▲	●
1976	●		1995	+ ■	▲	2014	+ ●	●
1977	■		1996	× ●	▲	2015	+ ■	●
1978	▲		1997	× ■	▲	2016	× ●	●
1979	●	●	1998	× ▲	▲	2017	× ■	●
1980	■	▣	1999	● ×	▲	2018	× ▲	●
1981	▲	▲	2000	■ ■	▲	2019	● ●	●
1982	● ■	×	2001	▲ ▲	●	2020	■ ■	●
1983	× ▲	×	2002	● ■	●	2021	▲ ▲	▲

(Left margin, rotated) A year symbol, designating the year of manufacture, is incorporated into the edgeprint legend of almost all 8 mm, 16 mm, 35 mm and 70 mm films. These symbols, shown below, may be either open or solid.

Legend	Plant		MP FILMS	EdgePrint
KᵒODAK SᵒAFETY	Kodak Park		5247	5295 E
KOᵒDAK SAᵒFETY	Canada		5248 B	5297 C
KODᵒAK SAFᵒETY	England		5250 C	6247 B
KODAᵒK SAFEᵒTY	France		5251 A	5294 G
KᵒODAK SAFETᵒY	Australia		5254 E	7247 ECN
KOᵒDAK SAFETYᵒ	Mexico		5247 H	7293 ECH
KODᵒAK SᵒAFETY	Colorado		9247 F	7294 294
KODAᵒK SAFETYᵒ	Brasil		5293 H	7291 291

A plant-of-origin dot is incorporated into almost all edgeprint legends in either the word KODAK or SAFETY. The dot varies in size according to the film product and/or the equipment on which the film is produced. Listed below is a summary of these dot locations:

DATE OF FILM PRODUCTION
Each film company has coded methods by which it dates each batch of film it produces. *Eastman Kodak Company.*

method. Its edgeprint information now gives the film name and number, along with the emulsion (batch) number. This narrows the date of manufacture to a year or less. The emulsion number appears in code only once per roll between frame numbers.[67]

The fact that the year of manufacture was coded into the film was especially helpful to the U.S. Department of Justice in their investigation of Soviet Communist infiltration into government agencies in the 1940s.

Whittaker Chambers, a *Time* magazine editor, had joined the American Communist party in 1925 and became a party functionary in a group that also included Alger Hiss of the State Department. This group, according to Chambers, was directly involved in espionage against the U.S. Government. Chambers received summaries of State

Department cables, some of which he photographed on microfilm and gave to Soviet agents. In August 1948, Chambers was called to testify before the House Un-American Activities Committee about his role in the group, and he implicated Alger Hiss, by then a high-ranking State Department official. Hiss testified that he did not know Chambers and threatened to sue Chambers for libel.

Chambers testified that he had asked a nephew in New York in 1938 to hide an envelope for him. In that envelope were sixty-five typed pages of confidential State Department cables, along with three cylinders of undeveloped microfilm and a small spool of developed film. Chambers provided the documents to the Justice Department but, fearing that his home might be ransacked by American Communist Party members, kept the microfilm. According to Chambers: "I broke off a pumpkin, took it into the kitchen, cut out the top, scooped out the seeds. I wrapped the developed film in waxed paper to prevent damage by juices from the pumpkin. Then I laid the developed film and the cylinders of undeveloped film inside the hollowed pumpkin and replaced the top. It was all but impossible to see that the top had been plugged. I took the pumpkin out and laid it where I had found it at the farther edge of the patch."[68]

Shortly after, Chambers removed the microfilm and provided it to the Justice Department. It was crucial to the investigation as to whether Chambers was telling the truth when he said he had given his nephew the package containing the microfilm in 1938. Some contended the microfilm had been faked. Eastman Kodak experts were approached by the FBI. They were able to tell from its codes that the microfilm had been produced in 1937.

FILM, PAPER, AND FILM PROCESSING EXAMINATION

There is an ever-present and expanding market for old photographs, especially from well-known photographers. The financial profit to be gained is a powerful incentive for forgery. The price of old photographs has risen, and certain esteemed nineteenth- and twentieth-century pictures have sold at auction in the five- and six-digit range.[69]

Historically, photography is inextricably linked to the commercial manufacture of various chemicals, paper, and the science of optics—and various constraints on the commercial production of each. Experts in film and laboratory techniques often can examine photos, film, and negatives and by considering the emulsions, film base, or processing techniques to determine an approximate time-frame within which a photo was taken. From the beginning of photography until World War II, optics (number and quality of element) used in cameras were of better quality than the film emulsions available; that is, the lenses could "see"

more information than could be recorded on the film. By World War II, film quality had increased to such a point that the quality of the lenses and the emulsions were about equal. Since World War II, there have been enormous advances in lens design and production, primarily as a result of the introduction of computerized design and grinding techniques, and in film emulsions. Within the past ten years, it has become possible for an expert to date an emulsion to a specific time period.

For example, the ASA rating of advanced films in World War II was 100, while the ASA ratings of modern advanced films have reached into the hundreds. The granularity of film has been reduced. There have also been significant advances in the photo printing process, as well as in the production of new photographic print papers. There are now a variety of printing processes and papers. The dimensional stability of papers has also improved, and the papers do not stretch as much as in former prints. The introduction of fine-grained film permits extremely large enlargements.

In considering a suspicion of a photo being faked, it could be possible to determine the relative date of the photography through a close examination of either the print or the negative. After chemical analysis of the emulsion has been performed, it is a relatively simple process to obtain the technical data for all films available during the specific year the photo was supposedly taken. It becomes a process of comparing the data of the photo in question with such things as ASA ratings, development data, resolution data, sensitometric curves, root mean square granularity, base plus fog, chemical content, sensitizing dyes, anti-halation coating, and so on.

If the analysis of film itself fails, then experts can turn to tests of paper. The type of photographic paper used by the forger can be a giveaway. Any forger using photographic papers not common to the period of the purported photo risks quick discovery by experts. When a "quantity" of such photos are discovered, experts become extremely suspicious.

"Old" photographs arouse much interest. When a cache of photos from a bygone period surfaces, the photos are seldom sufficiently analyzed by experts before they appear in the press and media. The key to the authenticity of the photos often lies in the type of paper that the photos are printed on, along with identification of the chemicals used in the processing.

The first criterion of identifying an original or a copy of an old photo should be any signs of deterioration. Paper prints become more brittle with time and chemicals fade. Paper prints and negatives tarnish and turn yellow. They sometimes fade or bleach, grow fungus, stick together, and often suffer the effects of careless handling. A crisp, pristine photo

of the past would be immediately suspect. In the forgery of older photographs, the forger attempts to mimic the paper and chemicals of times gone by. Then too, the materials in old photographs vary and it is not always easy for the faker to determine the proper materials. Among the tests that can be performed on photos are the physical properties, optical properties, fibers, chemical composition, spectrographic analysis, chromatography, x-ray defraction, infrared spectra, watermarks, and possible source and dating. The essence of dating is to establish a time before which the paper could not have been made. An excellent table of dating can be found in Dr. B. L. Browing's book, *Analysis of Paper*.[70]

Analysis of the paper and the chemicals would be similar to those conducted on the so-called Hitler diaries. In those analyses, the bindings revealed polyester threads, which were not produced until after World War II, and the glue used contained postwar chemicals. The diaries that supposedly survived an aircraft crash were surprisingly well preserved.[71]

In 1974, seven photos of Victorian waifs, supposedly taken in the 1840s by a photographer named Francis Hetling, appeared in the press media and were later displayed in the prestigious National Portrait Gallery in London. Depicting the poverty and squalor of street urchins in the Victorian era, the photographs were aged-looking and brown, similar to other photographs of the era that had been developed and printed by the then popular calotype process. Despite the claim that these photos were nearly a century old, the paper was remarkably well preserved. Detailed paper analysis of the photos proved them to be false. When the individual who supposedly unearthed the photos was confronted, he said he had created the photos as a grand hoax on the art establishment to show their ineptitude in authenticating historical photos.[72]

The recommended procedure to determine photographic paper dating (to put a rough time bracket around the production of the paper) consists of the following:

1. Examine the photo with the naked eye to see whether the photo is showing its age.

2. Examine it microscopically.

3. Dissolve the paper and examine the content and species of its fibers.

4. Use x-ray analysis to identify minerals (if present).

5. Determine pH of paper to ascertain whether it was produced using an acid or alkaline paper-making process.

6. Analyze by infrared spectroscopy organic solvent extractives of the paper to determine the presence and identity of other organic binders.

7. Conduct radiocarbon analysis of the wood fibers. Carbon is found in all living matter. It has three naturally occurring isotopes, the least abundant being unstable and radioactive. Its scientific symbol is ^{14}C, usually referred to as Carbon 14. Carbon 14 is continually being formed in the upper atmosphere and via the photosynthesis process enters the chain of all plant life. Therefore, it is in wood fibers used in paper production. When a plant dies, it ceases to take on radioactive carbon and the levels of carbon decrease as radioactive decay occurs; this decay can be measured in a number of scientific ways that can be converted to age estimates.[73]

Analysis of the chemicals in the paper or negatives can also be accomplished. Albumen, made from the whites of eggs, was the first paper-coating material in 1850. This was followed with popular printing papers coated with silver in either albumen or collodion (cellulose nitrate) emulsions. Gelatin emulsions were used to coat printing papers after 1880. Insects such as cockroaches and silverfish thrive on the gelatin-based film, as does fungus.

Negatives were made of nitrate sheet or roll film. Nitrate-based films degenerate, giving off dangerous gases. Nitrate film is flammable and if stored in large quantities can be extremely dangerous. Witness a large fire at the National Archives film-storage area at Suitland, Maryland, on December 7, 1978, when old nitrate-based movie film caught fire. Nitrate-based film was followed by safety film.

THE CAMERA AND FRAME-EDGE MARKINGS

One is seldom fortunate enough to have the negative, along with the camera, of a purported fake photo. As mentioned previously, photographic film consists of a plastic base to which an emulsion is applied. The emulsion is soft and therefore easily scarred.

Each camera, like a firearm, has its unique signature or marking. Most cameras, especially the less expensive ones, are made of molded plastic. The plastic will have tiny imperfections around the film plane aperture—that portion of the camera that the film lies against when it is exposed. After an exposure has been made as the film is advanced, scratches are introduced as the film drags across the film-plane to the take-up spool. The scratches will be especially evident along the frame-edge markings. The more expensive cameras will have a roller, usually made of stainless steel or a comparable material, to keep the film from dragging across the film-plane surface. With use, however, even the rollers of expensive cameras will develop unique irregularities.

During the investigation of the assassination of President Kennedy by the Select Committee on Assassinations, expert testimony was given

by Lyndal L. Shaneyfelt, an FBI photographic expert. He had analyzed an Imperial Reflex camera and a negative, seized from Marina Oswald, of a photo of Oswald with the purported assassination rifle. A detailed microscopic examination of imperfections in the camera mold and the negative led him to conclude that marginal irregularities on the negative coincided with imperfections in the camera's mold. His examination established beyond doubt that the three photos had been taken with the Imperial Reflex camera found at the Oswalds' landlord's home.

IMPORTANCE OF TIMING A FAKE PHOTO

For a photo faker to achieve maximum impact, timing is critical. Damage should occur in the interval between the publishing of a fake photo and the time it is disclosed that the photo is a fake. Fake photos are often used as a smear tactic in political campaigns to undermine reputations. One historical instance where a "fake" photo played a prominent role in an election campaign, and was most likely a deciding factor in a closely contested Senate race, occurred in 1950. Senator Joseph R. McCarthy of Wisconsin brought charges of widespread Communist infiltration against the State Department in the spring of 1950. A Senate subcommittee, headed by Senator Millard E. Tydings, Democrat, of Maryland investigated the charges and denounced them as false. Senator McCarthy called the subcommittee's action a "whitewash" and accused Senator Tydings of being "soft on Communism."

In the 1950 Maryland senatorial campaign, the incumbent Tydings

IMPORTANCE OF TIMING
This faked photo purportedly showing Senator Millard E. Tydings (on the right) with communist Earl Browder was released a few days before an election. It was instrumental in Tydings losing the election. *U.S. Senate.*

was pitted against Republican John Marshall Butler, who had the support of Senator McCarthy. A few days before the election, a four-page tabloid entitled "For the Record" was widely distributed by Butler supporters. In the tabloid was a photograph of Senator Tydings in supposed intimate conversation with Earl Browder, an American communist leader. The photograph, which showed Browder speaking and Tydings listening, was actually a poor-quality montage. The perspective was bad (Browder's head is much too large), and light is falling on Tydings's head from one direction and on Browder's from another. A crop line is also distinctly visible. However, its impact was substantial: Tydings lost the election.

Tydings protested of unfair election practices to the Senate Elections

Subcommittee. Subsequent investigations revealed that the photograph was a montage created by a photo technician at the *Washington Times-Herald*, a newspaper controlled by an avowed opponent of Senator Tydings.[74] Although Butler's campaign manager pleaded guilty to violating Maryland election laws and was fined $5,000, Butler never apologized for the photo, saying it was "merely designed to illustrate the positive attitude displayed by Tydings toward Browder."[75]

A similar incident occurred in California in 1950 during the race between Congresswoman Helen Gahagan Douglas and Richard Nixon for the U.S. Senate. As a congressman, Nixon, a member of the House Un-American Activities Committee, was in pursuit of alleged communists in the film industry and wanted them cited for contempt. Douglas had close ties to Hollywood and voted against the motion. A week before the 1950 election, front pages of California newspapers carried pictures of Douglas embracing a well-known Communist activist, kissing a black person, and shaking hands and beaming at another Communist. According to Supreme Court Justice William O. Douglas: "The pictures were composite—that is to say, doctored. The person whom Helen embraced actually had nothing to do with Communism. He had been cut out of the original picture and that of a known Communist was substituted. But Helen Douglas was unprepared for the assault and did not have a chance to show how phony the manufactured photos really were."[76] She lost the election.

TECHNOLOGICAL AND SCIENTIFIC INCONSISTENCIES

It is possible to create a faked photo to depict almost any event. But often specialists who create photos on scientific and technological events are not sufficiently learned or informed of the finer substantive points of what they are depicting. Events are frequently portrayed that are not only physically impossible but also could be disastrous.

The secrecy involved in Communist weapons production, testing, and deployment during the Cold War caused photos of these events to be carefully scrutinized by Arthur C. Lundahl and myself. When both the United States and the Soviets were testing atomic weapons aboveground, one of the big concerns was estimating the safety of a battlefield when atomic weapons were detonated.

In one Soviet photo of a purported nuclear detonation, an armored force is maneuvering precariously close to the detonation. Experts looking at the photo quickly pointed out that the effects of the blast and shock waves coming from the detonation would have already seriously damaged, if not destroyed, the tanks, not to mention the camera taking the picture. Careful examination of the nuclear plume reveals no dis-

TECHNOLOGICAL AND
SCIENTIFIC INCONSISTENCIES
When the Soviets shot down Gary
Powers's U-2 spy plane, they published a
photo of what they said was its wreckage.
Rows of rivets can be seen on the wing.
Kelly Johnson, the U-2's designer, was
quick to point out that the U-2 is flush-
riveted and that the wing's configuration
was not that of the U-2. *Central
Intelligence Agency*.

cernible blast damage along the base of the detonation, nor is there any dust or debris moving along the ground from shock waves resulting from it.

When Gary Powers's U-2 spy plane failed to return from its mission on May 1, 1960, the Russians maintained a discreet silence for several days. Then Khrushchev began an avalanche of criticism and a bombastic propaganda effort against the Eisenhower administration.

Pictures of Gary Powers and the personal equipment he carried were published by the Soviets. In Washington, meanwhile, concern was mounting as to what charges might be levied against Powers by the Soviets and their possible effect on world opinion. Of special concern was the condition of the U-2 itself. When it crashed, did it burn? Of equal concern was the condition of the camera, its film, and the technical recorders that would probably be used as evidence that Gary Powers was spying on the Soviet Union. All photographs released by the Russians on the incident were carefully reviewed by Lundahl and myself for any evidence of photo fakery.

The Russians subsequently issued a photograph of the purported crash of the U-2. I examined the photograph carefully and quickly noticed that lines of raised rivets were clearly visible on the wing of the purported U-2. I knew that the U-2 was flush riveted. Measurements also revealed that the wing was too short and far too narrow to be that of the U-2.

Questions immediately arose as to why the Soviets would release a

photo they knew was false and which they knew would be carefully analyzed by CIA experts. It was regarded in the Agency as a very stupid move. The only rational explanation advanced was that the Russians didn't want to reveal any details of the crash until their experts had fully examined it. The cameras and emission recorders would be sought to charge Powers as a spy.

The photograph was called to the attention of Kelly Johnson, the designer of the U-2. At a press conference, Johnson showed the photo and explained why the wing and certain other parts of the aircraft depicted were not those of the U-2. The propaganda advantage that the Soviets had attempted to gain from the downing of Powers's U-2 was now seriously compromised by their own incompetence. The ignominy and chagrin of the Soviets prompted an embarrassed Khrushchev to prove that, indeed, the Soviets had downed the U-2. The downed U-2 was moved to Moscow and placed on public display in Gorky Park. Our attachés visited the display and confirmed that the Soviets had indeed recovered technical recorders, parts of the camera, and had made reproductions of the exposed film.

The Soviets, however, persisted in their original photo deception, although it had been unmasked. In the Soviet publication *No Return for the U-2* prepared by the Union of Journalists of the U.S.S.R. and printed in many languages, supposedly to give the world the true facts regarding the U-2, the faked photograph appeared again with the caption "The Wreckage of the American Plane That Invaded the Soviet Union."[77]

When Turkish military forces invaded Cyprus in 1974, Greek Cypriots charged the British with assisting the Turks and tried to prove their

point with photos. In an article in the magazine *Eikones*, several photos were shown as proof of British complicity. A photo purported to show the British destroyer *Devonshire* outside the Cypriot port of Kyrenia as it "gave the Turkish invaders the victory signal."[78] Naval experts looking at the photo claimed the vessel portrayed was not a destroyer. Even closer inspection of the vessel revealed the number F-57 on its side. It was the frigate *Andromeda*, which was not near Cyprus during the invasion.

During and after the Korean War, a close watch was maintained for any Soviet aircraft that could pose a threat to U.S. air operations. Photographs of purported new Soviet fighter aircraft were collected all over the world. When a photo of a supposed new Soviet aircraft was acquired during the Korean War, it was immediately analyzed, since the aircraft appeared to be a dead ringer for the American-made F-100. Close analysis, however, revealed that a pitot-static tube had been stuck in the engine, hardly a practice that an aircraft designer would recommend. The tail seemed to be flopped over, which would have created enormous stability problems. Comparing the photo with photos of the U.S. F-100, we found that an exact copy of a photo of the F-100 had been tampered with to produce the Soviet photo.

TECHNOLOGICAL AND SCIENTIFIC INCONSISTENCIES
When a photo of a "new" Soviet fighter surfaced (above), close analysis revealed a number of aeronautical anomalies: a pitot tube was stuck in the engine and its tail was flipped over. It turned out to be a tampered photo of an American F-100 (facing page). *Department of Defense.*

TRANSPOSITION OR REPOSITIONING

Transposition or repositioning is to reverse, change the order of, or change the place of objects or persons. Often this is done to present a more pleasing composition or for an aesthetic effect in a photo. It is also often done to fit the image to a printed page.

Probably the best-known repositioned photo appeared on the February 1992 issue of the *National Geographic* magazine. Images of the Cheops and Mycerinus pyramids were moved for purely aesthetic reasons and digitally repositioned one beside the other. Egyptian experts immediately noticed the move and protested to the National Geographic Society. Although Wilbur Garrett of the National Geographic Society maintained that the movement did not alter the picture's worth, many experts complained that the National Geographic Society's highly respected integrity had been compromised. Although the cover appeared on a number of publications,[79] the Society was so chagrined at the manipulation that they have since refused any request to reprint the cover. Thomas Kennedy, the magazine's director of photography, has

TRANSPOSITION OR REPOSITIONING
Jeffrey Lord used photographs of Lee and Grant taken at different locations and combined them in this clever poster.
Jeffrey Lord: Photo Enhancement-Imax/
Sharon A. Swab.

stated that there had been so much negative fallout that he would be reluctant to do that again.

There is a great interest in all Civil War photography and especially in pictures of famous generals. Although Generals Grant and Lee met at Appomattox, they were not photographed. Jeffrey Lord, a poster maker, combined photos of Grant and Lee taken at different places and at different times in a clever poster. It proved to be a best-seller.

IMAGE ENHANCEMENT

The advent of computer enhancement techniques allows the expert to glean more details that are not readily apparent. Photographs can be enhanced so that the information they contain appears more clearly evident. There are times when enhancement can also make a photo more appealing. Image enhancement techniques can also be used to determine if a photo has been tampered with.

Although highly technical, a variety of contrast and other manipulations can be performed that can show, for example, blurring or aberrations where images are joined or where the focus on one image may be sharper than the other.

Similarly, enhancement of images may help photo analysis. Though many examples can be cited, one of the most interesting involved the Yuba City, California, Police Department and the NASA Ames Research Center. A robber with his head draped in a towel and his arms extended was photographed by a video intermittent surveillance camera at a convenience store during a burglary, which included a homicide. The Yuba City Police Department had no leads, and appealed to the Ames Research Center for help.

The Graphics Development Group of the Computer Systems and Research Division of the Ames Research Center was installing a video digitization enhancement facility to use on videotapes taken during wind tunnel testing. NASA agreed to use its image-enhancing equipment on the police tape. Pertinent frames of the videotape were identified and enhanced. Ames technicians became intrigued with the burglar's outstretched arms, which showed spots on the forearms.[80] Through enhancement techniques, the Ames technicians brought out details not seen on the original, and concluded there were tattoos or markings on each arm. The information was passed on to the Yuba police. The burglar was identified through the tattoos and the enhanced photos were used in the trial, which resulted in a first-degree murder conviction. The Ames efforts were later featured on a *Hard Copy* TV segment.[81]

The advent of digitizing imagery has opened a number of new ave-

 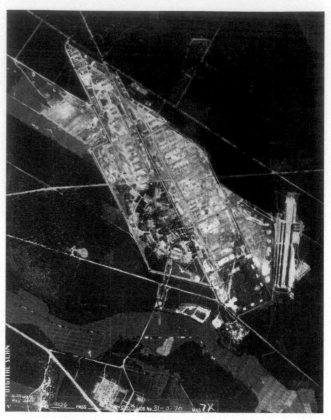

IMAGE ENHANCEMENT TECHNIQUES
Above left: Modern computer techniques can often reveal data that was not apparent in older photos. During World War II, British troops liberated the Belsen concentration camp. Fearing an epidemic of typhus and typhoid, they burned the barracks. An aerial photo was taken after the burning.

Above right: Through progressive stages of computer enhancement, the camp can be reconstructed through the ash left from the burned buildings.
Department of Defense.

nues for extracting new information from old imagery. After British troops liberated the Bergen-Belsen concentration camps at the close of World War II, they burned its barracks to prevent the spread of typhus and typhoid. Afterward, an aerial photo was taken. A modern-day digital scan of that photo enables us to see exactly where the barracks were. The digitizing adds new information to the history of the Holocaust, since the camp was later completely destroyed and now only a monument remains.

Belzec, a small, remote Polish village, would become one of the killing camps of the Holocaust. Opened in 1942, people sent to Belzec would never return. Upon arrival at the railyard, prisoners were herded into chambers and killed with fumes from diesel engines. The dead were buried in large pits that were graded over. It was estimated at the Nuremberg trials that approximately 600,000 people were executed at Belzec before the killing was transferred to Auschwitz-Birkenau in 1944. After the camp had been totally destroyed by the Germans, it was inadvertently photographed by Allied reconnaissance aircraft. Looking at those images, one sees little evidence of what happened there. Through modern digitizing methods of those same images, the large mass graves become very apparent.

DENSITY SLICING

There are times when data in a photograph of special interest can be emphasized or enhanced at the expense of other background features. Such enhancements can be carried out photographically or digitally. The use of multiple exposures of a given area on film, or on a paper print, to extract data is referred to as density slicing, density cuts, density exposures, or density chips. Through exposure controls, a darkened area on a photograph may be underexposed to a degree that new information can be seen. The process can be done with an enlarger or with more sophisticated computerized equipment. The digital computer approach has the advantage of being very flexible, whereas the photographic approach requires extremely talented laboratory equipment and processing personnel. Basically, through a series of exposures in a photographic laboratory in which the exposure is increased or decreased from one photo to the next, details not seen in the original print are often made visible. Variation of exposure times permits sequential extraction of different gray levels in black-and-white prints. In the lighter exposures, details are often seen that would not be visible in the darker ones. The photos may be compared visually or under magnification to search

IMAGE ENHANCEMENT TECHNIQUES
Although the Nazis destroyed all the facilities at the Belzec death camp, computer image-enhancement of old World War II photos revealed the massive pits where the bodies were buried. They are in the lower right here.
Department of Defense.

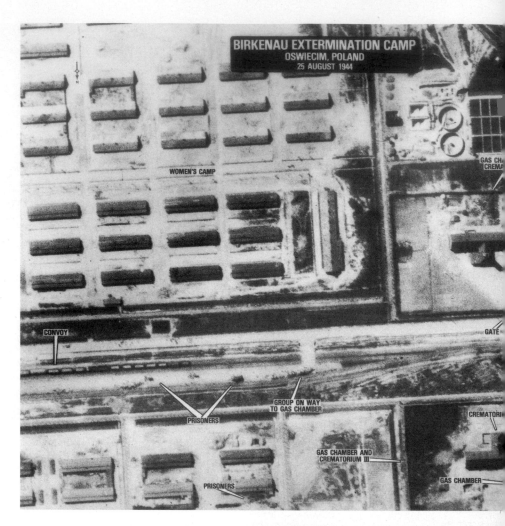

BIRKENAU EXTERMINATION CAMP
OSWIECIM, POLAND
25 AUGUST 1944

WOMEN'S CAMP

CONVOY

GATE

PRISONERS

GROUP ON WAY
TO GAS CHAMBER

GAS CH
CREMA

CREMATORI

GAS CHAMBER AND
CREMATORIUM III

GAS CHAMBER

PRISONERS

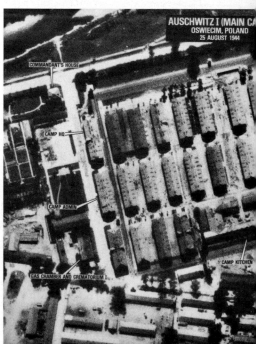

AUSCHWITZ I (MAIN CA
OSWIECIM, POLAND
25 AUGUST 1944

COMMANDANT'S HOUSE

CAMP HQ

CAMP ADMIN

CAMP KITCHEN

GAS CHAMBER AND CREMATORIUM I

DENSITY SLICING
Above: In 1978, Robert Poirier and the author discovered aerial photos of the Auschwitz-Birkenau Extermination Complex that had been overlooked since World War II. Using a variety of density cut techniques, prisoners could be seen being marched to their deaths. *National Archives and Records Administration.*

Right: In this photo, in a curved line at the lower right, prisoners can be seen lined up to be processed for slave labor. *National Archives and Records Administration.*

for details not seen in the original. Density slicing frequently will improve the detection of edges of a scene for mensuration purposes. This technique is also valuable if there are shadows in a photo. Usually in density slicing, in the lighter exposures, details of objects in shadows are revealed.

In 1978, photo interpreter Robert Poirier and I discovered World War II aerial photos of the Auschwitz-Birkenau death camp that had inadvertently been taken on leader film during an Allied reconnaissance mission against the nearby I. G. Farben Synthetic Rubber and Fuel Plant. Using a variety of density slicing and enlargement techniques, Holocaust victims who had arrived in boxcars at Auschwitz could be seen being marched to their deaths in the gas chamber. Others could be seen lined up at a processing center for slave labor assignments.

CHAPTER 6

Communists, Ghosts, Monsters, and Aliens

During the Cold War, there was an appreciable upsurge of Soviet photo forgeries. Most were meant to show the Communist regimes in their best light in the hope of making viewers more receptive to Soviet policies and points of view. They were also created to hide Soviet technical advances and to peddle distorted information and plausible mistruths about their enemies. After considerable study, however, CIA photo experts found that Soviet photo forgeries tended to be somewhat stereotyped. It was also obvious that editors of Communist publications were granted some freedom in their forgeries. Discrepancies between the various publications and their editors' lack of attention to detail made it easy for experts to spot the photo fakes.

The Soviet Union used the term "active measures" to cover a broad range of systematic falsification designed to promote Soviet foreign policy goals, including undercutting opponents of the U.S.S.R. Active measures included photo forgeries. The forgeries were timed to influence opinion on current or sensitive issues.[1] The key to such disinformation was to release it in such a manner that even with painstaking investigation it would be impossible to establish the individual or the institution that created it. Soviet forgery requirements were charged to Service A

of the First Chief Directorate,[2] the International Department, and the International Information Department of the Central Committee of the Communist Party of the Soviet Union. Forgeries of documents, some of which included photos, were recognized by the CIA in the early 1950s. The objective of the forgeries was a propaganda ploy to isolate the United States and its allies and to create a worldwide image of the United States as aggressively "imperialist" and "racist." Soviet disinformation operations took place primarily in Third World and allied nations.[3] Forgeries frequently were sent through the mail to journalists, officials, or other personnel who might make them available to the media. Arthur C. Lundahl and I were asked to look at photographs from a number of publications created by "phantom" organizations, that is, organizations that actually did not exist. One in particular, the African Friends Association, distributed "Dear Friends" publications in Africa in which a number of photographs depicted America's treatment of blacks in the most despicable manner.

The increased flow of forged documents and photos prompted Allen

COMMUNIST TAMPERING
Soviet and satellite Communist leaders were always shown in the best light. Blemishes were removed and wrinkles in their rumpled clothes were photographically ironed.
Central Intelligence Agency.

SOVIET TAMPERING
When Premier Nikita Khrushchev visited the United States, he was photographed while being given a hot dog. It was interesting to note how the various Soviet newspapers manipulated the photo.
Central Intelligence Agency.

Dulles to have Richard Helms, Assistant Director of the Central Intelligence Agency, to testify before Congress on June 2, 1961. Helms stated, "the Soviet propaganda campaign against the West grows daily more intense. It's focused on the United States, our Government, and our diplomatic, military, and intelligence services. Even before the U-2, but particularly afterwards, the Soviets began to train heavy artillery on the Director of Central Intelligence and the CIA. We have had an intimate view of their tactics." Helms proceeded to show a number of Soviet and East European forgeries.[4] In 1978, Admiral Stansfield Turner, Director of Central Intelligence, made a similar presentation to the House of Representatives Permanent Select Committee on Intelligence on KGB covert forgeries.[5]

There was a constant probing by the Soviets to find weak spots in the press. During President Carter's administration, the Soviets adopted a new tactic. A reporter from a national newspaper would get a call from an anonymous, supposedly CIA employee who had a document that would prove that President Carter had recklessly planned the rescue of American hostages held in Tehran in 1980. *Washington Post* reporter George C. Wilson was contacted and later sent the document to U.S. government sources. He suspected that it was fake and had it examined closely by those actually involved in the raid. There were many inconsistencies in the report, such as spurious codewords, CIA organizational plans, etc. But columnist Jack Anderson received a similar letter and he published excerpts, prompting a firm denial by Jody Powell, Carter's press secretary. The Soviets had spotted a weakness in the press media. In these days of worldwide communications, there are often no adequate checks and balances when a given news department prints something that others have found flawed.[6]

During the Vietnam War, the North Vietnamese carefully monitored public opinion in the United States, especially the American public's re-

action to any massacre of innocent civilians. Sensing sympathy, they began to orchestrate a program to denigrate the U.S. military by showing that the killing of the innocents was not accidental but a policy deliberately fostered by the U.S. high command in Vietnam. General William Westmoreland was singled out for condemnation. To foster this idea, the North Vietnamese combined a *Newsweek* cover photo of the general with a massacre scene and circulated the result as proof that the United States military had embarked on a deliberate policy of killing innocent civilians.

CIA Director William J. Casey, in an address in 1985, pinpointed some of this activity. He stated "Soviet press manipulation in the Third World is enhanced by its two press agencies, TASS and Novosti. While the former is openly identified as an official Soviet news agency, the latter is listed as an 'independent' news organization. Yet, the Novosti headquarters in Moscow contains a section of 50 KGB officers who work full time on disinformation programs."[7]

In testimony to the U.S. Senate in December 1979, former Czech General Major Jan Sejna stated "Deception, disinformation and camouflage is not just the practice of being clever. Rather, it is in the Soviet Union, a true art form, a science."[8]

Obliterating a person from historical records, usually for political or traitorous acts, goes back at least to the Roman Empire. In a practice called *damnatio memoriae*, the Roman Senate would order a deposed emperor's face chiseled off sculptures. Retrofitting history by removing a person's image from a photograph has been a feature of all Communist and Fascist regimes. Communist countries will often go back to alter past photographs to suit present needs or thinking. People are erased and backgrounds are blocked out. Many photos of Lenin were altered to make him stand out more prominently, usually by erasing the men or area around him. During the Stalinist period, whenever some official

COMMUNIST TAMPERING
During the Vietnam War, the North Vietnamese created a bogus photo of General William Westmoreland at a "massacre" site. *Department of Defense.*

was in political disfavor or was put to death, that individual would disappear altogether from the Communist press. This eradication was often total, including the removal of photographic evidence of antigovernmental activity in which the individual may have participated. For example, Leon Trotsky, Lev Kamenev, Nikolai Bukharin, Karl Radek, and Grigori Zinoview were removed from most of the photos that showed them with Lenin after they were executed on Stalin's orders. Stalin himself was subjected to some of this photographic revisionism after his death in 1954.

When people are removed from a photo there are two methods of filling the void. One is the use of a few brushstrokes or computer erasers. If a number of people are removed there is a shifting of those remaining to fill the void.[9] In his book *The Commissar Vanishes*, David King shows a number of photos of Soviet leaders during the Stalinist era that were removed or shuffled. Many of the photos were crudely created and are easily detectable.

Photographic revisionism extended from the U.S.S.R. to other Communist governments in China, North Vietnam, Czechoslovakia, Yugo-

slavia, Hungary, Romania, Albania, and Cuba. The leaders of these nations are always shown in a well-ordered fashion. Wrinkles are removed, clothing smoothed out, backgrounds obliterated.

Shortly after Mao Tse-tung's death on September 9, 1976, reports circulated that there was a power struggle regarding Mao's successor. At Mao's funeral, however, everything appeared peaceful and calm as ranking members of the Chinese Communist party lined up to be photographed paying their last respects to their departed leader.

On October 12, a formal announcement was made that Premier Hua Guo-feng would succeed Mao as Chairman of the Party Central Committee of the Peoples' Republic of China. He would also fill the post of Chairman of the Military Affairs Commission. Also on that date, reports were circulated that Jiang Qing, Mao's widow; Wang Hongwen, deputy chairman under Mao and ranked third in the leadership after Mao's death; Zhang Chunqiao, former Shanghai mayor, vice premier, and ranked second after Hua; and Yao Wenyuan had been purged from the party and arrested. All were members of the so-called "Shanghai radical" sect who had supported the Cultural Revolution and allegedly com-

COMMUNIST TAMPERING
A memorial ceremony for Mao was also held at Tiananmen Square with over a million people in attendance. Later the "Gang of Four" was also removed from the photo. *CIA presentation to Congress.*

mitted excesses while in office. They would later be labeled the "Gang of Four" and referred to as "unrepentant archcriminals."

Photos of Mao's mourning ceremonies were disseminated widely not only in China but also in the rest of the world. In the *China Pictorial* published in November 1976, however, the Gang of Four had been deleted from all photographs relating to Mao's funeral. The deletion work, at first glance, appears skillful, but large gaps where the four had stood in the original photograph were immediately apparent; the photograph had been tampered with. No attempt was made to close the line of leaders, as was so often done in other Chinese photos.

Historical photo revisionism does not occur only in current photography. The Communist Chinese have also gone back a number of years to eradicate photos in history books. The August 1977 *China Pictorial* commemorated the fiftieth anniversary of the founding of the Chinese Peoples' Liberation Army and showed a number of historic pictures of Chairman Mao and his army on various campaigns and marches. One particular photo shows Mao on horseback surrounded by subordinates, supposedly directing a battle against Chiang Kai-shek's Nationalist forces. A comparison of this particular photo with the same scene appearing in the October 1967 issue of *China Pictorial*, devoted entirely to Mao, revealed that Jiang Qing, Mao's wife and the leader of the "Gang of Four," had been deleted from the 1977 photo.[10]

The Czechs were second only to the Soviets in faking photos. When Alexander Dubcek resigned as premier of Czechoslovakia on April 17, 1969, the Czech government began a deliberate campaign of removing Dubcek from many of the photographs taken during national celebrations and events in which he had participated. In a 1968 photo of Czech leaders outside Saint Vitus Cathedral in Prague, Dubcek had been skillfully removed, showcasing the special skills of Czech fakers.

Communist political leaders are extremely conscious of rank and traditionally align themselves at official functions and public displays according to their positions in the Communist hierarchy. The gatherings of Soviet officialdom at Lenin's tomb on May Day and October Revolution celebrations were always watched with great interest by Kremlinologists, because changes in relative positioning of the leadership often indicated an increasing or decreasing role for the person being shifted. During the Stalinist period, especially during and after the purges, this lineup took on special interest and meaning which continued to the 1980s. It was especially important when it became known that Brezhnev's health was failing. In a 1980 May Day photo, Konstantin Chernenko stood sixth from Brezhnev. In May 1981, he was moved to the fourth position, and in 1982 to the second. Ultimately he was Brezhnev's successor.[11]

It was also known, however, that these pictures were often altered.
People supposedly present at some of these events were simply not
there. Photo analysts would often view Soviet newsreels of the events
and compare them to the official pictures.

On May 1, 1979, Soviet officials were gathered as usual at Lenin's
tomb. In the official TASS photograph, Dmitri Ustinov and Nikolai
Ogarkov are to Brezhnev's right. To his left are Alexi Kosygin, Mikhail
Suslov, Andrei Kirilenko, Victor Grishin, and Andrei Gromyko. After
the photo was altered Ustinov and Ogarkov are still at Brezhnev's right,
but on his left the lineup had changed: Kosygin (his right hand raised in
salute rather than at his side) and Suslov, Grishin and Gromyko. Kiri-

lenko had been completely removed from the photo. Further detailed study of this photo revealed additional tampering. The shadows from the two towers of the GUM department store across the street fall onto the side of Lenin's tomb, but only one tower shows on the faked photo. Also, the size of the stone on the tomb tower has been tampered with and is smaller than the others. One would hardly suspect that a prestigious monument such as Lenin's tomb would have different-sized stones across its face. On the smaller stone, the flat tones indicate deleted data. On the unaltered official photo, however, the tops of stones at various levels are emphasized with unnatural white lines, probably to increase the aesthetic effect of the photo.

Revisionism of pictorial history has been applied to many Soviet endeavors but probably most often to the Russian cosmonaut program. When cosmonauts are removed from training programs, either because of medical disqualification, political unreliability, or motivational weak-

SOVIET TAMPERING
The yearly May Day lineup of Soviet leaders at Lenin's tomb was always closely analyzed by Kremlinologists because changes in the relative positions of the leadership often indicated an increasing or decreasing role for the person being shifted. The Soviets frequently altered photos of reviewing dignitaries gathered on Lenin's tomb. In the unaltered photo that appeared in the *Soviet Belorussia*, the line-up from left to right is Ogarkov, Ustinov, Brezhnev, Kosygin, Suslov, Kirilenko, Grishin, and Gromyko. In the *Evening Moscow*, Kirilenko was removed. Note also that the shadow of the GUM department store across the street has been altered in the *Evening Moscow* edition. *Central Intelligence Agency.*

**2 MAY 1979
SOVIET BELORUSSIA**

**1 MAY 1979
EVENING MOSCOW**

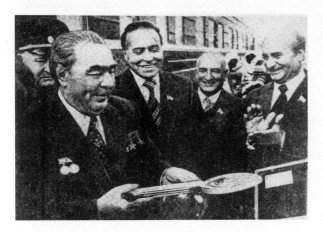 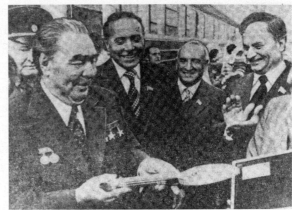

nesses, they inevitably disappear from all previously taken pictures. This phenomenon apparently was the work of General Nikolai Kamenin, the first commander of the cosmonaut corps. General Kamenin, an arrogant and opinionated man, oversaw the recruitment, training, and ideological reliability of the cosmonauts. He frequently conducted purges of the trainees. A large number of photos issued during training and launch programs have been tampered with. A photo was taken in 1971 of Serge Corolla, who was in charge of training, and his cosmonauts. Comparing this photo with a 1974 version, one notes that Cosmonaut Grigory Nelyubov has vanished through photo retouching. In a belated attempt to rectify the removal of Nelyubov, a bush has been planted in his place in a photo published in 1982. In a 1983 version, a stairway has replaced the bush.

A photograph of Dmitri Vianov as the backup commander for Voskod-2 was released. He was medically disqualified in 1969 and his likeness was subsequently brushed out of all official photos.[12] In a Soviet publication, *Most v Kosmos*, heralding Yuri Gagarin's flight, many of the photos reveal heavy brushwork deleting details of Soviet space ventures.

The Soviets, masters of deception and the effacement of individuals fallen from grace, have also removed people from photos in other fields such as music, literature, the military, sports, and scientific research. They seem to ignore the fact that photos of these people can be found in other historical records.

Photo fakery was sometimes employed by one Soviet faction against another. Frequently, one Soviet republic would deliberately try to embarrass or poke fun at another. There is little accord between the Armenians, whose capital city is Yerevan, and their Azerbaijani neighbors, whose capital is Baku. On September 21, 1978, Brezhnev visited Baku and was presented with the key to the city by Azerbaijani President Kuban Ali Ogly Khalilov, who was almost completely bald. The Baku newspaper,

INTERNATIONAL PHOTO FAKERY
Top: The German magazine *Stern* used on its cover one of the photos from an article on art photography. *Stern.*

Bottom: The Czech Communist magazine *Zivot* used the *Stern* photo to illustrate an article on crime, terrorism, and prostitution in Italy.

Baku Worker, and other national and regional newspapers, pictured him as bald. However, the Armenian newspaper, *Kommunist*, added a full head of hair to Khalilov and to an unnamed official on his right. Even in staid Soviet politics, it appears there was still a vestige of humor.

During the Communist Czechoslovakian regime, many photos were faked to suit Communist ideals. The West German magazine *Stern* used a photo from an article on art photos on its cover. The Slovak magazine *Zivot* took the picture and used it in an article about crime, terrorism, and prostitution in Italy. The Slovak caption reads: "Many women have been driven by an unhappy social situations [*sic*] to prostitution."

Although it might be thought that Communist practitioners of this art have departed, it appears that the Russian practice of deception still continues. The official Russian news agency ITAR-TASS released a photo on July 15, 1995, said to be of Boris Yeltsin in his hospital room at Moscow's Central Clinical Hospital, where he was admitted on July 11 suffering from heart trouble. A video obtained by the Associated Press, however, showed an identical scene of Yeltsin with the same sport shirt, in front of drapes with a bank of four telephones at his left elbow. Yeltsin was sitting in front of documents with a pen in his hand. The video, shot by Russians on April 2, 1995, had been filmed in the southern resort town of Kislovodsk, where Yeltsin was vacationing. The Russian television correspondent who assembled the video was Sergei Medvedev, now Yeltsin's press secretary. Dmitry Ardamatsky of Yeltsin's press service scoffed at NBC's reporting on the same sport shirt and telephones. He said, "If the President wears the same shirt in both old and new pictures, so what? A man can have certain preferences. Do they suppose he could change his shirt three times a day?"[13] Yet, the Russians were now compelled to cover their deception, and Yeltsin, in a new sport shirt, was later seen on Russian television.

DOUBLES

Throughout history, famous world leaders have often used stand-ins or look-alikes for various reasons. Among them have been Hitler, Churchill, Stalin, Roosevelt, and Idi Amin. Recent defectors from Iraq have shown photos indicating that Saddam Hussein has two doubles. George Washington had a double, Colonel Elias Dayton, who was his intelligence officer in New Jersey. Few doubles, however, ever reveal their identity. One exception was M. E. Clifton James, an actor who impersonated Field Marshal Viscount Montgomery in England, at Gibraltar, and in Algiers during World War II. He wrote a book about his experiences entitled *I Was Monty's Double*.[14]

An integral part of this type of deception is that not only must the double look like his famous counterpart, he must also act like him and

display the same mannerisms. Most deceptive efforts are done for security reasons. There could be situations where the double would also have to speak like his famous counterpart. The objective of such a charade usually is to have the double performing a duty or official act and be very visible while the real person is occupied elsewhere. Concern about the use of doubles also arises when the health of world leaders is suspect.

Probably the best known system for positive identification of doubles was devised by a French statistician and criminologist, Alphonse Bertillon. The Bertillon system, devised in 1878–1880, used records of anthropometric measurements of such characteristics as the color of eyes and hair, scars, and deformities. A feature of the Bertillon system known as the *portrait parlé* (front and side view portraits taken of known criminals) is still used today by most police organizations.

While a double is usually attired in the same clothes as his famous counterpart, an attempt is usually made to shield the face as much as possible. A hat or cap is normally worn, or high-collared coats that also shield the face. Expert make-up artists create deformities, scars, or blemishes of the famous counterpart.

If a photogrammetric analysis of a photo showing a head-on view fails to reveal a double, then a side view can be analyzed. Other than a fingerprint, the ear is the best human feature for making a positive identification of an individual. The use of photogrammetric measurement is the first and foremost method for doing this. The transparency method is another. A third method is a systematic approach suggested by Alfred Iannarelli, a former police official.[15] Using any of the three methods usually leads to quick determination of similarities or dissimilarities.

Current knowledge of the health of world leaders is of great importance to those concerned with intelligence. Intelligence officers will go to great lengths to acquire information on the ability of foreign leaders to perform their decision-making functions in times of ill health or during recuperation from surgery. If the decision-making functions have to be delegated, the usual result is an overall weakening of the government.

Foreign governments, especially Communist countries, frequently instituted stringent security measures to shield such information from public knowledge. In Communist China, Mao Tse-tung disappeared from public view in late 1965. In the spring of 1966, he was still not attending diplomatic receptions or public functions. This led to considerable speculation about his health, in that shortly before his disappear-

When Mao was not seen for months in early 1966, rumors persisted that he had suffered a debilitating stroke. In response, the Chinese News Agency released several photos that were given wide publicity of a vigorous Mao swimming in the Yangtze River. *Sovfoto.*

ance he had seemed to be incapacitated and in need of assistance for climbing stairs or getting in and out of chairs. Rumors persisted in Peking that Mao had suffered a debilitating stroke.

On July 16, 1966, the Chinese News Agency, in an attempt to show that Mao was enjoying good health, issued a news release that the Premier had undertaken a nine-mile swim downstream in the Yangtze River near Wuhan. The swim supposedly took place in view of thousands of cheering Chinese and was witnessed by a number of foreigners. No Western correspondents, however, had been allowed to witness the event, although it was obvious that the swim was undertaken in response to Western speculation that Mao's health had deteriorated to a point where he was no longer in control of the government of China.

Despite elaborate efforts by the Chinese, there was immediate doubt among U.S. intelligence officers that a seventy-two-year-old could swim nine miles in sixty-five minutes, even downstream. The Chinese account had added that while the swim was occurring, "the Yangtze was in a spate; its current was swift and rolling waves pounded the shores" and that Mao "made his way through the turbulent waters by side-stroking and sometimes floating on his back." In addition, the account continued, when a young woman accompanying Mao on the swim could only execute one type of stroke, Mao "amicably taught her the backstroke."

The Chinese later published a magazine article and released a number of photos of the event. The photos showed Mao on a launch and in the water, and spectator scenes along the shore and in the river. Detailed analysis of the photographs revealed many inconsistencies with the released text. There were no waves in the water—the river was extremely calm in contrast to the Chinese textual description. Only the heads of Mao and other swimmers were visible in the water, with no water disturbances shown about their necks from the supposedly fast-flowing river. Crowds on the shore and swimmers in the water held placards inscribed with quotations from Mao's works.

But the Chinese Communist press did not stop there. In a wave of publicity about Mao's wonderful health, Mao began to appear at a number of diplomatic receptions and public functions, both in Peking and in the Chinese provinces. Foreign leaders who met with Mao spoke with glowing references to his health and the buoyant spirit of the seventy-two-year-old Communist leader. Photographs of Mao at these events were also released by the Chinese News Agency.

Careful analysis of these photos revealed, however, that the individual purported to be Mao was not the Chinese leader but a double. While the Chinese double had the same mole on his chin and the same receding hairline, and looked like Mao, the perpetrators of this deception had failed in a most significant aspect. His ears gave the double away.

Next to fingerprint analysis, the features of an ear can be used for identification. Details of Mao's ear were carefully analyzed and measured using a number of modern techniques. *Central Intelligence Agency.*

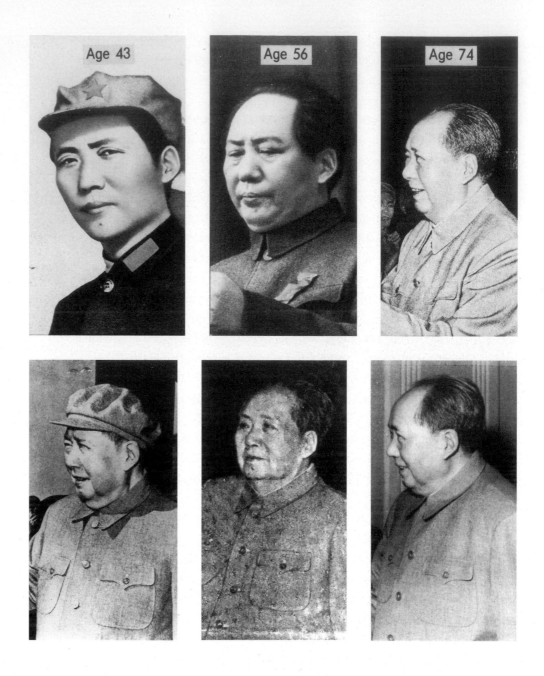

Age 43 Age 56 Age 74

Top: Many official photos of Mao taken through the years provided a good base for analysis. *Central Intelligence Agency.*

Bottom: The analysis proved that Mao had one, and possibly two, doubles. The middle person is a double. *Central Intelligence Agency.*

The odds of two different ears being exactly alike are astronomical—not even the ears of the same individual. The ear begins to form after the thirty-eighth day of conception and continues to develop until the time of birth. It does not reach maturity until nine or twelve months after birth. The ear will continue to grow proportionately during the adolescent and maturation years. In advanced age, the lobe will usually lengthen.

The ear, in its use as an identification criterion, is made up of thirteen parts that can be used for comparison purposes. There are several ear identification systems, but perhaps the best known is that devised by Al-

fred Iannarelli. Police and investigative units frequently use the physical characteristics of the ear in making positive identification. In addition to carefully analyzing the physical features, the ear can also be measured and its contour traced in a manner similar to that employed in creating a map. By carefully matching known characteristics with those that are suspect, the differences become very apparent.

It was relatively easy to get photographs of the real Mao, taken on occasions when he was known to have been present. The configuration of Mao's left ear also appeared on official government medallions and seals. A make-up artist can cleverly place a mole or a scar on an impostor and, with modern make-up techniques, can attempt to duplicate a real ear on an impostor. However, such deceptions have seldom been employed successfully in creating doubles.

GHOST OR SPIRIT PHOTOS

A double photo exposure results from making either an intentional or accidental second camera exposure, which produces a negative with two images. Every photographer makes mistakes and one of the common mistakes in early cameras was the failure to move the film forward after taking a photo.

In the late nineteenth and early twentieth centuries, unscrupulous photographers found a market for exposing photos of a client's departed loved ones around his own portrait. The claim was that the spirits were still around the client and that the camera had captured them. There were those who, during the early period of photography, actually believed that the camera could steal a person's soul and capture it on paper.

Photographers thrived on this belief and began to produce ghost or spirit photos. The ghost figure is usually made to appear alongside or above the sitter to achieve the impression that the spirit was present when the photo was taken. Some photographers, working with spiritualists, would ask the sitter to think about an image of the departed when the photo was being taken. The photographer would often go into his collection of previously discarded photos of the customer's loved ones and would pre-expose parts of those negatives with the portrait negative. To make a scene even more realistic, photographers would often use triple exposures to have the loved one appear suitably draped in a white sheet or partially obscured by fog.

Around the turn of the twentieth century, it became fashionable to attend seances in attempts to reach deceased loved ones. Groups would gather around a table and, with a medium, call upon the spirit of a departed personage.

There were also certain spirits supposedly photographed in catastrophic events such as fires and in cloud formations. Most photos of

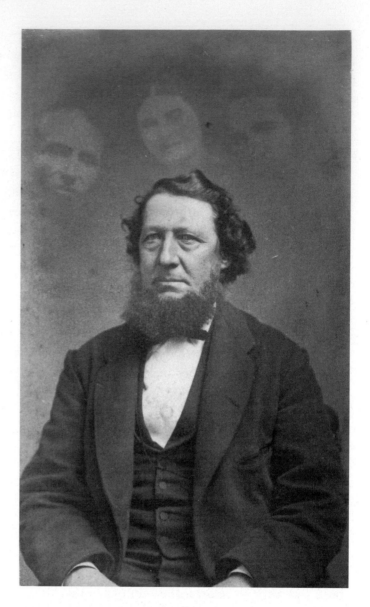

GHOST PHOTOS
Some believe that the camera can capture the soul. Early photographers made easy money exposing photos of deceased loved ones onto their clients' photos. *George Eastman House.*

these instances are actually crude double-exposures or superimposed cut-outs.

One of the more famous spiritualists' camps was located in Chesterfield, Indiana, where spirits of the departed would be induced to help in the affairs of the living. Spirit photos taken at the camp included one of an "Indian spirit" appearing alongside the stone statue of an Indian.

Spirit photos were employed to keep children from visiting undesirable areas. Also, bootleggers in the 1920s used many guises to keep people away from their whiskey stills. One was to display a spirit photo in the area in which they had their stills.

Mary Todd Lincoln attempted on several occasions to make contact with her dead husband. At a seance in Boston, under the assumed name

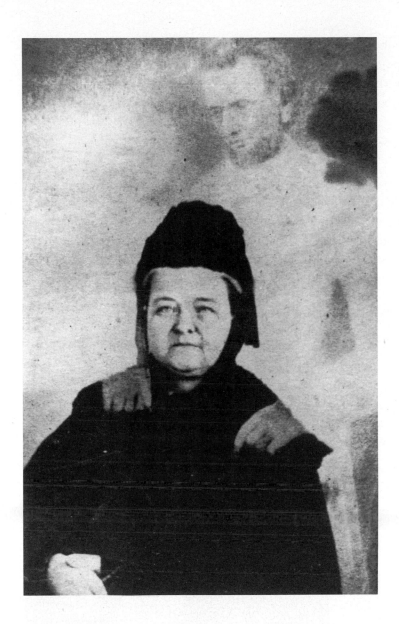

LINCOLN'S GHOST
Mary Todd Lincoln attended seances
under an assumed name and believed she
had made contact with her dead husband.
A spirit photographer, William Mumler,
"captured the authentic spirit" of Lincoln
looking down on his pleased wife.
Meserve-Kunhardt Collection.

of Mrs. Tundall, she believed she had made contact with her husband
and stated she had felt his hands on her shoulders. Later, working in
Mathew Brady's studio, the spirit photographer William Mumler—pre-
viously indicted for fraud—"captured" the "authentic" spirit of her hus-
band in a fog-like atmosphere looking down on a pleased Mrs. Lincoln.[16]

"HALO" AND "AURA" PHOTOS

Many spiritualists believe that spirits are always about keeping watch
over them. Some photos reportedly have captured an "aura," a supposed
luminous radiation or enveloping glow about an individual. Detailed
analysis of these photos reveal most to be clever fakes. Some have been
explained as a leaking of light, a reflection of light, or purposeful expo-

sure. A "halo" photo shows a radiant circle or disk surrounding the head of a holy person or a person of spiritual character.

One of the most intriguing halo photos is one of the Reverend William Branham. Branham came from humble origins and his family struggled with poverty throughout his growing years. Tragedy struck with the loss of his young wife and daughter. Throughout his early life he allegedly encountered visitations with God that he kept to himself. After his many tragedies, he began his ministry, which expanded into the healing of physical ailments.

Debates about Branham's healing powers led the Reverend W. E. Best to denounce Branham and issue a challenge to Branham's partner, the Reverend F. F. Bosworth, to debate him in Houston in January 1950 regarding Branham's healing abilities. Branham also appeared in the program. Best had hired professional photographers, James Ayers and Ted Kipperman, to take a series of pictures of Branham while he was speaking. When Ayers went back to his studio to develop the negatives he had exposed, all of them turned out blank except one with a "halo" immediately over Branham's head.

Branham agreed that Ayer's negative should be turned over to George Lacy, an authority on questionable documents in the Houston area. Lacy reported:

HALO PHOTO
A "halo" appears over the head of the Reverend William Branham in a photo taken for a clergyman opposed to Branham's ministry. *Library of Congress with permission from W. P. Branham of the William Branham Evangelistic Association.*

A macroscopic and microscopic examination and study was made of the entire surface of both sides of the film, which was Eastman Kodak Safety Film. Both sides of the film were examined under filtered ultra-violet light and infra-red photographs were made of the film. The microscopic examination failed to reveal any retouching of the film at any place whatsoever by any of the processes used in commercial retouching. Also, the microscopic examination failed to reveal any disturbance of the emulsion in or around the light streak in question. The ultra-violet light examination failed to reveal any foreign matter, or the result of any chemical reaction on either side of the negative, which might have caused the light streak, subsequent to the processing of the negative. The infra-red photograph also failed to disclose anything that would indicate that any retouching had been done to the film. The examination also failed to reveal anything that would indicate that the negative in question was a composite or a double exposed negative. There was nothing found which would indicate that the light streak in question had been made during the process of development. Neither was there anything found which would indicate that it was not developed in a regular and recognized procedure. There was nothing found in the comparative densities of the highlights that was not in harmony. Based upon the above described examination and study I am of the definite opinion that the negative submitted for examination was not retouched nor was it a composite or double exposed negative. Further, I am of the definite opinion that the light streak appearing above the head in a halo position was caused by light striking the negative.[17]

The photograph has not been further analyzed.

There have been a number of photos of purported "auras" emanating from certain individuals. A number of these can be attributed to Kirilian photography, a method of electrophotography that records the luminous glow produced when a high-voltage, high-frequency electric potential is applied, usually by a sitter placing his or her hand on the electrical source. Kirilian photography is the popular term for a type of photography named for two Russian researchers, Semyon and Valentina Kirilian, who began publishing the results of their research in the late 1950s. It is also referred to as electrophotography, corona-discharge photography, electroluminescence photography, and photo-electrographic process.

MONSTER PHOTOS

Over the years, numerous photos have appeared of mythical animals, such as mermaids and unicorns. The mermaids (and sometimes "mermen") have usually been monkeys and fish sewn together; the latter have simply been white horses sporting glued-on horns.

In November 1983, "hikers" Keith Hallam and Steve Evans emerged from Virginia's Shenandoah National Park and told a park ranger that they had seen a white creature with a gold mane and a large horn emerging from its forehead. The men produced five instant-color photos they had

taken before the "unicorn" had bolted. While the rangers searched for the animal, Hallam and Evans told their stories to *USA Today,* the Associated Press, *The Washington Post,* the New York *Daily News,* and several television stations. Hallam, it turned out, was an entrepreneur who had been involved in other hoaxes. He had written a book called *Unicornucopia: The Capture, Care and Feeding of Your Own Unicorn,* which had been turned down by several publishers, and he was seeking publicity for the book. Later Hallam would display the wooden horn and blond wig they had attached to a white horse to give it mythical features.[18]

In Wisconsin in the 1930s, a "hodag" (a combination of horse and dog) was supposedly found near Rhinelander. It was photographed after it supposedly had killed a man, with men surrounding it with guns drawn and pitchforks and axes at hand. It was later displayed in the town in dim light. The men later revealed it was a hide from a large dog with horsehide stretched over it and with horns from a cow.

In 1906, a mysterious sea monster supposedly washed up on the beach at Ballard, Washington, and was photographed. Analysis of the photo revealed that the monster was obviously the trunk of a tree, the head being the roots and the fins the branches.

VANITY

During the glory years of Hollywood, glamour portraits of Hollywood stars showed smooth faces, strong profiles, carefully coiffed hair, and im-

maculately tailored and wrinkle-free clothes. Over the years, a certain fetishism developed as eminent sitters asked nationally known photographers not only to pose them in certain postures but also to remove certain disturbing features.

The great Russian ballerina, Anna Pavlova, took an ardent interest in all photographs taken of her. She insisted that her feet be shown exaggeratedly small and with delicate tapering points. While they added grace to a photo, they were unreal. In one photograph taken by James Abbe of Pavlova descending a flight of stairs, the feet have been retouched and appear delicate and pointed, while the shadow shows a boxy foot and the shoes squared at the toe.

The CIA has maintained an open curiosity about the health and ailments of foreign leaders with special emphasis on cancer, heart conditions, and kidney functions.[19]

The spread of French President François Mitterand's prostate cancer was carefully monitored by the CIA. His taking of cortisone caused considerable swelling of his face and neck. Some of his official photographs were carefully retouched.

When Leonid Brezhnev's health began to fail, the CIA arranged for him to sit in a soft chair on foreign visits, where he would be filmed and his difficulty in rising from the chair could be recorded. His many wrinkles were always removed in Soviet publications.

Kim Il-Sung, the late North Korean leader, had a rather large lymphoma on the base of his neck, which was always brushed out in any official photograph.

Soviet premier Aleksei N. Kosygin had a large Hutchinson's freckle, a tumor arising from cells which produce melanin, the dark pigment found in skin and hair, on his cheek. In all of the official photos distributed by the Soviets, the freckle was brushed out. There was concern about the freckle, since about 15 percent of such freckling turns into malignant melanoma, which is a fatal type of cancer. Later, Mr. Kosygin had the freckle surgically removed.

The rose-colored birthmark on Mikhail Gorbachev's head has been removed from many of his official photos.

UFOS

It would be remiss to author a book about photo fakery and not include a discussion of unidentified flying objects (UFOs)—aerial objects or optical phenomena not readily explainable. This inclusion, however, will not attempt to document or evaluate the many photos that have been collected, but rather to cite some representative examples of photos that have been evaluated by experts.

There can be little doubt that the fear of a breakthrough in military

UFO PHOTO
Air Force experts, after detailed analysis, said this photo was a hoax.
U.S. Air Force Museum.

developments by the Soviet Union heightened the interest in UFOs. In 1948, the U.S. Air Force began collecting and maintaining a file of photos and reports of UFO sightings under Project Blue Book.[20] Analysis of the photos often revealed that many could be attributed to film defects, soot, grease marks, drops of moisture, lint, lens flare, movement of the camera, overlapping exposures, lens out of alignment or atmospheric phenomena. It was also known that some photographers submitted images for the sheer joy of confounding experts. One favorite trick was to flip a hub cap or a large plate up in the air and photograph it. No explanation was possible for some. After detailed analysis of all the photos collected, the Air Force categorized the photos into one of three categories: hoaxes; insufficient data for analysis; and those with rational explanations.

In 1968, the noted scientist Dr. Edward U. Condon conducted an extensive study and recommended against further scientific study of the UFO phenomenon because the field did not appear fruitful for any major discoveries. The U.S. Air Force canceled its seventeen-year Project Blue Book on December 17, 1969.

The testing of the high-flying U-2 and SR-71 spy planes accounted for a rash of UFO reports. There were thousands of sightings; several photographs were taken of the sun striking a U-2 and giving off a large ball-like reflection. There were also photos of the fiery trail the SR-71 can leave under certain atmospheric conditions. In August 1997, the CIA admitted in an article in a declassified version of *Studies in Intelligence* that over half of all UFO sightings during the 1950s and 1960s were accounted for by manned and secret reconnaissance flights.

The detection of fake UFO photos has been difficult enough. New computer technology will make it even more difficult in the future. Brad Dorn, president of Printbox, Inc., usually uses his sophisticated computer equipment to generate ad images for Madison Avenue clients. He maintains that he could use his machines to manufacture UFO images that could defy the best of experts.[21] According to Steve Gutman of Adobe Systems, sophisticated UFOs can be created on a relatively inexpensive PC-DOS desktop computer or a Macintosh.

FAKE PHOTOS DURING POLITICAL CAMPAIGNS

Although fake photos are frequently used in political campaigns, most of them are rather harmless and readily recognizable as publicity-gathering devices.

During the 1980 presidential campaign, Ronald Reagan was the subject of a series of derisive montages designed to ridicule him. The May 1980 issue of *Washingtonian* featured Reagan on the cover as a muscular weight lifter displaying a hefty biceps. The cover emphasized an arti-

UFO Photo
Top: Analysis revealed these UFOs to be lens reflections. *U.S. Air Force Museum.*

Bottom: The Air Force indicated there was insufficient data to determine whether or not this photo was a hoax. *U.S. Air Force Museum.*

cle entitled "Secrets of Eternal Youth." The magazine did explain, however, that the body was that of an eighteen-year-old university student.

The Democrats also engaged in a bit of photo fakery during the 1980 presidential campaign. The Democratic National Committee prepared a brochure entitled "Small Town America Can Depend on Jimmy Carter." After the text was completed, the authors searched for appropriate photographs to illustrate the brochure. They chose a photograph of the President signing the Rural Development Act. Republican congressman John Paul Hammerschmidt was in the photo. Thinking it would be bad politics to include a Republican in a Democratic brochure, he was brushed out of the picture, but he reaped a bonanza of publicity from the Democrats' bungling.[22]

CAMPAIGN PHOTOGRAPHY
This image is from a televised
campaign ad for Senator John Warner,
R-VA. It shows Democratic challenger
Mark Warner shaking hands with former
Governor L. Douglas Wilder as President
Clinton looks on. In the original photo,
Wilder was shaking hands with Democratic
Senator Charles S. Robb. In this altered
imaged, Mark Warner's head replaces
Robb's. John Warner blamed the
alteration on the media consultant who
produced the ad. *AP Wide World Photos.*

During the 1994 campaign, photographic morphing techniques proliferated in over thirty congressional campaigns. A number of challengers had incumbents' photos slowly morphed with President Clinton's photos with telling effect—capitalizing on the widespread unhappiness with the President's performance.[23] Visual impact was the key to the Republican ads. In an ad in Alabama, Republican Charlie Graddick linked Democrat Don Siegelman with Clinton, Surgeon General Joycelyn Elders, and Health and Human Services Secretary Donna E. Shalala and then morphed Siegelman into President Clinton. Representative Dan Rostenkowski and Senators Ted Kennedy and Jim Sasser were morphed onto Mount Rushmore.[23] Criticism about the Clinton administration led to comparisons of Clinton to former President Carter. Clinton's image was morphed into Carter's.[24]

During the 1996 senatorial campaign between John Warner and Mark Warner in Virginia a photo was altered to show Mark Warner as a liberal political insider. A photo taken in October 1994 shows former Governor L. Douglas Wilder shaking hands with Senator Charles Robb before President Clinton. In the altered photo Mark Warner's head appears on Robb's shoulders.

PHOTO FAKERY IN THE INTERNATIONAL ARENA

It is not only the Communists who doctor photos. I have spotted a number coming from Middle Eastern countries. Many of these are not done very professionally.

Palestinians working out of Beirut released a number of fake photos, many condemning the Israelis and other opponents. As early as 1977 at

its Oslo meeting, the International Press Institute examined fake photographs and captions coming from Beirut. One photo of a supposed Israeli air raid made the front page of *The Washington Post*. Careful examination of the photo shows that the bombers were mirror images. Experts also concluded that the Israeli bomber shown could not have executed such a maneuver so close to the ground.

Another photo, which was awarded a prize in 1977, bore the caption, "One can see how an old Palestinian woman is begging a Phalangist soldier not to separate her from her children, while the [Beirut] area of quarantine is burning and small children are raising their hands." The uniformed soldier can be identified as a Palestinian by his weapon, an American M-1. The Phalangists were armed with the Soviet AK-47.[25]

Libya has a history of fabricating photos. Its leader, Mu'ammar Qaddafi, has threatened and in return has been threatened by the United States and his neighbors. During President Carter's administration, Qaddafi began to show his military strength by displaying new weapons obtained mainly from the Soviet Union. Many photos appeared in the Libyan press, but most were poorly created montages that were laughed at by both the Carter and later the Reagan administrations.

When Dr. Konrad Adenauer became chancellor of West Germany in

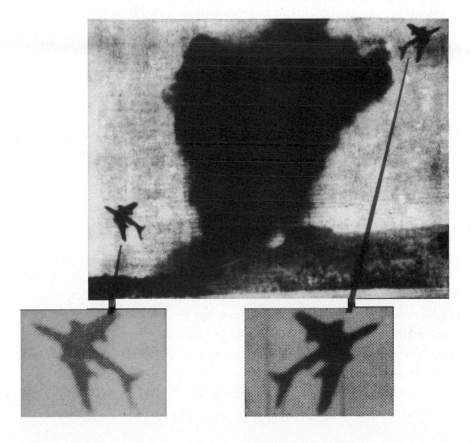

INTERNATIONAL PHOTO FAKERY
Faked photos are often released by spurious organizations in the Middle East. This photo of a purported Israeli bombing raid was closely analyzed. The images of the bombers are mirror images. Aircraft experts also concluded that a bombing maneuver executed so close to the ground would be extremely dangerous. *Central Intelligence Agency.*

1949, he advocated that a strong and united position be taken against the Russians. When Adenauer became a supporter of NATO, the Russians began a strident campaign to portray him as Hitler's heir and West Germany as a persistent threat to Eastern Europe. The East German press took up the call and a photomontage was created depicting Adenauer in a Nazi uniform. This montage was given wide circulation in the Communist press. The West Germans quickly countered with a montage of Walter Ulbricht, the East German Communist leader, showing him with a dejected face in a Russian's private uniform. To poke further ridicule at Ulbricht, the West Germans claimed that it was the highest rank he had ever attained with the Soviets. The photomontages of Adenauer stopped.

WARTIME PHOTO FAKERY

In wartime, many photo fakes are perpetrated. Released along with true photos, they can have an enormous propaganda impact. The Germans during World War II were especially adept at faking photographs for propaganda purposes. They created newsreels of faked events, faked battle scenes, and even created fake heroes. One of the most impressive publications was the magazine *Signal*, the brainchild of Dr. Paul Leverkuehn, an intelligence officer and propaganda specialist. This highly effective propaganda weapon, printed in over twenty languages, with a staff of nearly 5,000 reporters, cameramen, and translators, made extensive use of color photography, a medium new for that period.

It is extremely difficult for a photographer to focus on the point

where an incoming artillery round or bomb will hit. To photograph an explosion at the height of its burst requires a brave cameraman who could be hit by shrapnel. Many of the *Signal* photos bore captions like "a damned close shot, luckily heads were lowered in time," etc. What wasn't revealed was that most of these photos were staged in training areas in Germany rather than in combat.

Air-to-air photography, especially of planes involved in high-speed dogfights, is particularly hard to achieve. Most of the best combat photographs in the air during World War II were taken with gun cameras. In one issue of *Signal*, there is an excellent photo of an Me-109 closing in on a Spitfire. The caption reads: "In the cloud covered English skies it is the same story every day. A Messerschmidt has discovered a Spitfire and turns toward it. The hunter becomes the hunted. The RAF pilot banks down and away, trying to escape; but the Messerschmidt stays with him, gains on him and peppers him with machine gun fire until he crashes."[26]

What the creator of this photo did not know was that every marking on an airplane has a specific meaning or reason. On the Spitfire in question, various insignia and letters were incorrectly placed. The conclusion: It was probably a made-over Spitfire that had crashed in France. The photo was obviously staged.

POSTERIZATION

Posterization lies on the fringe of photography and graphic arts but it is a photographic technique. Normally, a photographer strives for a maxi-

INTERNATIONAL PHOTO FAKERY
Above left: The Communists portrayed Konrad Adenaur as a modern-day Hitler and gave wide publicity to this montage. *Central Intelligence Agency.*

Above right: The West Germans retaliated and portrayed East German Communist leader Walter Ulbricht as a Russian private. *Central Intelligence Agency.*

POSTERIZATION
The Soviets frequently portrayed the
United States as a racist country and
often used posterization techniques
in publications released in Africa.
Central Intelligence Agency.

mum number of subtle shades of gray to delineate detail in an attempt to
achieve exquisite precision. However, some subjects are best rendered
in solid black-and-white tones to produce a harsh and raw force. Further
graphic starkness is often achieved by deliberately exaggerating the con-
trast. In the Western world, the most effective application is usually
found on posters or advertising materials.

Posterization is widely used by artists, designers, and architects be-
cause it emphasizes sharper and purer lines. Starkness in a photograph
can best be achieved by a sharp delineation of tones. A dark tree in a
field of snow is a good example. It is characterized by a small number of
tones; the simplest consists of two tones—black and white. More com-
mon are three- and four-tone posterization. A four-tone print consists of
black, white, light gray, and dark gray which delineate detail in exquisite
precision. In these harsh tones, almost all detail is lost but this lack sup-
plies raw force and produces unique and dramatic effects. Posterization
lends itself to dramatic impact, especially of scenes that may be repug-
nant.

The Soviets used a variety of posterization techniques in attempts to

depict harsh or unfavorable scenes in the United States. Scenes depicting racial violence, lynching, or maltreatment of minorities were frequently used. Probably one of the most effective posterization campaigns was one that the Soviets employed in Africa. The United States was portrayed as being aggressively racist and imperialist, and stark photos of blacks being hung or beaten by whites were featured in a publication released in Africa.

When these photos were released, or used in publications, they were never attributed to real governments or real persons or organizations. Often they were attributed to groups or associations which, when investigated, proved to be nonexistent. One of the best examples of such a publication was the "Dear Friends" leaflet distributed by a phantom "African Friends Association" and publicized to the U.S. Congress.[27] Another example of such pamphlets, "America Has Colonized 20 Million Negroes," was cited by Ladislav Bittman in his book *The Deception Game* as a virulent propaganda piece given distribution in Africa.[28]

7

Photo
Manipulation

While "photo fakery" has a sinister sound, "photo manipulation" has less of a negative connotation. The many computer advances that have made it relatively easy to create a fake photo also bring benefits that should be cited. I will dwell primarily on those that are being used by law enforcement or private organizations to aid in the identification of missing persons; the fields of science and education have also benefited.

This new computer technology has a great future in making difficult issues understandable. With considerable care and planning information can be presented in a manner that is not only informative but entertaining.

PHOTOMONTAGING FOR BETTER UNDERSTANDING

The ability to photograph some of the details of the planets in our solar system became a reality with the inception of NASA's deep space program. While the photographs obtained from the program were studied in depth by scientists, engineers, and astronomers, the presentation of the derived data for public consumption presented problems. The general public has little knowledge of the planets, much less their satellites

PHOTOMONTAGES OF PLANETS
To show relationships that cannot be photographed in a single exposure, NASA has made effective use of photomontages by various Voyager spacecraft missions. The relationship of the moons in the Saturnian system is shown here. *National Aeronautics and Space Administration.*

or moons. NASA, on occasion, has resorted to creating montages made from a number of images to depict the various planets and what their systems look like. Artistic work is often added to give the montages added dimension and realism. The montages are created to compensate for the limitations of the various lenses and the camera systems employed. Current systems do not have the depth of field or lenses to capture and record on one frame an entire planet and its satellite moons.

There has always been considerable interest about Saturn and its moons. One of the most dramatic scenes created by NASA was a montage of the Saturnian system. It was carefully constructed from an assemblage of images taken by Voyager I during its passing of Saturn in 1980. Saturn and its moons were reduced to an appropriate scale and computations were made as to the relative positions of the moons and the planet. The resulting montage shows Saturn and its ring along with its six moons. Details of the moon Dione can be seen in the foreground, with Saturn in the background. Tethys and Mimas are shown in the distance on the right. Enceladus and Rhea are off Saturn's rings to the left and Titan is in its distant orbit at the top of the photo.

COMPUTER-ASSISTED PHOTOGRAPHIC SUPERIMPOSITION

It is often possible to reconstruct face lines from skulls using modern computer superimposition technology, which allows for rapid compari-

sons of faces with skulls. In the past, there have been instances where photographs taken of a person before death have been superimposed on a recovered skull and aligned to bring out the points of similarity or dissimilarity between the photograph and the skull.

Dr. Josef Mengele, the notorious "angel of death" at the Auschwitz-Birkenau extermination complex, was sought by the Allies after the war. Eventually the Israelis and American Nazi-hunter Simon Wiesenthal took up the chase. In 1985, a dedicated and painstaking search to find him was launched by the U.S., Israel, and West Germany. The Mengele family, at this point, had not revealed any information about his whereabouts. The search took an unexpected turn when West German investigators raided the home of Hans Sedlmeier, an officer of the family firm Karl Mengele and Sons. Sedlmeier had boasted that he had delivered money to Josef Mengele abroad. A search in Mengele's hometown of Gunzburg revealed letters by the doctor and others to Wolfram and Liselotte Bossert, an Austrian couple living in Sao Paulo, Brazil. When contacted, the Bosserts claimed that Mengele had been buried as Wolfgang Gerhard in Embu, Brazil, after drowning February 7, 1979, at a Brazilian beach resort. On June 11, Rolf Mengele, the son of the Nazi doctor, finally declared that the body in Brazil was that of his father.

The body was exhumed by Brazilian authorities, and Brazilian, West German, and U.S. experts began a battery of tests to determine whether the exhumed remains were those of Mengele. Among the experts were David A. Crown, a former CIA lab expert, and Gideon Epstein, an analyst at the Forensic Document Laboratory at the U.S. Immigration Service. A number of tests were performed, including superimposition techniques in which photos of Mengele were superimposed on the skull; they matched neatly. In addition, tests conducted on the skeleton matched Mengele's height, and its estimated age range was consistent with Mengele's age in 1979. Experts also pointed out that the bones bore marks of injuries that Mengele was known to have suffered.

On June 21 at a press conference in Sao Paulo, the experts released their findings. Later U.S. Attorney General Edwin Meese said in Washington that the United States and Israel had accepted the scientific identification of the skeleton as being Mengele's.

The same techniques were used for the identification of Czar Nicholas and his family. On the night of July 16, 1918, Czar Nicholas II, his wife, Alexandra, their daughters, Olga, Tatiana, Maria, and Anastasia, and their son, Alexis, along with five of their servants, were brutally murdered by their Bolshevik captors. Rumors persisted for years about what had happened to the bodies. There were reports that their bodies were dismembered and burned. Another version was that the bodies had been thrown down an abandoned mine shaft. There remained a fas-

cination about their deaths; it was rumored that at least one member of the family, Grand Duchess Anastasia, had survived. Anna Anderson of Virginia, who claimed right up to her death that she was Anastasia, was the subject of many articles, several books, and a Hollywood movie. Rumors also persisted that Czarevitch Alexis had escaped and was living in Brazil.

In 1979, a mass grave was discovered in Russia, from which nine skeletons, five male and four female, were recovered. The skeletons in Russia "showed traces of violence and mistreatment before death, which match the existing accounts of the murders."[1] The skull of Nicholas had been fractured and bullet marks were found. Computer specialists led by Sergei Abramov, director of new technologies for the Russian forensic medicine service, used superimposition techniques on the skulls along with other forensic methods. For example, the identification of the skull of the empress was aided by the fact that she had false teeth made of porcelain and platinum.[2] It was also fortunate that there were many photographic "head on" and profile views of the czar and czarina that allowed for computer superimposition of their skulls from several views.

While Russian experts are firm on their identification of the czar and czarina, they maintain that the identification of the skulls of the czar's daughters remains difficult since they were very close to the same age and had similar features; their skulls were damaged, and bones were missing. The skulls of Anastasia and Alexis have not been found, adding to rumors that their lives had been spared.

Despite the photographic analysis, divergent views persisted on whether the bodies unearthed were those of the Romanovs.[3] It wasn't until the bones underwent DNA testing that it was agreed almost universally that they were. After her death, DNA tests of Anna Anderson's tissues proved she was not Princess Anastasia.

In the United States, the FBI, along with Douglas H. Ubelaker of the Smithsonian Institution, has also made tremendous advances in the use of computer-assisted facial reproductions. The technique was developed to use computer technology in order to reproduce facial images from skeletonized human remains and to superimpose images of recovered skulls with facial photographs to determine if they could be from the same individual. The technique requires the collaboration of a computer specialist from the FBI and a skeletal anatomist forensic anthropologist.[4] Ubelaker, often referred to as the FBI's "bone man," helped identify the dead at the David Koresh compound and determine how they died.[5]

The FBI has on file photos of missing persons that can be compared to a given skull discovered by law-enforcement personnel. Such was the case, in January 1978, when a hunter discovered a human skeleton pro-

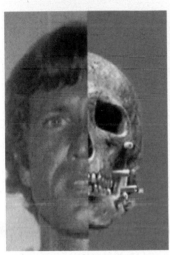

COMPUTER-ASSISTED
PHOTOGRAPHIC SUPERIMPOSITION
A new computer-assisted superimposition
system allows for the comparison of a
facial photo with a skull as a faster, more
accurate technique for identifying an
unknown dead person.
Federal Bureau of Investigation.

truding from frozen ground in Ohio. Anthropologists from a local university suggested that the skeleton was that of an adult black female. The age at death was estimated to be between thirty-seven and forty-seven. Neither dental nor other medical records were available to allow positive identification, and there was evidence that the victim had died from a gunshot wound. In subsequent years, evidence accumulated that the skeleton might be that of a locally missing black woman. In January 1991, thirteen years after the discovery, the skull, along with a photograph of the possible victim, was sent to the FBI. Once the skull and the photo were properly oriented, the comparison revealed an apparent match.[6]

Images on photographs can be digitized, compared, and manipulated and photographic superimposition normally has been confined to differences between two images. The art of juxtaposing is not limited to photography. Juxtaposed images of the Mona Lisa and Leonardo da

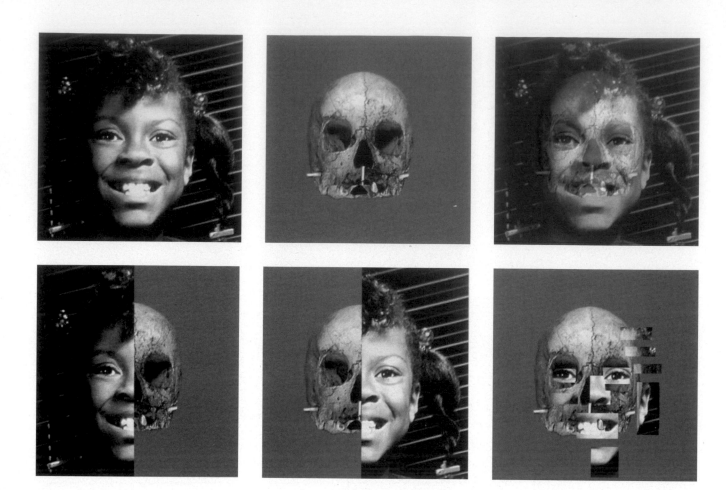

COMPUTER ASSISTED
SUPERIMPOSITION
There are a number of stages involved in
the careful matching of human features
with a recovered skull. Frontal photos are
preferred, but FBI experts have also used
this system when only side views were
available for comparative purposes.
Federal Bureau of Investigation.

Vinci created interesting results. Some maintain that in the absence of the original sitter, probably Isabella, Duchess of Aragon, Leonardo used himself as a model.

This has opened a new and wide field of endeavor. For example, in the search for an image of the real Shakespeare, paintings of Shakespeare have been compared to Francis Bacon, the Earl of Oxford, and even with Queen Elizabeth I.[7]

MACHINE-ASSISTED CHANGE DETECTION SYSTEMS

The intelligence community pioneered "change detection" photographic systems. Comparisons are made electronically between two different aerial or satellite images over the same target but taken at different times. The photos are scanned and changes that have occurred between the two images are highlighted or printed in a different color. The machines, however, do not draw conclusions as to what the changes mean. The changes must be carefully analyzed by experts.

These same detection systems show enormous promise in the med-

ical field. The Department of Defense has teamed up with the Department of Health and Human Services to create a new science called "digital mammography," which will reveal substantially more data than the conventional one. Images of a small spot imaged in a breast can be viewed from different angles and manipulated, allowing radiologists a greater confidence in their analysis. Images of previous years can also easily be compared with current ones.

Change detection systems have been used in a number of civilian disciplines. They have proven to be especially beneficial in allowing comparisons of before and after photos of floods and hurricanes. Emergency planners have a new and versatile assessment tool.

COMPUTER-ASSISTED FACIAL REPRODUCTION

The FBI created the Facial Identification Catalogue which allowed not only FBI agents but also other police departments to send witnesses' descriptions to the FBI laboratory in Washington. A witness would pick out hair styles, facial contours, eyes, nose, lips, etc., that would clearly identify a criminal in wanted posters. If the criminal wasn't immediately captured, and years passed, there was an additional problem of attempting to show how the criminal might have aged.

In recent years, however, the FBI, again with Ubelaker of the Smithsonian Institution, has made tremendous advances in the use of computer-assisted facial reproduction.[8] Using equipment designed to show age progression has applications in identifying missing persons.

When skeletal remains, including the skull, are received, experts place tissue-depth markers at selected sites around the skull. The skull is photographed and an artist sketches in appropriate facial details.

Facial components are selected from a large FBI hand-drawn database of drawings "showing variations in the eyes, noses, ears, chins, facial hair, scars, complexions, cheeks, hairstyles, etc."[9] The database can be scanned to facially reproduce what the victim may have looked like.

On September 19, 1990, a cleanup crew in North Carolina found a partially clothed and severely decomposed body of a young Caucasian female. Examination suggested a height of about five feet and three inches, brown or blond hair color, and an estimated age of death of less than twenty years. The head was partially skeletonized, with extensive decomposition of the face. Although dental restorations were present, the remains could not be matched with local missing persons and no positive identification could be made. The FBI brought the skull to Ubelaker, who, with Gene O'Donnell, an FBI visual information specialist and artist, began to work. Ubelaker indicated that the racial affiliation was white and the age at death was estimated to be between fifteen and

nineteen years. The Smithsonian's anatomical data for females and specialized computer equipment were used. Appropriate facial components, selected from the FBI database of hand-drawn drawings of facial variations, were merged with the digitized image of the found skull on the computer screen. The artist and the anthropologist produced the likely image of the face of the found skull.[10]

The body of a young man remained unidentified until the FBI was asked to help. Using the facial reconstruction techniques described above, Gene O'Donnell created an image of what the young man probably looked like. The reconstruction was shown on television and within an hour the victim was identified.

Another computer-assisted facial reconstruction of a middle-aged male was accomplished. The victim has, as yet, not been identified.

COMPUTER-ASSISTED FACIAL REPRODUCTION
The reconstruction begins with attaching average tissue-depth markers on a skull and photographing it. Individual features such as eyes, nose, and hair are custom drawn. Gene O'Donnell, the FBI's expert in this field, created this image. When it was shown on television, the victim was identified within an hour. His actual photograph appears at the lower right.
Federal Bureau of Investigation.

COMPUTER-ASSISTED
FACIAL REPRODUCTION
This victim has not, as yet, been
identified. *Federal Bureau of Investigation.*

COMPUTER FACIAL IDENTIFICATION TECHNIQUES

Since most police departments do not have forensic artists available, many use manual composite systems such as PhotoFit or Identikit to assist a victim or a witness in recalling a face involved in a crime. New computer technology is revolutionizing the old craft of piecing together information on criminals based on descriptions provided by victims, eye witnesses, or from sketchy information. A new computer technology called EFIT (Electronic Facial Identification Technique), begun as a project for Scotland Yard, now adds both speed and diversity in the creation of facial composites.[11] The idea is to get a composite done while it is still fresh in the victim's mind. The computer has an advantage over the artist, who may take hours or days to render a sketch.

The witness sits down with a computer operator who uses a computer program to produce a sketch of what the suspect may have looked like. It is a step-by-step process to create a face. The victim begins by describing facial features in any order. Images are displayed on a screen to be viewed by the victim. There is a huge database to draw from. When a victim or witness gives a description, similar features are automatically selected from the data base. There are libraries of information on eyes, nose, ears, earrings, scars, skin blemishes, dimples, eye bags, wrinkles, facial lines, etc. For example, the database contains hundreds of hair styles, 54 different kinds of eyeglasses, and 108 hat variations. Computer controls allow features to be moved or resized. When a victim or witness becomes sure of any size or position of a feature, the operator can lock in that data so that subsequent features attain the same size or position. The operator, with the victim's help, can alter a hair line, retouch facial details, and add skin blemishes or scars. Once an image is complete, it can be printed immediately or distributed directly from a workstation.

In the Baltimore Police Department, thirty-six composite drawings have been made, leading to fourteen arrests in cases from homicide to bank robbery to rape.[12]

This system also allows for the identification of victims from a morgue photo of a mutilated or partially decomposed face. Through such technology the reconstruction of facial and other features from skeletons or badly decomposed bodies can be accomplished.

AGE-PROGRESSION EFFORTS

Losing a child is the greatest nightmare of any parent. An increase in child abductions in the 1970s and 1980s led the FBI to seek newer and faster methods in forensic art. The computer can aid in age-progression efforts in forensic art. One of the most innovative and productive uses of the computer with photos is occurring at the National Center for Miss-

1. The first step in considering an age progression of a missing child's facial image is the collecting of family photographs and videotapes. Images are needed of close biological relatives—the mother, the father, and older siblings who are near the missing child's present age. These reflect valuable information about growth, family likeness, and unique features and facial patterns influenced by heredity. The quality of the images should be good and in the same pose as the missing child. Figure 1 is the last known photo of a missing child before her abduction at age three.

2. Child's photo scanned into computer and stretched for merging with nine-year-old brother.

3. Nine-year-old brother.

4. Three-year-old stretched photo merged with nine-year-old brother.

5. Result of merger.

6. Photo of a nine-year-old girl from reference file chosen for hairstyle and dress.

7. Photos merged to transfer hair and dress to missing child's aged image.

8. Final age-progressed image as nine-year-old.

9. Recovery photo.

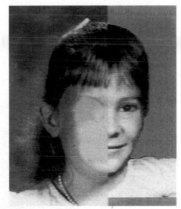

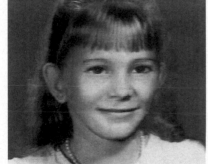

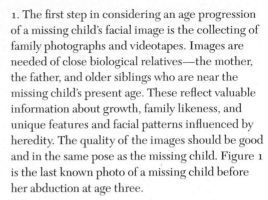

COMPUTER AGE
PROGRESSION EFFORTS
One of the most successful efforts in aging has been accomplished by the National Center for Missing and Exploited Children. With modern computer techniques and using sibling and family photographs along with videotapes, they have been extremely successful in portraying a missing child's present age. *National Center for Missing and Exploited Children.*

ing and Exploited Children (NCMEC) and at the Federal Bureau of Investigation. At both, the purpose is to provide an updated photo of a child or individual who has been missing for some time.[13]

At the NCMEC, Horace Heafner and Glenn E. Miller, using state-of-the art hardware and software, are able to take a photo of a child and show what he or she might look like years after the abduction. The photo of a missing child is first reproduced and enlarged on a computer screen. The child's photo is scanned on the computer and "stretched" to match the skull and facial growth of the child's age. Family portraits of older siblings or photos of parents when they were the age of the missing child are then merged with the missing child's photo. By limiting the selection within the biological family, the computer technician can impart family likenesses and features. According to Heafner and Miller, the eyes, bridge of the nose, and teeth are most important in creating the new image. The technicians can use the computer mouse as an electronic paintbrush to highlight some features while subduing others. Any pertinent identifying information, such as moles and scars, is also carefully added. Finally, age-appropriate hair styles and clothing are added. The enhanced photo is sent to the parents for approval and then reproduced on flyers. This technology fills a vital role: it speeds up the process since speed plays a crucial role in a missing child investigation. The software accounts for features changed with age. For example, a child's eyes will not get much bigger, but the head does; and girls' heads stop growing earlier than boys. As of March 1999, these two men have "aged" the photos of 830 missing children; 196 have been found. The changes are artful, subtle, and the photos are remarkable likenesses.[14]

A similar method is used to age photographs of adult subjects. In this case, family photographs are not incorporated with photographs of the subject to achieve the aged image. The addition of facial lines, addition or removal of hair, increase or decrease of body weight, and change in hair style are the most common factors in the FBI process.[15] The FBI, for example, used these techniques to show how American flyers shot down in the Soviet Union during the Cold War might look today.

The FBI developed the Facial Identification Catalog, which allowed field officers to send local witness descriptions to the FBI laboratory in Washington. What a criminal or a missing person might look like years in the future then became the question. The FBI was the first to use composite drawings and continued to use this technology in an attempt to apprehend criminals. Now, with age-enhancement methods, new data can be layered over original data and people missing for over thirty years can be portrayed.

Nancy Burson, a leading exponent for digitized portraits, has created a number of them with political, cultural, or humorous overtones. For

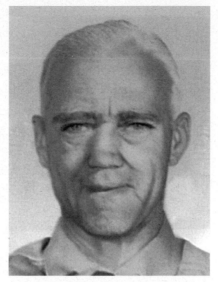
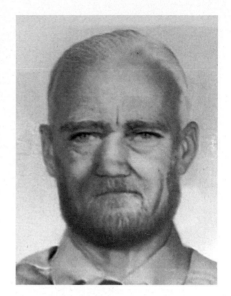

example, she exhibited portraits of how the British royal family would look in the year 2110. When a dying mother wanted to see how her child of five would look at eighteen, Burson created the image.[16] She has also combined photos of prominent persons to highlight differences and similarities. One of the most striking was a combined photo of Joanne Woodward and Paul Newman.

THREE-DIMENSIONAL REPRODUCTION (FORENSIC ANTHROPOLOGY)

When conventional avenues have failed to produce the desired results in finding or identifying an individual, a three-dimensional reproduction is often prepared by anthropologists and artists. The reconstruction of head and shoulders of individuals has been done from either photographs or skulls.

If a body is not available, one method is to take measurements from a number of photos of the individual and sculpt the features in clay. Glass eyes, wigs, and clothing are added to make the reproduction as lifelike as possible. This technique has been widely used in recent years to portray a number of criminals who have been missing for extended periods. To identify decomposed bodies, measurements can be taken from photographs and tissue-depth markers placed at selected sites about a recovered skull. Clay is then sculpted between the markers to recreate the fine features of the face. Again, glass eyes, wigs, and often clothing are added to make the reproduction as lifelike as possible.

Reproductions have also been used on TV programs. *America's Most Wanted* showed not only photos but used a reproduction of John List, a

COMPUTER AGE
PROGRESSION EFFORTS
The FBI has used computer-assisted efforts in locating criminals who may be missing for extended periods. The FBI used similar techniques in aging American flyers who were shot down over the Soviet Union during the Cold War.
Federal Bureau of Investigation.

murderer who had evaded the law for many years. Within hours after the remarkable reproduction was shown, List was apprehended near Richmond, Virginia.

One of the most famous anthropological reproductions was of a prehistoric male now known the world over as "The Iceman."[17] On September 19, 1991, a German couple hiking near the Italian-Austrian border stumbled across a perfectly preserved corpse under melting glacier ice. Before a forensic team had arrived from Innsbruck, Austria, some damage had occurred to the body and clothes as well-meaning hikers and officials tried to free the Iceman from the ice. Only when the archaeologists viewed the body and its belongings in a laboratory was the Iceman's antiquity revealed. There was immediate speculation that the Iceman was an elaborate hoax—a stolen Egyptian mummy or a body from an ancient civilization in South America that had been conveniently planted near a well-trodden path. Even those convinced of the authenticity of the Iceman conceded it was extraordinary that the body had survived virtually intact for thousands of years under tons of slow-moving glacier ice before turning up near a well-trodden path. There were many assumptions as to how and why the Iceman had died; among them that the

THREE-DIMENSIONAL REPRODUCTION
Three-dimensional computer images, X-rays, and CT scans were used to reconstruct what the "Iceman" may have looked like when he died centuries ago in the Alps. *Kenneth Garrett.*

corpse had been an accident victim or that he was drunk and had passed out in a snowstorm. Radiocarbon dating on the mummy, the berries, the sewing gear, and the fire flints found on him show them to be about 5,000 years old.[18]

From a series of photos, measurements, three-dimensional computer images, X-rays, and CT scans produced by the Anatomy Institute of the University of Innsbruck, John Gurche began to create a bust of how the ancient traveler might have looked in life. In addition to the above-listed data, Gurche used anatomical data from European data banks as well as his own interpretations. Using clay, he fleshed out the muscles and fatty tissues of the face. He reconstructed nasal cartilage and positioned glass eyes. Using soft urethane, tinted to suggest a wind-burned skin and adding human hair, he created an almost realistic model of how the Iceman might have looked on the day he died. It was one of the most realistic such models ever made.

Recently, three old lead-lined coffins were discovered in a cornfield in Saint Mary's County, where the first capital of Maryland once stood. The lead indicated the coffins were rare and expensive. It was immediately assumed that the bodies inside the coffins were important personages of early Maryland. The discovery prompted a major scientific investigation into the history of early America. In "Project Lead Coffins," over 150 specialists from across the United States and Canada analyzed samples of hair, bone, pollen, insects, and other detritus of death. Research resulted in the identification of Anne Wolseley Calvert, her husband Philip Calvert, a member of Maryland's founding family, and a six-month-old girl, whom specialists guess to be the child of a seventeen-year-old woman whom Philip married after Anne's death.

Anne Calvert died in 1679 or 1680 and was buried "very lovingly," according to Henry Miller, the director of the project. To give the press and media a better idea of what Anne looked like in the prime of her life, a bust was made by forensic artist Sharon Lange. At a press conference on April 6, 1994, the identification of the bodies was announced and the bust was shown. The bodies were reinterred at the same location.[19]

MORPHING

One new computer-created entertainment vehicle that not only captures our imagination but also holds our attention is "morphing." "Morphing," a contraction of the word "metamorphosis," is a computer-generated illusion in which an image of one object or person is smoothly transformed into an image of another. This technique has been used in movies and commercials; the viewer who sees them is generally impressed and delighted with the result. This technique makes the impossible completely believable and, usually, is most entertaining.

The technology dates from the 1988 movie *Willow* and was developed by George Lucas's Industrial Light and Magic special effects company. In *Willow*, animals change from one species to another. The movie was followed in 1989 by the deep-sea drama, *The Abyss*, which featured a "pseudopodia," which at one point shapes itself into human faces. In Michael Jackson's music video "Black or White," faces of children from different ethnic backgrounds are melded into one another. The highlight of the video came when Jackson morphed into a panther.[20]

The first impressive morphing ad to catch the public eye was EXXON's, in which a speeding car ripples into a tiger. The tiger was filmed running on a blue stage against a blue screen on a Hollywood indoor stage and at a ranch in California. This allowed a matte, or a clean image of the tiger at full stride. In all, four tigers had to be used, because some did not perform as the directors wanted. Older tigers have more photogenic faces, so they are used for close-up shots. Young tigers, however, run and jump better. The bronze car was filmed on a twisting road among Nevada's Valley of Fire's red cliffs. A shot of the cliff behind the car was taken at the same film speed that the car was going. The foreground shot of the car was made using a truck, traveling at the exact speed of the car, that had a 40-foot blue screen attached. The blue screen dropped out in film editing, leaving only the image of bushes whizzing by.[21] Although the action in the commercial took only seconds, the transformation was not only eye-catching but also appealing.[22]

To make more complex morphs requires the design of an idea that can be backed up with banks of near-super computers, dozens of software programs, the talents of scores of graphics engineers, and frequently

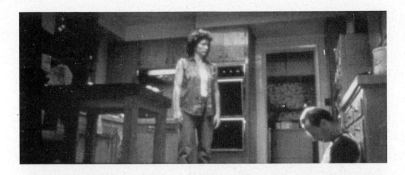

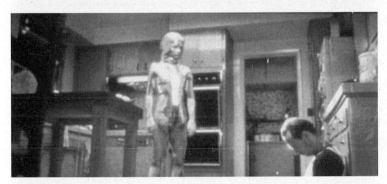

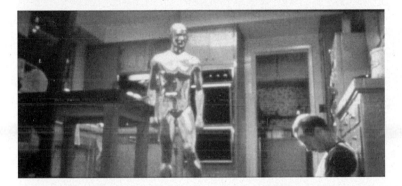

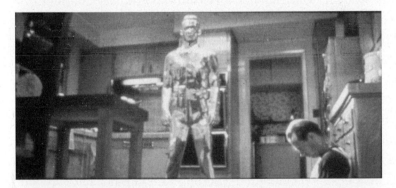

MORPHING
One of the most amazing morphs was a robot's transformation from a woman to a metallic state to actor Robert Patrick in the film *Terminator 2: Judgment Day*. *Lightstorm Entertainment.*

requires the skills of model makers. One of the most complex morphs appears in the movie *Terminator 2: Judgment Day* when a liquid metal "polyalloy" robot from the future transforms itself into a police officer with self-healing bullet holes, a woman, a checkerboard floor, a knife, and passes fluidly through a security gate. One of the most spectacular effects occurs when the robot walks out of the burning wreckage of a truck in a Los Angeles flood-control channel and is transformed from a metallic state to become the actor Robert Patrick.

In the *Young Indiana Jones* TV series, numerous morphing techniques were used to make the series a delight to watch. In the episode "True Lies," there is a terrifying scene in which a janitor is traumatized by a jump-jet crashing into the office he is cleaning.

An innovative and technically sophisticated Oldsmobile commercial features a woman at a cocktail party disappearing into a painting and driving an Aurora along its brushstroke highways. Another, titled "Assembly," features a couch-bound man who drifts into space to find his Aurora automobile being assembled by astronauts in space. As computerized robotic arms twirl in motion and sparks fly, his car is assembled and painted in space.[23]

During the 1994 Christmas season, Chanel launched a multi-million-dollar campaign. A young woman is shown in a movie theater eating popcorn while watching a film in which Marilyn Monroe is splashing on Chanel No. 5 perfume. The model's hairline suddenly changes, her blouse pops open and her face is morphed into Marilyn Monroe's. The ad contains black-and-white footage of Monroe, then transforms Monroe into Chanel-style clothing and colors to match the model while she sings "I Want to be Loved by You." Monroe morphs back to the woman, who clutches a perfume bottle and continues to watch the movie.[24]

In addition to Industrial Light and Magic, other companies such as Digital Domain have entered the market with a cockiness that is best explained by Digital Domain's Ed Ulbrich; "If you can think it, we can execute it."

Once the exclusive domain of big-budget special-effects companies, with super computers and expensive software, morphing can now be done on a limited scale by combining two digital images in various permutations on a desk-top computer. There is a plethora of software and hardware for painting, editing, contrast changing, resizing, creating special effects, for scanning, correcting colors, retouching images, and collaging, for both black-and-white and color.[25] Software packages are available for almost all computer operating systems. They include DOS, Windows, UNIX, and Macintosh. Simple software packages for combining images are now available for about $50.00.[26] More capable software

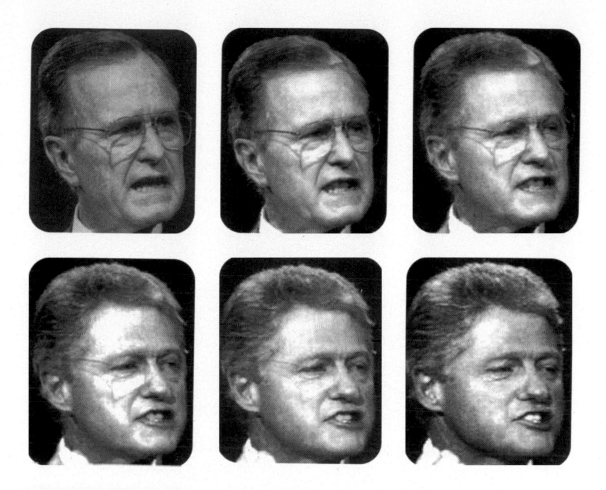

such as Adobe Photoshop Deluxe costs about $2,000 and provides a wide variety of accommodations to manipulate images.

A simplified morph of two photos can be accomplished by selecting two people in similar poses. The images are scanned or taken from existing images on a disk. A series of images can be made combining the two images until one becomes the other. A small San Diego–based company, Gryphon Software Corporation, using a program they developed on a Macintosh computer, easily transformed George Bush into Bill Clinton.[27]

MORPHING

The *Washington Post* showed how easy it was using computer techniques to morph President George Bush into President Bill Clinton. © 1993, *The Washington Post*.

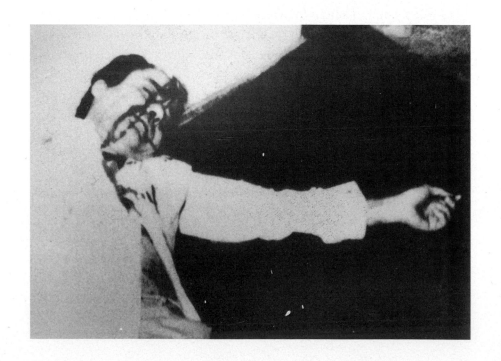

CHAPTER 8

Legal Ramifications

While writing this book, I became acutely aware of the many benefits the computer has brought to humankind. I also became concerned that there are two professions in which tampering with a photo could have enormous impact. They are the legal profession and copyright management.

The potential of any medium is dependent on its purity. Photographs are evidence and the word "tampering" arouses a queasiness among those in the legal profession, who generally feel there is a need for truth and objectivity. Computers by themselves are not dangerous; but their potential misuse when applied to the legal system is an increasing source of concern. Digital information can be manipulated, modified, and erased and poses a challenge to a deliberate legal system that relies on documentary evidence and past decisions. The potential for photo fakes being presented as evidence to an unsuspecting legal system is huge. The ease with which electronic images can be manipulated is not widely known in the legal profession. What is to stop some unscrupulous lawyer or police officer from planting evidence in a photo—a gun or a knife— in a scene in which there never was one? I recently asked Autometric, Inc., in Springfield, Virginia, which specializes in photographic and pho-

togrammetric endeavors, to create a digitized photo of a murder scene such as would be analyzed by law enforcement personnel and lawyers. I also asked that several inconsistencies be included in the photo that neophytes might not notice but that experts would immediately recognize.

Autometric, Inc. showed how such a photo would be created digitally using a standard World War II German bayonet and a brick background. On the finished photo, the first thing an expert would examine is the source of light and shadows. A light source coming from the top of the photo has produced shadows adjacent to and falling down on the bricks. The light source of the bayonet is coming from the right, reflecting on the bayonet's handle and blade. Note, however, that the bayonet is not casting a shadow.

A second concern would be scale and dimensions. The dimension of a standard construction brick is $7\frac{1}{2}$ inches long by 2 inches wide. Photogrammetric measurements of the bayonet based on the brick dimensions reveal the bayonet to be $22\frac{1}{2}$ inches long. The known length of such bayonets is 15 inches.

If the above two examinations fail, the photo should be viewed under high magnification to see if there is any evidence of discontinuities between the bayonet and the background. An analyst would look for minute scratches or anomalies in the background. Any sudden break at the edges of the bayonet would indicate possible insertion of the bayonet's photo into the photo of the brick. A close examination along the edges of the bayonet's blade may provide evidence of aliasing—a thin discontinuous line between the bayonet and its background, which is prominent in color images.

The evidentiary nature of a photo is accepted in most courts without question. What is said or written about an event is open to interpretation and question, but the power of the visual image is considered unimpeachable testimony that an event has transpired. There is growing concern within the legal profession as to the authenticity of photographs.

Since evidence is often transitory, there is always a question as to whether a photo was taken by an amateur or a professional or whether the photographer was working under the direction of an investigative officer. Photographs of a victim, crime, or accident scene are objects easily understood by juries in the context of an average juror's experience. An experienced photographer will try to avoid inclusion of extraneous elements that might be confusing to a jury. The question then arises of whether a photo is a "fair and accurate" representation of a scene. It has been shown that color photos are more realistic and preferred by lawyers.

There is a yearly average of 48,700 deaths and 2,000,000 physical injuries in the United States related to accidents.[1] Many of these will re-

Murder scene photo or fabrication?
Autometric, Inc.

sult in lawsuits, which create a demand for accurate documentation of the accident scene and probable causes. This demand is most often satisfied with good quality photographs. These photos are used not only for documenting the scene, but also to denote, for example, the time, condition of roadways, skid marks, etc. Forensic experts, coroners, accident reconstructionists, and experts from various disciplines are often called upon to testify and will often use the same photos in attempts to show the cause of injuries or deaths. The veracity of the photography is seldom challenged. There is general agreement that safeguards have to be found to protect against undermining the whole legal system when photos are introduced.

Photography also serves as a tool for police and other investigative organizations to make a straightforward record of the scene of a crime or accident, details of the scene, or the victim. The photos show items of evidence and their relation to the scene. Close-up records of significant portions of a scene are also made. Since some items of evidence are transient or perishable, proper recording must be done at the time of the accident or crime as soon as possible. There are times when a photographer must use special lighting to capture a scene. Infrared, ultraviolet, or x-ray photos can often reveal additional information. In order to document an accident scene properly, many police forces have trained their

officers to take appropriate photos of accident scenes. Frequently, close-up photos are also taken to show significant details at a scene, which can be fitted into the overall scene. Where topography is important as evidence, an aerial photo could be used to show the relationships.

Home videos are now widely used and understood by the public and are not immune from manipulation. Alterations can be made on a conventional (analog) videotape. This type of manipulation, however, can be detected by equipment such as those used by intelligence agencies. Manipulation of a digital videotape, however, could potentially leave few or no traces.

What is disquieting about this new computer technology is its "believability" which could lead to dangerous deceptions. The ability to manipulate images or rearrange the content of a photo to suit deceptive purposes is now something that must be reckoned with. At first, images could only be manipulated with larger, more expensive equipment. Today, however, it can be done on a home computer with only modest computer skills.

The first demand for photography in legal action should be the introduction not only of a print but also of the negative. Careful examination of the negative should be undertaken. Detailed examination of individual objects often requires enlargement or microscopic analysis. If a number of prints have been made, they should be closely examined to see that they are the same in both quality and size. If there are enhancement efforts made on such items as fingerprints, shoe marks, etc., they should be identified. If a color photo is used, an expert should be consulted as to the accuracy of the photographic rendition.

There appears to be no limit to what the computer can do. We have ventured out to the frontiers—both moral and legal. Digital journalism can result in a dimension of falsity that could become an element of libel. Where such a photo results in falsity and defamation, individuals can seek damages from publishers for making them appear in a false light. For example, where there is manipulation to make a person look more sinister, the question is where the manipulation moves from ethical to legal bounds. Don E. Tomlinson stated it best when he wrote: "[Digitizing] is like genetic engineering. You can tell the doctors not to mess with genetics, but, in point of fact, science marches on." He later added, "The conclusion reached here is that digitizing never should occur where it would involve or create even the appearance of impropriety. In this context, impropriety would be defined as any manipulation of the content of any image for the purpose of altering substantive reality."[2]

The photo presented in a legal case should no longer be considered as *prima facie* evidence. But two problems prevail. The first is that there

are few photographic experts to examine photos to determine their authenticity. There is also the problem that few lawyers are trained in this important field. One suggestion is to include courses in law schools on the ways that photographs can be tampered with. There is great interest in the media in photo fakery, yet few are trained in photo faking techniques.

The demarcation between "public and private issues" seems to change constantly. The U.S. Postal Service, for example, in honoring blues and jazz greats in postage stamps, used a photo of Robert Johnson with a cigarette dangling from his mouth but removed the cigarette. A spokesman for the Postal Service said the image was altered "because they didn't want to be perceived as promoting cigarettes."[3] In photos that were used in creating stamps, the Postal Service has also removed cigarettes from the mouths of James Dean, Thornton Wilder, Humphrey Bogart, and Jackson Pollock.

There is a need to define where manipulation crosses a line of decency. An Italian clothier featured in its magazine an indisputably vicious photo of Ronald Reagan's face, manipulated so that it was covered with the type of lesions typically found on AIDS patients. The picture was accompanied by a fake obituary criticizing Reagan's record on AIDS.[4] Reagan spokeswoman Cathy Bush blasted the company, saying that it "apparently believes that offensiveness and bad taste will sell its products to the American people. The truth is that no one will be saved — nor will a cure or vaccine be found sooner—through irresponsible attempts to commercialize on human suffering."[5] The company also produced a series of controversial ads. In the opinion of many, these ads have gone beyond decency.

The assassination of Yitzhak Rabin prompted many in Israel to ask "why?" For months before, Rabin had been called a traitor and a murderer by the Likud opposition party. He was frequently shouted down as a quisling and a collaborator. Leaflets were distributed showing Rabin with his hands dripping with the blood of Jews killed by Hamas terrorists. One of the most damaging photos shows him wearing an SS uniform, with a large swastika on his left sleeve; it was distributed in a leaflet a few weeks before his assassination.

The White House became upset when, in the movie *Contact*, some authentic footage of two Clinton news conferences, one on the Mars probe and the other on the Oklahoma City bombing, was manipulated so it appeared that the President was talking about alien communications. White House council Charles Ruff sent a letter to filmmaker Robert Zemeckis complaining that the manipulation was "fundamentally unfair," since it used public statements to fit the film's plot.

Actress Mira Sorvino thought she was posing as Marlene Dietrich in

a photo taken by David Lawrence Chapelle. The photo was altered, however, to portray Sorvino as Joan Crawford. A child model holding an ax was superimposed in the photo, which appeared in the May 1997 issue of *Allure*. Sorvino objected, but *Allure* stated that the issue was between Sorvino and Chapelle. The question remains of whose rights should prevail: Sorvino to appear as she thought she would appear or Chapelle's to create the image he wanted.

Sick humor has also entered the Internet. Daniel Burford of Virtual Visions selects photos of people he dislikes—among them, Bob Dole, Rush Limbaugh, Boris Yeltsin, Bill Gates, and Tom Hanks—and blows their heads off in his World Wide Web page. He asks his viewers to pick one you don't like, "chop out parts of the head you want to explode, paint in some fake blood and there you go."[6] His exploding Hall of Fame, indexed under both "tasteless humor" and "political humor," attracted as many as ten thousand browsers a day when it first appeared. The Secret Service became concerned about Burford and interviewed him at their headquarters, but brought no charges.

The traditional legal and technical restrictions against counterfeiting and forgery provide limited protection to those being abused. There have been times, however, when people have been sued for carrying an idea too far. In October 1980, the owners of a poster company, strong backers of Jimmy Carter, created a poster—a photomontage of Ronald Reagan's face imposed on Ronald McDonald's body, the familiar clown associated with the giant hamburger chain. The poster showed President Reagan dressed as Ronald McDonald with the title "Give Ronald a Job He Can Handle." The poster depicted Reagan in front of a McDonald's restaurant with the background sign paraphrasing the famous McDonald's slogan to read "Ronald's Over 69 Years Old."

This resulted in a lawsuit filed by the McDonald Corporation. Lawyers from the chain filed a copyright infringement suit against Tom Shaydac and his company, Punch Posters. The suit alleged: "The use of McDonald's well-known symbols in connection with a poster which will obviously be viewed as tasteless and without humor by many Americans is likely to injure McDonald's image and reputation." Lawyers from the McDonald Corporation convinced District Judge Albert V. Bryan, Jr., that the poster firm had used the McDonald's copyright symbol "to denigrate the ability of Ronald Reagan, the Republican candidate for the President of the United States." Judge Bryan agreed, and McDonald's was granted a restraining order against Punch Posters, barring the distribution of the posters. McDonald's also filed a copyright infringement suit against the poster firm.[7]

When one looks to the future, there appears to be no limits to the advances of computer technology in the manipulation of both still and

motion pictures. There have been discussions about "reviving" a dead movie star by taking images from previous movies and, with computer graphics, producing an entirely new one. The creation of such an endeavor has been referred to as synthetic acting. An early demonstration of synthetic acting came at the 1988 ACM ISGGRAPH Convention when Humphrey Bogart and Marilyn Monroe, who had never appeared in the same movie, appeared together in a demonstration in which careful editing, manipulating images, and adding voices created a realistic effect.[8]

The technology for synthesizing a realistic-looking image of a human exists and it appears possible that computer-generated actions could be used in motion pictures. Some feel that within a decade there will be a movie starring a fake human. A Hollywood filmmaker has trademarked the word "synthespian," e.g., the creation of actors by computers.[9] In 1995, *Casper* was the first film feature to star a digital image. The success of *Toy Story* proved that smooth motion could be attained through computer technology. One of the hurdles that filmmakers faced was the creation of computer-generated skin. In *Death Becomes Her*, created by George Lucas, computer-generated skin was used. It's now only a matter of time.

COPYRIGHT

With the advent of electronic technology, a number of questions have surfaced regarding the copyrighting of photos. Photos are considered works of art. Copyrighting a work can normally be described as obtaining the exclusive right to reproduce, distribute copies of, prepare derivative works from, or publicly display of the work. Moreover, a distinction exists between ownership of a photo that embodies a copyrighted work and the ownership of the copyright itself.

Computer technology presents a host of new legal questions regarding photo-editing that were not present with the traditional photo-chemical technology. How many changes can be made without altering the original integrity of a photo? When a new photo is made from several copyright photos, who owns the copyright? In the past, photographers maintained the original negative as proof of copyright. For example, San Francisco freelance photographer Roger Ressmeyer cites a picture he took on an America's Cup racing yacht. It was used on a poster in which an art director changed the number on the sail and made the water a deeper blue. Ressmeyer remarks, "people want the altered image, and I don't have it. My original is worthless." Copyright attorney Christopher Meyer probably stated it best when he said that, when several people have access to the same image and then manipulate it, "at the end, it's hard to figure out who owns what."[10]

Questions have been raised as to how far this "digital doctoring" can go. A photo of Princess Caroline appeared on the cover of *Harper's Bazaar*. What was not revealed was that the photo was created from different photos. The skin, hair, face, and body were made from four different photos through computer technology.

U.S. copyright laws maintain that the individual who takes an original idea and develops it, such as a photographer, owns the copyright. Questions of copyright protection and who controls the images if they are manipulated have not been addressed. If an editor electronically "enhances" a photo, does he ruin the integrity of a photo and can he be sued? Photographers maintain that the original images they create are theirs to control. Under the present copyright law, the person who takes the photo is the copyright owner of the image. There is an exception, known as the "work for hire" rule, in which the employer or the person who pays for the original photo is considered the copyright owner.

In the past, the negative was often used as proof of ownership. In the coming digitized world, there may not be a negative to examine. The magnetic storage disks of advanced photo systems can be erased and used over and over again with the image recorded over, leaving no original or permanent archival negative.

Often photos are combined because it was impossible to get the people together to create an original negative. The question of combining photos should be accompanied, some feel, with a statement such as "with subjects' permission."

The electronic age has added another possible infringement of copyright laws. Digital images fall into a gray area in the copyright laws. Photos are now available on CD-ROMs. There is some evidence that individuals have lifted photos from computerized catalogues without paying for them.[11] If portions of the image are extracted, it becomes difficult to sort out who is entitled to compensation or royalties. An even greater question arises as to who will police these violations.

Changes in technology, especially those affecting computers, are outpacing attempts to modify or change copyright laws. In February 1993, President Clinton formed the Information Infrastructure Task Force to articulate and implement the Administration's vision for the National Information Infrastructure. The group was to develop a comprehensive plan for the future.[12] It recognized that "Changes in technology generate new industries and new methods for reproduction and dissemination of works of authorship, which may present new opportunities for authors, but also create additional challenges." The group also noted that "Use of computer technology—such as digitization—and communications technology—such as fiber optic cable—have had an enormous impact on the creation, reproduction and dissemination of copyrighted

works." In its recommendations, the group admitted, "It is difficult for intellectual property laws to keep pace with technology. When technology advances cause ambiguity in the law, courts look to the law's underlying purposes to resolve that ambiguity. However, when technology gets too far ahead of the law, and it becomes difficult and awkward to adapt the specific statutory provision to comport with the law's principles, it is time for reevaluation and change."

An editorial in the *Washington Post* in 1995 concluded that the government is operating "in a hard-to-understand realm, many of whose denizens proudly insist that the Internet is naturally anarchic and unpoliceable."[13] A huge amount of copying and changing happens when photographs are put on display; the changes in technology are so rapid that the U.S. government is in the awkward position of having to consider not only the changes that have occurred but also the changes that are to come.

The Library of Congress launched an ambitious plan in the early 1990s to convert into digital form the most important materials in its collections, and in the collections of other research libraries in the country. Information from the Library of Congress will be in a form capable of being received over the Internet. While a large part of the older collections in the Library are in the public domain, a substantial part is new enough to be covered by copyrights. If an event happened fairly recently, most of what is written about it would be covered by copyrights and authors of that material could claim compensation. Suzanne Thorin, chief of staff at the Library of Congress, recently stated, "Copyright is the big issue," in transferring images to the Internet.[14] The issue of copyright will have to be faced not only by the Library of Congress, but also by major colleges and universities that are putting special holdings on the Internet.

In its first software case, the Supreme Court in January 1996 split 4–4 and refused to give federal copyright protection to a computer program that guides a user through a computer application. David G. Post, a Georgetown university law professor who specializes in the law of information technology, commented on the Supreme Court decision: "Developments in cyberspace are coming so fast, and it looks like going to court is not an effective way to get fast answers."[15]

There is a glimmer of hope. On December 20, 1996, delegates from the United States and 159 other countries agreed on two new treaties to fight the piracy of books, software, and music. One treaty concerns electronic copyright protection of books, movies, and other literary and artistic works and the second concerns the duplication of sound recordings.

In October 1998, the U.S. Congress passed and the President signed

the Digital Millennium Copyright Act of 1998. It incorporates in large part the two copyright treaties mentioned above. The bill creates stiff penalties for anyone who disables or tampers with software programs that scramble or otherwise block unauthorized online copying.[16]

CONCLUSION

Photography is a powerful tool. Its invention has been compared historically with that of gunpowder. Photography transcends natural boundaries and verbal language and is probably the most important vehicle for advancing ideas, and ideals, throughout the world. When a photo is manipulated in any way, truth is compromised; when truth is compromised, distrust begins. Distrust produces a lack of faith in the media and any other manipulators.

Photography, however, has always been manipulated. Photomontages were probably first created to appeal to the personal sentimentality of Victorians. During the American Civil War, photographers manipulated battleground photos and, when the photos were sent to engravers, deception was also engaged in by adding additional gore to already gory scenes. Before the end of the nineteenth century, the photo had often become the medium for promoting the truth. Yet the "yellow" journalists altered photos to sway public opinion and, sometimes, for other nefarious purposes. After the turn of the twentieth century, heavily manipulated photos were produced to create supposed intrinsic and artistic values. The photomontage was used as an important propaganda weapon both for and against Nazi Germany. Communist and other nations often rewrote history by removing people and events from photos, despite the fact that copies of the original photos were usually available throughout the world. Many nations tamper with photos of their military equipment to this day.

The touch-up brush and other manipulative paraphernalia ultimately gave way to the computer, a much more powerful and pliable tool. As with all inventions, we are seeing the worst and best of its use. The ultimate use of manipulation is advertising. Persons with altered eye color, poreless skin, tucked bodies, and blemishes removed are evident everywhere. The news photo was supposedly sacroscanct and news organizations vowed not to manipulate it in any way. Yet, editors have taken liberties in using computers to "clean up" or remove pertinent details from news photos. Advances in computer technology, and lowering of prices, have brought computers into nearly every household. Even young students with appropriate scanners and software are manipulating photos. One father showed me a photo of his son attending a party where the students were drinking beer. The resourceful young man had

used a computer to replace the beer can labels with those of soft drinks. That photo had been shown to parents.

The altering of photos is easily accomplished and has made them untrustworthy when presented in courts as *prima facie* evidence in some cases. Experts often must be brought in to verify every facet of the imagery. And even the experts are sometimes fooled.

Manipulated photos, however, sometimes do have a positive effect on many disciplines, especially in law enforcement and the finding of kidnapped or missing children.

Photo fakery has proliferated to such an extent that the average viewer has begun to doubt the veracity of many photos appearing in newspapers and magazines, and therein lies an unqualified danger. It is hoped that this book will be of aid in determining whether a photo has been manipulated.

We live in a world of photographic and digital imagery. Changes in computer and electronic technology are occurring with such speed that even the experts cannot predict where it will lead. Looking back over 150 years of photography, we can clearly see how photo fakery has made most of us doubters rather than believers. With the new and expanding technology, faith in photography as the purveyor of truth has been weakened and, in the future, it will be further weakened rather than strengthened.

NOTES

CHAPTER 1 Photo Fakery Is Everywhere

1. William G. Hyzer, "January 1, 2000: Doomsday for Film?" *Photomethods* (February 1991): 8.

2. John Holusha, "Kodak, Taking the Digital Plunge, Will Line Up with Computer Giants," *New York Times*, April 3, 1995.

3. Clare Ansberry, "Alterations of Photos Raise Host of Legal, Ethical Issues," *Wall Street Journal*, January 26, 1989.

4. Mark Power, "Can You Believe Your Eyes?" *Washington Post*, April 26, 1989.

5. Ibid.

6. Howard Kurtz, "Newsday's Phony Skater's Waltz," *Washington Post*, February 18, 1994.

7. "New Picture Technologies Push Seeing Still Further from Believing," *New York Times*, July 3, 1989.

8. Alan S. Kay, "Digital Cameras," Fast Forward, *Washington Post*, June 1996.

9. "Two Canadian Newspapers Snap Up High-Tech Cameras," *Straits Times Press* (Singapore), February 6, 1995.

10. *Scitex Work Stations* (brochure), (Bedford, Mass.: Scitex America Corporation, 1994).

11. Fred Ritchin, "Photography's New Bag of Tricks," *New York Times*, November 4, 1984.

12. Department of the Navy, Chief Office of Information (CHINFO), Washington, D.C. Cable R011700Z, February 1995.

13. Ibid.

14. Howard Kurtz, "Electronic Surgery," *Washington Post*, August 23, 1994.

15. Howard Kurtz, "A Nude Awakening," *Washington Post*, February 1, 1995.

16. Howard Kurtz, "Now You See It, Now You Don't," *Washington Post*, October 7, 1995.

17. Gary Bryant, "Ten-Fifty P.I.: Emotion and the Photographer's Role," in National Press Photographers Association, *The Ethics of Photojournalism* (special report) (Durham, N.C.: National Press Photographers Association, 1990).

18. Howard Kurtz, "Time to Newsweek: What's Wrong with This Picture?" *Washington Post*, June 24, 1994.

19. "Pictures That Lie," *Illustrated London News* (August 1987): 40–43.

20. National Press Photographers Association, "A Statement of Principle"; passed by the NPPA Executive Committee on November 12, 1990; revised by the NPPA Board of Directors on July 3, 1991; *NPPA Directory* (Durham, N.C.: National Press Photographers Association, 1993).

21. Keith Kenny, "Ethical Attitudes," *News Photographer* (November 1991): 11–14.

22. *Time* cover, "An American Tragedy" (June 17, 1994).

23. Howard Kurtz, "Time's 'Sinister' Simpson," *Washington Post*, June 22, 1994.

24. Ibid.

25. "To Our Readers," *Time* (July 4, 1994): 4.

26. "They're Sorry," *Washington Post*, June 28, 1994.

27. "To Our Readers," *Time* (July 4, 1994): 4.

28. Ibid.

29. Howard Kurtz, "Time to Newsweek: What's Wrong with This Picture?" *Washington Post*, June 24, 1994.

30. Cynthia Grenier, "The Mag Trade," *Washington Times*, August 26, 1995.

31. Alan Butterfield and Reginald Fitz, "Battered Nicole—Her Sister Took Photos," *National Enquirer*, January 3, 1995.

32. Ibid.

33. Vicki Goldberg, "False Witness," *Mirabella* (October 1993): 126–31.

34. Ibid.

35. Frank Van Riper, "The Truth About Fakes," On the Town, *Washington Post*, February 18, 1994.

36. Mary Tannen, "That Scitex Glow," *New York Times Magazine*, July 10, 1994.

CHAPTER 2 Types of Photo Fakery

1. Joe Dziemianowicz, "McCall's Tells All: How We Make the Stars So Beautiful," *McCall's* (July 1992): 105.

2. Rose Mitchell, "Behind Every Pretty Face," *Know How* (Spring 1994): 88–91.

3. "Greetings from the Leaning Tower of Minneapolis," *TWA Ambassador* (October 1978): 65–66.

4. Fred Ritchin, "Photography's New Bag of Tricks," *New York Times*, November 4, 1984.

5. Linda Wheeler, "Shocking Shots," *Washington Post*, August 12, 1984.

6. David B. Ottaway, "Egypt Fools Libyans on Slaying," *Washington Post*, November 18, 1984.

CHAPTER 3 The Beginning

1. Arthur Goldsmith, "Photos Always Lied," *Popular Photography* (November 1991): 68–75.

2. Helmut Gernsheim and Alison Gernsheim, *The History of Photography* (New York: McGraw-Hill Book Company, 1969), 243.

3. Alfred Stieglitz, *Camera Work* (New York: Dover Publications, 1978), vii.

4. Beaumont Newhall, *The History of Photography* (New York: The Museum of Modern Art, 1993), 81.

5. Malcolm Rogers, *Camera Portraits* (New York: Oxford University Press, 1990), 62.

6. William Frassanito, *Gettysburg: A Journey in Time* (New York: Charles Scribner's Sons, 1975), and Frederic Ray, "The Case of the Rearranged Corpse," *Civil War Times* (October 1961).

7. Gettysburg National Military Park, "Wayside Exhibit Plan," Exhibit 24 (on-site marker).

8. Sarah Greenough, Joel Snyder, David Travis, and Colin Westerbeck, *On the Art of Fixing a Shadow* (Washington, D.C.: National Gallery of Art, 1989), 27.

9. Swann Galleries, Inc., *Public Auction Sale. 19th and 20th Century Photographs* (October 3, 1994), 1.

10. Roy Meredith, *Mathew B. Brady, Mr. Lincoln's Camera Man* (New York: Dover Publications, 1974), fig. 128.

11. Robert Taft, *Photography and the American Scene* (New York: Dover Publications, 1938), 359.

12. David Streitfeld and Elizabeth Kastor, "Stolen Whitman Papers Surface After 50 Years," *Washington Post*, February 18, 1995.

13. Beaumont Newhall, *The History of Photography* (New York: The Museum of Modern Art, 1993), 78.

CHAPTER 4 The Media Years

1. Editors of Time-Life Books, *Frontiers of Photography* (New York: Time-Life Books, 1972), 125.

2. Emile Zola, "Zola's New Hobby," *Photo-Minaasture* (December 2, 1900): 396.

3. Sarah Greenough, Joel Snyder, David Travis, and Colin Westerbeck, *On the Art of Fixing a Shadow* (Washington, D.C.: National Gallery of Art, 1989), 140.

4. William Wordsworth, quoted in Robert Taft, *Photography and the American Scene* (New York: Dover Publications, 1938), 447.

5. Richard A. Kay, "Future Shock," *Civilization* (July–August 1995): 40–47.

6. Alfred Stieglitz, *Camera Work* (New York: Dover Publications, 1978), vii.

7. George Bernard Shaw, "The Unmechanicalness of Photography," *The Amateur Photographer* (October 9, 1902): 23.

8. Peter Pollack, *The Picture History of Photography* (New York: Harry N. Abrams, 1969), 261.

9. Alfred Stieglitz, *Camera Work* (New York: Dover Publications, 1978): x.

10. "100 Years of Pictures, Perils," *New York Times Magazine*, June 9, 1996.

11. Ibid.

12. Garry Wills, "Twilight of the American Cowboy," *Civilization* (November/December 1995): 61.

13. Harry Coleman, *Give Us a Little Smile, Baby* (New York: E. P. Dutton, 1943), 34.

14. Ibid.

15. Ibid., 163.

16. "Photomontage," *International Photo Technik* no. 3 (March 1980): 54.

17. J. Dudley Johnson, "One Hundred Years of Pictorial Photography," *Photographic Journal* (February 1954): 41–43.

18. "Prez's Family Photo Is a Bush-League Phony!" *Globe* (September 1, 1992): 2.

19. Paul L. Anderson, "Some Pictorial History," *American Photography* (April 1935): 16.

20. Joan Brunskill, "Stieglitz Show Surprises," *Fredericksburg (Va.) Free-Lance Star*, October 2, 1995.

21. Frank Kuznik, "Birdmen Come to Cleveland," *Air and Space Magazine* (April/May 1992): 75–81.

22. "Speech Before the Institute of Human Relations," Williamstown, Mass., September 2, 1937, quoted in Robert Taft, *Photography and the American Scene* (New York: Dover Publications, 1938), 499.

23. Marvin Kalb, "The Journalist: An Endangered Species?" *GW Magazine* (George Washington University) (Winter 1995): 33.

24. Ibid.

25. "Seltsamer Bilder-Fluss," *Weltwoche Magazin* (Zurich) (September 23, 1981): 10–14.

26. "Wow! A Showcase for Spectacular Images and How They Are Made," *Popular Photography* (November 1994): 64–65.

27. Tom Zito, "Through a Lens Lightly," *Washington Post*, July 3, 1983.

28. Peter Gambaccini, "The Amazing Paccione," *American Photographic* (May 1980): 34–38.

29. Gilbert Adair, "The Age of Parody," *Illustrated London News* (November 1988): 42–52.

30. Tom Shales, "Ad-vantage, Abdul and Friends," *Washington Post*, August 3, 1992.

31. Bob Thomas, "Kelsey Grammer Happy to Honor His Inspiration," *Fredericksburg (Va.) Free-Lance Star*, November 29, 1995.

32. Leo Janos, "Special Science Creates Illusions in Sci-Fi Spectacles," *Smithsonian* (April 1978): 56–65.

33. Jack Friedman, "Movie Magician Gordon Willis Explains the Tricks that Make Zelig a Treat," *People* (October 24, 1983): 24–26.

34. Desson Howe, "Hanks Displays True Gumption," Weekend, *Washington Post*, July 8, 1994.

35. Rita Kempley, "Forrest Gump: Dimwitty Delight," *Washington Post*, July 6, 1994.

36. "Securing Gump's Place in History," *Washington Post*, July 14, 1994.

37. Jeffrey Staggs, "The World According to Gump," *Washington Times*, July 10, 1994.

38. Sharon Waxman, "Wizards of Ah," *Washington Post*, July 5, 1996.

39. Jay Mathews, "Poking Fun at the Puff Patrol," *Washington Post*, November 19, 1994.

CHAPTER 5 Spotting Fakes

1. American Society of Photogrammetry, *Manual of Photogrammetry* (Falls Church, Va.: American Society of Photogrammetry, 1980), 284.

2. Dick Cheney, "The POW-MIA Effort: Our Fullest Support," *Defense Magazine* (January/February 1992): 1.

3. Memo to Lt. Gen. Leonard H. Perroots from Lt. Gen. Eugene F. Tighe, Jr., *Review of DIAs PW/MIA Analysis Center*, May 27, 1986. Washington, D.C.

4. Charles F. Throwbridge, Jr., Special Office for Prisoners of War and Missing in Action, letter to author, August 31, 1992.

5. John Wagner, "MIA Families Fault Pentagon Research," *Washington Post*, July 24, 1992.

6. Adrian Berry, "How the Queen Got Pixelated," *Sunday Telegraph* (London), February 13, 1994; and "Making the Queen Dance with Fred Astaire," *Sunday Telegraph* (London), March 27, 1994.

7. Gordon Baldwin, *Looking at Photographs: A Guide to Technical Terms* (Malibu, Calif.: The J. Paul Getty Museum, 1991), p. 36.

8. Peter Kolonia, "Depth of Field 101," *Popular Photography* (July 1994): 38–41.

9. Keith Kenny, "Computer-Altered Photos: Do Readers Know Them When They See Them?" *News Photographer* (January 27, 1993): 11–13.

10. Frank Van Riper, "The Truth About Fakes," Weekend, *Washington Post*, February 18, 1994.

11. Howard Kurtz, "The Photo Op Where Heads Rolled," *Washington Post*, November 30, 1994.

12. *Die Welt* (Bonn), May 7, 1980.

13. William J. Mitchell, "When Is Seeing Believing," *Scientific American* (February 1994): 68–73.

14. Howard Kurtz, "Newsday's Phony Skater's Waltz," *Washington Post*, February 18, 1994.

15. Cover, *Sports Illustrated for Kids* (August 1995).

16. David Ginsburg, "Marketing Cal Ripken," *Fredericksburg (Va.) Free-Lance Star*, September 7, 1995.

17. Dubious Achievements of 1995, "O. J. and Mark: Faking It?" *Washington Post*, December 7, 1995.

18. Andy Grundberg, "Ask No Questions: The Camera Can Lie," *New York Times*, August 12, 1990.

19. Cover, *Stern Magazine* (December 29, 1977).

20. Malcolm W. Browne, "Computer as Accessory to Photo Fakery," *New York Times*, July 24, 1991.

21. William J. Mitchell, cover, *Scientific American* (February 1994).

22. "Re-dressing the Queen," *Parade* (August 8, 1982): 7.

23. Richard Leiby, "Victoria's Dirty Little Secret," *Washington Post*, March 5, 1995.

24. Mark Potts, "Regarding Digitally Altered Photos," Wash Tech, *Washington Post*, March 27, 1995.

25. Jonathan Green, "Pedro Meyer's Documentary Fictions," *Aperture* (Summer 1994): 32–37.

26. "Pictures That Lie," *Illustrated London News* (August 1987): 40–43.

27. Kathy Sawyer, "Is It Real or Is It . . . ?" *Washington Post*, February 21, 1994.

28. American Society of Photogrammetry, *Manual of Photogrammetry* (Falls Church, Va.: American Society of Photogrammetry, 1980), 1.

29. Hearings Before the Select Committee on Assassinations of the U.S. House of Representatives, 95th Congress, *Investigation of the Assassination of President John F. Kennedy*, September 11–15, 1978, vol. 2.

30. Thomas D. Davis, "New Evidence Places Peary at the Pole," *National Geographic* (January 1990): 44–61.

31. "Sun Angles, Anyone," *National Geographic* 177, no. 1 (January 1990): 3.

32. Hearings Before the Select Committee on Assassinations of the U.S. House of Representatives, 95th Congress, *Investigation of the Assassination of President John F. Kennedy*, September 11–15, 1978, vol. 2, pp. 409–12.

33. Howard Kurtz, "White House Cuts Time Out of Its Pictures," *Washington Post*, April 1, 1994.

34. Rose Mitchell, "Behind Every Pretty Face," *Know How* (Spring 1994): 89–91.

35. Clare Ansberry, "Alterations of Photos Raise Host of Legal, Ethical Issues," *Wall Street Journal*, January 26, 1989.

36. Woodlief Thomas, Jr., "Image Structure and Evaluation," *SPSE Handook of Photographic Science and Engineering* (New York: John Wiley and Sons, 1973), 925–33.

37. Hearings Before the Select Committee on Assassinations of the U.S. House of Representatives, 95th Congress, *Investigations of the Assassination of President John F. Kennedy*, September 11–15, 1978, vol. 2, p. 407.

38. Ibid.

39. Dino A. Brugioni, "Satellite Images on TV: The Camera Can Lie," *Washington Post*, December 14, 1986.

40. Tom Zito, "Panda Panic," *Washington Post*, September 2, 1981.

41. Anonymous, *Death in the Air: The War Diary and Photographs of a Flying Corps Pilot* (London: William Heinemann, 1932), 12.

42. "Deception in the Sky," *Washington Star*, February 24, 1980.

43. Edwards Park, "The Greatest Aerial Warfare Photos Go Down in Flames," *Smithsonian* (January 1985): 103–113.

44. Henry H. Bauer, *The Enigma of Loch Ness: Making Sense of a Mystery* (Urbana: University of Illinois Press, 1986); and Ronald Binns, *The Loch Ness Mystery Solved* (Buffalo, N.Y.: Prometheus, 1985), 97.

45. Paul Mandel, "Showdown for Loch Ness," *Life* (September 20, 1963).

46. William S. Ellis, "Loch Ness, The Lake and the Legend," *National Geographic* (June 1977).

47. Roger Highfield, "Legend of Loch May be Lovelorn Sturgeon," *London Daily Telegraph*, December 29, 1993.

48. Ronald Binns, *The Loch Ness Mystery Solved* (Buffalo, N.Y.: Prometheus, 1985), p. 97.

49. "A Monstrous Hoax," *Washington Post*, March 14, 1994.

50. Nicholas Witchell, "Unloching Ness's Secrets," *Geographical* (May 1944): 21–24.

51. Dick Cheney, "The POW-MIA Effort: Our Fullest Support," *Defense Magazine* (January/February 1992): 12.

52. Ibid.

53. Chuck Fremont, "Anatomy of a POW/MIA Scam," *Soldier of Fortune Magazine* (October 1991): 44–46.

54. Los Alamos National Laboratory, Letter to the Defense Intelligence Agency, October 28, 1991.

55. "Uncandid Camera," *Time* (March 9, 1992): 38.

56. "Photographs Cited by Haig Taken in 1978," *Washington Post*, March 2, 1982.

57. Henry Allen, "The Lens Always Wins," *Washington Post*, November 27, 1994.

58. Mitchell Landsberg, "Behind the Image of Iwo Jima," *Fredericksburg (Va.) Free-Lance Star*, February 11, 1995.

59. Andy Grundberg, "Ask No Questions: The Camera Can Lie," *New York Times*, August 12, 1990.

60. Ibid.

61. John Faber, *Great News Photos* (New York: Dover Publications, 1978), 38–39.

62. "Viet War Photo Is Challenged," *Washington Post*, January 19, 1986.

63. Michael S. Serrill, "Defiling the Children," *Time* (June 21, 1993): 52–55.

64. James Rupert, "From Moscow, Photojournalism or Photo Fraud?" *Washington Post*, August 7, 1993.

65. Howard Kurtz, "Fallout from Faked Photos," *Washington Post*, August 12, 1994.

66. "Patrol Car Decoys Save Lives and Money" (brochure), Port Chester, N.Y.: Rosco.

67. Teresa A. Schumacher, Consumer Affairs Advisor, Kodak Information Center, Eastman Kodak Company, letter to author, March 25, 1994.

68. Whittaker Chambers, *Witness* (New York: Random House, 1952), 753.

69. Daniel Grant, "The New Focus on Photo Fakery," *Washington Post*, June 14, 1987.

70. B. L. Browing, *Analysis of Paper* (New York: Marcel Dekker, 1977).

71. Ed Magnasun, "Hitler's Forged Diaries," *Time* (November 16, 1983): 36–47.

72. "The Puzzling Case of the Faked Photographs," *Life* (August 1981): 11–12.

73. Wayne B. Robbins, Director, Research Division, Institute of Paper Science and Technology, letter to author, January 26, 1994.

74. Clayton Knowles, "Defeated by Lies, Tyding Declares," *New York Times*, February 21, 1951.

75. "McGrath Condemns Butler Campaign," *New York Times*, September 15, 1951.

76. William O. Douglas, "Justice Recalls Dislike for Nixon, LBJ Feuds," *Washington Star*, September 12, 1980.

77. D. Asanov, S. Vishnevsky, N. Menshikov, K. Nepomnyashchy, N. Polyanov, *No Return for the U-2* (Moscow: Foreign Languages Publishing House, 1960), 47.

78. "Turkish Exercises for Conquest of All of Cyprus," *Eikones* (March 16, 1979): 26–27.

79. "Pictures That Lie," *Illustrated London News* (August 1987): 40–43.

80. Conversation between Eric Hubbard, NASA Ames, Aerodynamic Simulation Systems Division, and the author, August 1992.

81. Letter from Martin P. Kress, Assistant Administrator for Legislative Affairs, NASA Ames Research Center, along with report to author, August 27, 1992, re Cooperation with Yuba City, CA, Police Department.

CHAPTER 6 Communists, Ghosts, Monsters, and Aliens

1. Bureau of Public Affairs, United States Department of State, "Soviet Active Measures: An Update," Special Report no. 101, July 1982.

2. Doctor Christopher Andrew, Modern and Contemporary History, University of Cambridge, letter to author, March 7, 1994.

3. Glenn Frankel, "Officials See Soviets Between the Lines of Phony Stories about the US in Africa," *Washington Post*, December 3, 1983.

4. U.S. Senate Committee on the Judiciary, *Communist Forgeries: Hearings Before the Subcommittee to Investigate the Administration of the Internal Security Act and Other Internal Security Laws of the Committee of the Judiciary*, June 2, 1961.

5. Admiral Stansfield Turner, Director of the Central Intelligence Agency, Letter to the Honorable Edward P. Boland, Chairman Permanent Select Committee on Intelligence, House of Representatives, July 3, 1978.

6. George C. Wilson, "Is the Press Being Duped?" *Washington Post*, September 15, 1983.

7. William J. Casey, Director of the Central Intelligence Agency, "Soviet Use of Active Measures," U.S. Department of State, Bureau of Public Affairs, Washington, D.C. Current Policy No. 61, November 1985.

8. U.S. Senate, "Soviet Deception and Disinformation," *Congressional Record*, vol. 125, no. 84, pt. 2, December 20, 1979, pp. S19538–S19539.

9. Alain Jaubert, *Making People Disappear* (Washington, D.C.: Pergamon-Brassey's, 1986).

10. "The Lady Vanishes," *Parade* (January 1, 1978): 17.

11. Charles Fenyvesi, "The Secret Files of Mr. X," *Washington Post Magazine*, July 11, 1982.

12. "Bye-Bye, Boris, A Crash Course in Russian Photo Fakery," *Life* (December 1986): 67–68.

13. Vladimir Isachenkov, "Old Photo of Yeltsin Was Used," *Fredericksburg (Va.) Free-Lance Star*, July 1, 1995.

14. Jasper Maskelyne, *Magic—Top Secret* (London: Stanley Paul, 1949).

15. Alfred Victor Iannarelli, *The Iannarelli System of Ear Identification*, Police Science Series (Brooklyn, N.Y.: Foundation Press, 1964).

16. Philip B. Kundhardt, Jr., Philip B. Kundhardt III, and Peter W. Kundhardt, *Lincoln: An Illustrated Biography* (New York: Alfred A. Knopf, 1992), 397.

17. Gordon Lindsay and William Branham, *William Branham, A Man Sent from God* (Jeffersonville, Ind.: William Branham Evangelistic Association, n.d.), 2.

18. Charles Fishman, "Unicorn was Product of Promoter's Imagination," *Washington Post*, November 12, 1983.

19. Jack Anderson, "CIA Snoops Study Ailments of Leaders," *Washington Post*, March 1, 1982.

20. Frank Kuznik, "Aliens in the Basement," *Air and Space* (August/September 1992).

21. Dan Schwartz, "I've Seen a Genuine Film of UFOs that Could Not Have Been Faked," *National Enquirer*, September 14, 1976.

22. John Paul Hammerschmidt, letter to author, September 16, 1981.

23. "The 1994 Campaign Advertising: Now Playing in Politics, Latest Techniques of Hollywood," *New York Times*, October 19, 1994.

24. Howard Kurtz, "To GOP Hopefuls, Clinton Is Target of Opportunity," *Washington Post*, October 5, 1994.

25. *Frankfurt Allgemeine* (Frankfurt am Main), July 29, 1979, 3.

26. S. L. Mayer, *The Best of Signal: Hitler's Wartime Picture Magazine* (New York: Gallery Books, 1984), 53–54.

27. U.S. Senate Committee on the Judiciary, *Communist Forgeries: Hearings Before the Subcommittee to Investigate the Administration of the Internal Security Act and Other Internal Security Laws of the Committee of the Judiciary*, Testimony of Richard Helms, Assistant Director, Central Intelligence Agency, June 2, 1961 (Washington, D.C.: U.S. Government Printing Office, 1961).

28. Ladislav Bittman, *The Deception Game: Czechoslovak Intelligence in Soviet Political Warfare* (Syracuse, N.Y.: Syracuse University Research Corporation, 1972).

CHAPTER 7 Photo Manipulation

1. Peter Kurth, "The Mystery of the Last Czar's Bones," *Vanity Fair* (January 1993): 96–103.

2. "Nicholas and Alexandria, Graves Yield Answers to Mystery of Their Deaths," *Hello* no. 120 (July 11, 1992): 62–65.

3. Peter Kurth, "The Mystery of the Last Czar's Bones," *Vanity Fair* (January 1993): 96–103.

4. Connie Cass, "The FBI's Bone Man," *Fredericksburg (Va.) Free-Lance Star*, June 17, 1993.

5. Ibid.

6. Douglas H. Ubelaker, Erica Bubniak, and Gene O'Donnell, "Computer-Assisted Photographic Superimposition," *Journal of Forensic Sciences* (May 1992): 753–54.

7. Lillian Schwartz, "The Art Historian's Computer," *Scientific American* (April 1995): 106–11.

8. Connie Cass, "The FBI's Bone Man," *Fredericksburg (Va.) Free-Lance Star*, June 17, 1993.

9. Douglas H. Ubelaker and Gene O'Donnell, "Computer-Assisted Facial Reproduction," *Journal of Forensic Sciences* (January 1992): 155–62.

10. Ibid., 160.

11. "EFIT for Windows" (brochure) (Alexandria, Va.: New England Press, 1996).

12. Peter Herman, "Computer Images Give Police the Big Picture," *Baltimore Sun*, September 25, 1995.

13. Rick Allen, "They Trick Time to Find Missing Children," *Washington Post*, February 18, 1993.

14. Daniel Dale Jackson, "I Lost My Baby, and When I Got Him Back He Was a Toddler," *Smithsonian* (October 1995): 70–80.

15. John E. Collingwood, Inspector in Charge, Office of Public and Congressional Services, U.S. Department of Justice, Federal Bureau of Investigation, letter to author, August 25, 1992.

16. Rebecca Busselle, "A Defining Reality: The Photographs of Nancy Burson," *Aperture* (Summer 1994): 73–75.

17. David Roberts, "Iceman," *National Geographic* (June 1993): 36–68.

18. Theresa Riordan, "DNA Backs Up Ice Man's Legitimacy," Reuter, June 16, 1994.

19. Eugene L. Meyer, "Face to Face with Maryland History," *Washington Post*, April 6, 1994.

20. "Jackson Vid Changing the Face of 'Morph' Technology," *Billboard* (December 14, 1991): 38–39.

21. "Wow! Car-To-Tiger Metamorphosis. A Jaw Dropper," *EXXON Company Marketing Exxpress*, no. 91–19 (September 10, 1991): 5.

22. Bob Davis, "Car-to-Tiger Wins Gold Addy," *Exxon Today*, April 22, 1992.

23. Simi Horowitz, "Dream Commercials," This Week, *Washington Post*, March 26–April 1, 1995.

24. Stuart Elliott, "The Media Business: Advertising. A High Tech Fragrance Resurrects a Hollywood Icon," *New York Times*, December 2, 1994.

25. Jay Mathews, "Morph for the Money," *Washington Post*, October 2, 1994.

26. Andrew W. Davis, "The Latest Image Manipulation Software for Video, Publishing and Graphic Arts," *Advanced Imaging* (March 1994): 22–27.

27. Mark Potts, "Making Faces—and a Splash," *Washington Post*, January 19, 1993.

CHAPTER 8 Legal Ramifications

1. William G. Hyzer, "January 1, 2000: Doomsday for Film?" *Photomethods* (February 1991): 8.

2. Don E. Tomlinson, "Legal and Ethical Ramifications of Computer-Assisted Photograph Manipulation," *Protocol* (1991): 4–6.

3. Charles Paul, "Those Hellhounds-of-Censorship Blues," *Washington Post*, September 25, 1994.

4. "Reagan Aide: Benetton Ad in Bad Taste," *Fredericksburg (Va.) Free-Lance Star*, June 28, 1994.

5. "A Blast at Benetton," *Washington Post*, June 19, 1994.

6. Ben Dobbin, "Internet Art Wins Secret Service Visit," *Fredericksburg (Va.) Free-Lance Star*, January 27, 1996.

7. Jane Mayer, "McDonald's Chain Irked by 'McReagan' Poster," *Washington Star*, October 2, 1980.

8. Steve Moore, "Digital Deceptions," *Byte* (May 1992): 372.

9. Randall Lane, "The Magician," *Forbes* (March 11, 1996): 123–28.

10. Clare Ansberry, "Alterations of Photos Raise Host of Legal, Ethical Issues," *Wall Street Journal*, January 26, 1989.

11. May Yee Chen, "For Professional Photographers, a Digital-Age Debate," *New York Times*, July 24, 1994.

12. Bruce A. Lehman, *Intellectual Property and the National Information Infrastructure* (Washington, D.C.: Department of Commerce, September 1995).

13. "A Facelift for Copyright," *Washington Post*, September 7, 1995.

14. Peter H. Lewis, "Library of Congress Offers to Feed the Data Highway," *New York Times*, September 12, 1994.

15. Joan Biskupic, "High Court Split on Computer Copyright," *Washington Post*, January 17, 1996.

16. John Schwartz, "House Passes Copyright Bill," *Washington Post* (October 13, 1998).

BIBLIOGRAPHY

BOOKS

Aeronautical Chart and Information Center. *Height Shadow Factors*. St. Louis: Aeronautical Chart and Information Center, 1944.

American Society of Photogrammetry. *Manual of Photogrammetry*. Falls Church, Va.: American Society of Photogrammetry, 1980.

Baldwin, Gordon. *Looking at Photographs: A Guide to Technical Terms*. Malibu, Calif.: The J. Paul Getty Museum, 1991.

Bauer, Henry H. *The Enigma of Loch Ness: Making Sense of a Mystery*. Urbana: University of Illinois Press, 1986.

Benayoun, Robert. *The Films of Woody Allen*. New York: Harmony Books, 1985.

Binns, Ronald. *The Loch Ness Mystery Solved*. Buffalo, N.Y.: Prometheus, 1985.

Bittman, Ladislav. *The Deception Game*. Syracuse, N.Y.: Syracuse University Press, 1972.

Brugioni, Dino A. *Eyeball to Eyeball: The Inside Story of the Cuban Missile Crisis*. New York: Random House, 1990.

Chambers, Whittaker. *Witness*. New York: Random House, 1952.

Click, J. William, and Russell N. Baird. *Magazine Editing and Production*. New York: Brown and Benchmark, 1994.

Coleman, Henry J. *Give Us a Little Smile, Baby*. New York: E. P. Dutton, 1943.

Condon, Edward Uhler. *Final Report of the Scientific Study of Unidentified Flying Objects Conducted by the University of Colorado*. New York: Bantam Books, 1968.

Cruickshank, Charles G. *Deception in World War II*. Oxford: Oxford University Press, 1981.

Death in the Air: The War Diary and Photographs of a Flying Corps Pilot. London: William Heinemann, 1932.

De Mare, Eric. *Photography*. Middlesex, Eng.: Penguin Books Ltd., 1970.

Dewar, Colonel Michael. *The Art of Deception in Warfare*. New York: Sterling Publishing, 1989.

Eastman Kodak Company. *Conservation of Photographs*. Rochester, N.Y.: Eastman Kodak Company, 1985.

Eastman Kodak Company. *Encyclopedia of Practical Photography*, vol. 10. Garden City, N.Y.: American Photographic Book Publishing Company, 1978.

Editors of Time-Life Books. *Frontiers of Photography*. New York: Time-Life Books, 1972.

Editors of Time-Life Books. *Great Photographers*. New York: Time-Life Books, 1971.

Faber, John. *Great News Photos, and the Stories Behind Them*. New York: Dover Publications, 1978.

Fletcher, Cyril. *The Camera Never Lies*. London: Bloomsbury Books, 1992.

Frassanito, William. *Gettysburg: A Journey in Time*. New York: Charles Scribner's Sons, 1975.

Gernsheim, Helmut, and Alison Gernsheim. *The History of Photography*. New York: McGraw-Hill Book Company, 1969.

Great Photographers. Life Library of Photography. New York: Time-Life Books, 1971.

The J. Paul Getty Museum. *Photography: Discovery and Invention*. Malibu, Calif.: The J. Paul Getty Museum, 1990.

Greenough, Sarah, Joel Snyder, David Travis, and Colin Westerbeck. *On the Art of Fixing a Shadow*. Washington, D.C.: National Gallery of Art, 1989.

Gunston, Bill. *Aircraft of the Soviet Union*. London: Osprey Publishing, 1983.

Hartcup, Gary. *Camouflage: A History of Concealment and Deception in War*. New York: Charles Scribner's Sons, 1980.

Hartman, Tom. *Swastika at War*. Garden City, N.Y.: Doubleday, 1975.

Haswell, Jock. *The Intelligence and Deception of the D-Day Landings*. London: B. T. Batsford, 1979.

Horan, James D. *Mathew Brady: Historian with a Camera*. New York: Bonanza Books, 1955.

Hoving, Thomas. *False Impressions*. New York: Simon and Schuster, 1996.

Hynek, J. Allen. *The UFO Experience: A Scientific Inquiry*. Chicago: Henry Regnery Company, 1972.

Iannarelli, Alfred Victor. *The Iannarelli System of Ear Identification*. Police Science Series. Brooklyn, N.Y.: Foundation Press, 1964.

Jackson, Robert. *U.F.O.s*. New York: Smithmark Publishers, 1992.

James, Meyrich Edward Clifton. *I Was Monty's Double*. London: Rider and Company, 1954.

Jaubert, Alain. *Making People Disappear: An Amazing Chronicle of Photographic Deception*. Washington, D.C.: Pergamon-Brassey's, 1986.

Jones, Mark, ed. *Fake? The Art of Deception*. Berkeley, Calif.: University of California Press, 1990.

Kundhardt, Philip B., Jr., Philip B. Kundhardt III, and Peter W. Kundhardt. *Lincoln: An Illustrated Biography*. New York: Alfred A. Knopf, 1992.

Lavin, Maud, Annette Michelson, Christopher Phillips, Sally Stein, Matthew Teitelbaum, and Margarita Tupitsyn. *Montage, 1919–1942*. Cambridge, Mass.: MIT Press, 1992.

Lehman, Bruce A. *Intellectual Property and the National Information Infrastructure*. Washington, D.C.: Information Infrastructure Task Force, Secretary of Commerce, 1995.

Lindsay, Gordon, and William Branham. *William Branham, A Man Sent from God*. Jeffersonville, Ind.: William Branham Evangelistic Association, n.d.

Maskelyne, Jasper. *Magic—Top Secret*. London: Stanley Paul, 1949.

Mayer, S. L. *The Best of Signal: Hitler's Wartime Picture Magazine*. New York: Gallery Books, 1984.

Memo to Lt. Gen. Leonard H. Perroots from Lt. Gen. Eugene F. Tighe, Jr., *Review of DIAs PW/MIA Analysis Center*, May 27, 1986. Washington, D.C.

Meredith, Roy. *Mathew B. Brady, Mr. Lincoln's Camera Man*. New York: Dover Publications, 1974.

Mitchell, William J. *The Reconfigured Eye*. Cambridge, Mass.: MIT Press, 1992.

Morse, Michael A. *The Electronic Revolution in News Photography*. Durham, N.C.: National Press Photographers Association, 1987.

National Center for Missing and Exploited Children and Adam Walsh Center. *Bringing Children Home*. Washington, D.C.: National Center for Missing and Exploited Children, 1992.

National Investigations Committee on Aerial Phenomena. *UFOs: A New Look*. Washington, D.C.: National Investigations Committee on Aerial Phenomena, 1969.

National Press Photographers Association. *The Ethics of Photojournalism* (special report). Durham, N.C.: National Press Photographers Association, 1990.

Nazarieff, Serge. *Stereo Nudes*. Cologne: Benedikt Taschen, 1993.

Neblette's Handbook of Photography and Reprography. Edited by John M. Sturge. New York: Von Nostrand Reinhold, 1977.

Newhall, Beaumont. *The History of Photography*. New York: The Museum of Modern Art, 1993.

Norfleet, Barbara P. *Killing Time: Photographs by Joe Steinmetz*. Cambridge, Mass.: Amory and Pugh, 1982.

Pollack, Peter. *The Picture History of Photography*. New York: Harry N. Abrams, 1969.

Randles, Jenny. *The UFO Conspiracy*. New York: Barnes and Noble, 1987.

Reaves, Shiela. *What's Wrong with This Picture? Attitudes of Photographic Editors at Daily Newspapers and Their Tolerance Toward Digital Manipulation*. Madison: University of Wisconsin at Madison, School of Journalism and Mass Communication, July 1991.

Rhodes, Henry T. F. *Alphonse Bertillon, Father of Scientific Detection*. London: George G. Harrap, 1956.

Rogers, Malcolm. *Camera Portraits*. New York: Oxford University Press, 1990.

Rosenblum, Naomi. *A World History of Photography*. New York: Abbeville Press, 1984.

Sloan, Mark. *Hoaxes, Humbugs and Spectacles*. New York: Villard Books, 1990.

Stanley, Col. Roy M. *World War II Photo Intelligence*. New York: Charles Scribner's Sons, 1981.

Stieglitz, Alfred. *Camera Work*. New York: Dover Publications, 1978.

Swann Galleries, Inc. *Public Auction Sale. 19th and 20th Century Photographs*. October 3, 1994.

Szarkowski, John. *Photography Until Now*. New York: Museum of Modern Art, 1989.

Taft, Robert. *Photography and the American Scene*. New York: Dover Publications, 1938.

Teitelbaum, Matthew. *Montage and Modern Life, 1919–1942*. Cambridge, Mass.: MIT Press, 1992.

Thomas, Woodlief, Jr., ed. *SPSE Handbook of Photographic Science and Engineering*. New York: John Wiley and Sons, 1973.

Todd, Hollis N., and Richard D. Zakia. *Photographic Sensitometry*. Hastings-on-Hudson, N.Y.: Morgan and Morgan Publishers, 1969.

U.S. Senate Committee on the Judiciary. *Communist Forgeries: Hearing Before the Subcommittee to Investigate the Administration of the Internal Security Act and Other Internal Security Laws of the Committee of the Judiciary*. Testimony of Richard Helms, Assistant Director, Central Intelligence Agency, June 2, 1961. Washington, D.C.: U.S. Government Printing Office, 1961.

MAGAZINES, NEWSPAPERS, AND EPHEMERA

Adair, Gilbert. "The Age of Parody." *Illustrated London News* (November 1988): 42–52.

Allen, Henry. "The Lens Always Wins." *Washington Post*, November 27, 1994.

Allen, Rick. "They Trick Time to Find Missing Children." *Washington Post*, February 18, 1993.

Anderson, Jack. "CIA Snoops Study Ailments of Leaders." *Washington Post*, March 1, 1982.

———. "How We Get Inside Information on World Leaders." *Parade*, June 17, 1973, 69–71.

Anderson, Paul L. "Some Pictorial History." *American Photography* (April 1935): 16.

Ansberry, Clare. "Alterations of Photos Raise Host of Legal, Ethical Issues." *Wall Street Journal*, January 26, 1989.

Baskervill, Bill. "J. Warner Fires Consultant Who Altered Campaign Ad." *Fredericksburg (Va.) Free-Lance Star*, October 11, 1996.

Berry, Adrian. "How the Queen Got Pixelated." *Sunday Telegraph* (London), February 13, 1994.

———. "Making the Queen Dance with Fred Astaire." *Sunday Telegraph* (London), March 27, 1994.

"A Blast at Benetton." *Washington Post*, June 29, 1994.

Brack, Dennis. "Do Photos Lie?" *Proceedings* (U.S. Naval Institute, Annapolis) (August 1996): 47–49.

Branscomb, Anne W. "Common Law for the Electronic Frontier: Computers, Networks and Public Policy." *Scientific American* (September 1991): 154.

Brown, David. "Stamped Out." *Washington Post*, March 7, 1999.

Browne, Malcolm W. "Computer as Accessory to Photo Fakery." *New York Times*, July 24, 1991.

Brugioni, Dino A. "Satellite Images on TV: The Camera Can Lie." *Washington Post*, December 14, 1986.

———. "Photo Interpretation and Photogrammetry in World War II." *Photogrammetric Engineering and Remote Sensing* 50, no. 9 (September 1984): 1313–18.

———. "Spotting Photo Fakery." *Studies in Intelligence* (Winter 1969): 57–67.

Brunskill, Joan. "Stieglitz Shows Surprises." *Fredericksburg (Va.) Free-Lance Star*, October 2, 1995.

Bureau of Public Affairs, U.S. Department of State. "Soviet Active Measures: An Update." Special Report no. 101. July 1982.

Busselle, Rebecca. "A Defining Reality: The Photographs of Nancy Burson." *Aperture* (Summer 1994): 73–75.

Butterfield, Alan, and Reginald Fitz. "Battered Nicole—Her Sister Took Photos." *National Enquirer*, January 3, 1995.

Caras, Roger. "Pandas on Their Home Ground." *Geo* (August 1981): 62–69.

Casey, William J. "Soviet Use of Active Measures." U.S. Department of State, Bureau of Public Affairs, Current Policy No. 761, November 1985.

Cass, Connie. "The FBI's Bone Man." *Fredericksburg (Va.) Free-Lance Star*, June 17, 1993.

Chen, May Yee. "For Professional Photographers, a Digital-Age Debate." *New York Times*, July 24, 1994.

Cheney, Dick. "The POW-MIA Effort: Our Fullest Support." *Defense Magazine* (January/February 1992).

Davis, Andrew W. "The Latest Image Manipulation Software for Video, Publishing and Graphic Arts." *Advanced Imaging* (March 1994): 22–27.

Davis, Bob. "Car-To-Tiger Wins Gold Addy." *EXXON Today*, April 27, 1992.

"Deception in the Sky." *Washington Star*, February 24, 1980.

Department of the Navy, Chief Office of Information (CHINFO), Washington, D.C. Cable R011700Z, February 1995. Subject: Alteration of Official Photographic and Video Imagery.

Dobbin, Ben. "Internet Artist Wins Secret Service Visit." *Fredericksburg (Va.) Free-Lance Star*, January 27, 1996.

Durniak, John. "Camera: He's Seen the Future and It's Digital." *New York Times*, November 8, 1992.

———. "Photography: New Models, Design and Products." *New York Times*, January 19, 1992.

Dziemianowicz, Joe. "McCall's Tells All: How We Make the Stars So Beautiful." *McCall's* (June 1992): 105.

Ellis, William S. "Loch Ness, The Lake and the Legend." *National Geographic* (June 1977): 759–79.

"Fakes That Have Skewed History." *Time* (May 16, 1983): 48–49.

Farquhar, Michael. "Tricks." *Washington Post*, October 27, 1996.

Fenyvesi, Charles. "The Secret Files of Mr. X." *Washington Post Magazine* (July 11, 1982).

Fishman, Charles. "Unicorn Was Product of Promoter's Imagination." *Washington Post*, November 12, 1983.

Fountain, John W. "Drawing to a Close." *Washington Post*, March 14, 1996.

Frankel, Glenn. "Officials See Soviets Between the Lines of Phony Stories About the US in Africa," *Washington Post*, December 3, 1983.

Fremont, Chuck. "Anatomy of a POW/MIA Scam." *Soldier of Fortune* (October 1991): 44–48.

Freund, Charles Paul. "Those Hellhounds-of-Censorship Blues." *Washington Post*, September 25, 1994.

Friedman, Jack. "Movie Magician Gordon Willis Explains the Tricks that Make Zelig a Treat." *People* (October 24, 1983): 24–26.

Gambaccini, Peter. "The Amazing Paccione." *American Photographic* (May 1980): 34–38.

Gates, David. "Big Brother's Photoshop." *Newsweek* (November 10, 1997): 80.

Gerhart, Ann, and Anne Groer. "Looking for the Real McCaughey in Newsweek." *Washington Post*, November 25, 1998.

Ginsburg, David. "Marketing Cal Ripken." *Fredericksburg (Va.) Free-Lance Star*, September 7, 1995.

Goldberg, Vicki. "False Witness." *Mirabella* (October 1993): 126–31.

———. "A Glimpse of War." *Civilization* (October–November 1966): 80–91.

Goldsmith, Arthur. "Photos Always Lied." *Popular Photography* (November 1991): 68–75.

Grant, Daniel. "The New Focus of Photo Fakery." *Washington Post*, June 14, 1987.

Green, Jonathan. "Pedro Meyer's Documentary Fictions." *Aperture* (Summer 1994): 32–37.

"Greetings from the Leaning Tower of Minneapolis." *TWA Ambassador* (October 1978): 65–66.

Grenier, Cynthia. "The Mag Trade." *Washington Times*, August 26, 1995.

Gromer, Cliff. "New Hope for the Dead." *Popular Mechanics* (July 1997): 64–65.

Grosvenor, Rita, and Arnold Kemp. "Spain's Falling Soldier Really Did Die That Day." *Observer* (London), September 1, 1996.

Grundberg, Andy. "Ask No Questions: The Camera Can Lie." *New York Times*, August 12, 1990.

Haines, Gerald K. "CIA's Role in the Study of UFOs, 1947–1990." *Studies in Intelligence* 1, no. 1 (1997): 1–3.

Hannaford, Steve. "The All-Digital Experiment." Reprint. Bedford, Mass.: IRIS Graphics, 1993.

Hermann, Peter. "Computer Images Give Police the Big Picture." *Baltimore Sun*, September 25, 1995.

"A High-Tech Friend Joins the Hunt for Lost Kids." *Business Week*, August 10, 1992.

"Hollywood's July Foursome." *Newsweek* (July 11, 1994): 50.

Holusha, John. "Kodak, Taking the Digital Plunge, Will Line Up with Computer Giants." *New York Times*, April 3, 1995.

"Hoping Against Hope." *Newsweek* (July 29, 1991): 20–26.

Horwitz, Simi. "Dream Commercials." This Week, *Washington Post*, March 26–April 1, 1995, p. 6.

Howe, Desson. "Hanks Displays True Gumption." Weekend, *Washington Post*, July 8, 1994.

Hunter, Stephen. "Contact: The Truth Is Alien." *Washington Post*, July 16, 1997.

Hyzer, William G. "Deceptive Imagery." *Photomethods* (March 1991): 20–21.

———. "January 1, 2000: Doomsday for Film?" *Photomethods* (February 1991): 8–10.

———. "More on Deceptive Imagery." *Photomethods* (September 1991): 12–13.

Isachenkov, Vladimir. "Old Photo of Yeltsin Was Used." *Fredericksburg (Va.) Free-Lance Star*, July 18, 1995.

"Jackson Vid Changing the Face of 'Morph' Technology." *Billboard* (December 14, 1991): 38–39.

Janos, Leo. "Special Science Creates Illusions in Sci-Fi Spectacles." *Smithsonian* (April 1978): 56–65.

Johnson, J. Dudley. "One Hundred Years of Pictorial Photography." *Photographic Journal* (February 1954): 41–43.

Jones, Bill. "Legal Fictions." *Arts* (November 1991): 47–51.

"Judge Testifies on Bogus 'Slaying.'" *New York Times*, November 11, 1978.

"Jurors See 30 Photos of Simpson as He Wore Magli Shoes in 1993." *New York Times*, January 7, 1997.

Kalb, Marvin. "The Journalist: An Endangered Species?" *GW Magazine* (George Washington University) (Winter 1995): 33.

Kay, Alan S. "Digital Cameras." Fast Forward, *Washington Post*, June 1996.

Kay, Richard A. "Future Shock." *Civilization* (July–August 1995): 40–47.

Keefe, Patricia. "High Tech Helps Speed Location of Missing Children." *Computerworld* (October 21, 1991): 1.

Kempley, Rita. "Forrest Gump: Dimwitty Delight." *Washington Post*, July 6, 1994.

Kenny, Keith. "Computer-Altered Photos: Do Readers Know Them When They See Them?" *News Photographer* (January 1993): 11–13.

———. "Ethical Attitudes." *News Photographer* (November 1991): 11–14.

Knowles, Clayton. "Defeated by Lies, Tydings Declares." *New York Times*, February 21, 1951.

Kolonia, Peter. "Depth of Field 101." *Popular Photography* (July 1994): 38–41.

———. "When More Is Better." *Popular Photography* (January 1994): 30–33.

Krauss, Clifford. "A Photo Said to Show 3 Lost Fliers Jogs Congress on Vietnam Missing." *New York Times*, July 24, 1991.

Kress, Martin P., Assistant Administrator for Legislative Affairs, NASA. Letter to author with report re "NASA Ames Research Center Cooperation with Yuba City (CA) Police Department." August 27, 1994.

Kurth, Peter. "The Mystery of the Romanov Bones." *Vanity Fair* (January 1993): 96–103.

Kurtz, Howard. "Electronic Surgery." *Washington Post*, August 23, 1994.

——. "Fallout from Faked Photos." *Washington Post*, August 12, 1994.

——. "Newsday's Phony Skater's Waltz." *Washington Post*, February 18, 1994.

——. "Now You See It, Now You Don't." *Washington Post*, October 7, 1995.

——. "A Nude Awakening." *Washington Post*, February 1, 1995.

——. "The O. J. Story: Color It Yellow." *Washington Post*, July 6, 1994.

——. "The Photo Op Where Heads Rolled." *Washington Post*, November 30, 1994.

——. "Time's 'Sinister' Simpson." *Washington Post*, June 12, 1994.

——. "Time to Newsweek: What's Wrong with This Picture?" *Washington Post*, June 24, 1994.

——. "To GOP Hopefuls Clinton Is Target of Opportunity." *Washington Post*, October 4, 1994.

——. "White House Cuts Time Out of Its Pictures." *Washington Post*, April 1, 1994.

Kuznik, Frank. "Aliens in the Basement." *Air and Space* (August/September 1992): 34–39.

——. "Birdmen Come to Cleveland." *Air and Space Magazine* (April/May 1992): 75–81.

Landsberg, Mitchel. "Behind the Image of Iwo Jima." *Fredericksburg (Va.) Free-Lance Star*, February 11, 1995.

Lane, Randall. "The Magician." *Forbes* (March 11, 1996): 123–28.

"Lawyer Blisters Simpson Team's Photo Expert." *Washington Post*, December 21, 1996.

Leiby, Richard. "Victoria's Dirty Little Secret." *Washington Post*, March 5, 1995.

Lewis, Jo Ann. "The Medium Is the Machine." *Washington Post*, November 26, 1994.

Lewis, Peter H. "Library of Congress Offers to Feed the Data Highway." *New York Times*, September 12, 1994.

"List of Those to be Killed Finally Grew to 15." *Washington Star*, September 4, 1958.

Lopiccolo, Phil. "What's Wrong with This Picture." *Computer Graphics World* (June 1991): 6–9.

Magnuson, Ed. "Hitler's Forged Diaries." *Time* (May 16, 1983): 36–47.

Mandel, Paul. "Showdown for Loch Ness." *Life* (September 20, 1963): 17–18.

McCarthy, Paul. "Antimatter: UFO Update." *Omni* (March 1991): 73.

"McGrath Condemns Butler Campaign." *New York Times*, September 15, 1951.

McNamara, Michael J. "Digital Photography Comes of Age." *Popular Photography* 9 (September 1994): 33–40.

Mathews, Jay. "Morph for the Money." *Washington Post*, October 2, 1994.

——. "Poking Fun at the Puff Patrol." *Washington Post*, November 19, 1994.

Meyer, Eugene L. "Face to Face with Maryland History." *Washington Post*, April 6, 1994.

Miller, Gene. "The Case of the Ketchup-Stained Judge," *Tropic* (July 8, 1979): 21–25.

Mitchell, Rose. "Behind Every Pretty Face." *Know How* (Spring 1994): 88–91.

Mitchell, William J. "When Is Seeing Believing." *Scientific American* (February 1994): 68–73.

"A Monstrous Hoax." *Washington Post*, March 14, 1994.

Moore, Steve. "Digital Deceptions." *Byte* (May 1992): 372.

Mundy, Liza. "Punch Lines." *Washington Post Magazine*, July 25, 1998.

National Press Photographers Association. "A Statement of Principle." *NPPA Directory* (Durham, N.C.: National Press Photographers Association, 1993).

"New Picture Technologies Push Seeing Still Further from Believing." *New York Times*, July 3, 1989.

Newman, Melinda. "Jackson VID Changing the Face of 'Morphing.'" *Billboard* (December 14, 1991): 38–39.

"Nicholas and Alexandria: Grave Yields Answers to Mystery of Their Death." *Hello* no. 210 (July 11, 1992): 62–65.

"The 1994 Campaign: Advertising; Now Playing in Politics, Latest Techniques of Hollywood." *New York Times*, October 29, 1994.

Oberg, James. "Naive Perception of Soviet Space Activities as Unidentified Flying Objects." Paper submitted to the British Interplanetary Society, Technical Forum, June 4–5, 1982. London, Great Britain.

"O. J. and Mark: Faking It?" *Washington Post*, December 7, 1995.

"On the Trail of Howard Hughes." *Parade* (October 23, 1994): 7.

"100 Years of Pictures, Perils." *New York Times Magazine*, June 9, 1996.

Ottaway, David B. "Cairo Moves to Use Murder Plot to Make Qaddafi an Outcast." *Washington Post*, November 19, 1984.

———. "Egyptians Fool Libyans on Slaying." *Washington Post*, November 18, 1984.

Park, Edwards. "The Greatest Aerial Warfare Photos Go Down in Flames." *Smithsonian* (January 1985): 103–13.

"Photo of Simpson in Bruno Maglis Is Likely Forgery, Witness Says." *Washington Post*, December 19, 1996.

"Photographs Cited by Haig, Taken in 1978, Agency Says." *Washington Post*, March 2, 1982.

"Photomontage." *International Photo Technik* no. 3 (March 1980): 54.

"Picking Up a Lot of Static." *Washington Post*, July 15, 1997.

"Pictures That Lie." *Illustrated London News* (August 1987): 40–43.

Potts, Mark. "Making Faces—And a Splash." *Washington Post*, January 19, 1993.

———. "Regarding Digitally Altered Photos." Wash Tech, *Washington Post*, March 17, 1995.

Power, Mark. "Can You Believe Your Eyes?" *Washington Post*, April 26, 1987.

Powers, William F. "Virtual Politics: Campaigning in Cyberspace." *Washington Post*, November 8, 1994.

"Prez's Family Photo Is a Bush-League Phony!" *Globe* (September 1, 1992): 2.

Priest, Dana. "Cold War UFO Coverup Shielded Spy Planes." *Washington Post*, August 5, 1997.

"The Puzzling Case of the Faked Photographs." *Life* (August 1981): 11–12.

Ray, Frederic. "The Case of the Rearranged Corpse." *Civil War Times* (October 1961).

"Reagan Aide: Benetton Ad in Bad Taste." *Fredericksburg (Va.) Free-Lance Star*, June 28, 1994.

"Re-dressing the Queen." *Parade* (August 8, 1982): 7.

Rigdon, Joan E. "Finding Missing Children by 'Aging' Their Photos." *Wall Street Journal*, July 25, 1991.

Ringle, Ken. "The Masters of Deception." *Washington Post*, May 31, 1994.

Riordan, Teresa. "DNA Backs Up Ice Man's Legitimacy." Reuter, June 16, 1994.

Ritchin, Fred. "Digital Imagery." *Modern Maturity* (November/December 1997): 45.

———. "Photography's New Bag of Tricks." *New York Times*, November 4, 1984.

Roberts, David. "The Iceman." *National Geographic* (June 1993): 36–68.

Rupert, James. "From Moscow, Photojournalism or Photo Fraud?" *Washington Post*, August 7, 1993.

Ryan, Kathy. "The Subjective Eye." *New York Times Magazine*, June 9, 1996.

Safire, William. "Deception Managers." *New York Times*, August 6, 1981.

Sawyer, Kathy. "Is It Real or Is It . . . ?" *Washington Post*, February 21, 1994.

Schaub, George. "Pictures Bit by Bit." *Popular Mechanics* (August 1995): 60–64.

Schwartz, Dan. "I've Seen a Genuine Film of UFOs That Could Not Have Been Faked." *National Enquirer*, September 14, 1976.

Schwartz, John. "160 Countries Sign Treaties on Internet Copyrights." *Washington Post*, December 21, 1996.

Schwartz, Lillian. "The Art Historian's Computer." *Scientific American* (April 1995): 106–11.

Scitex Workstations (brochure). Bedford, Mass.: Scitex America Corporation, 1994.

"Securing Gump's Place in History." *Washington Post*, July 14, 1994.

"Seltsamer Bilder-Fluss." *Weltwoche Magazin* (Zurich) (September 23, 1981): 10–14.

"Sensor with an Eye for Contrast." *New Scientist* (June 1994): 18.

Serrill, Michael S. "Defiling the Children." *Time* (June 21, 1933): 52–55.

Shales, Tom. "Ad-vantage, Abdul and Friends." *Washington Post*, August 3, 1992.

Shaw, George Bernard. "The Unmechanicalness of Photography." *The Amateur Photographer* (October 9, 1902): 23.

Sorensen, Peter. "Terminator 2: A Film Effects Revolution; Raises Computer Graphics to Major Role in Film-Making." *Computer Graphics World* (October 1991).

Spindler, Amy M. "Making the Camera Lie, Digitally and Often." *New York Times*, June 17, 1997.

Sports Illustrated for Kids (August 1965): cover.

Squires, Carol. "Capa Is Cleared." *American Photo* (May/June 1998).

Staggs, Jeffrey. "The World According to Gump." *Washington Times*, July 10, 1994.

Streitfeld, David, and Elizabeth Kastor. "Stolen Whitman Papers Surface After 50 Years." *Washington Post*, February 18, 1995.

"Sun Angles, Anyone." *National Geographic* 177, no. 1 (January 1990): 3.

"Tabloid Apologizes: Diana Tape Was a Hoax." *Fredericksburg (Va.) Free-Lance Star*, October 9, 1996.

Tannen, Mary. "That Scitex Glow." *New York Times Magazine*, July 10, 1994.

"They're Sorry." *Washington Post*, June 28, 1994.

Thomas, Bob. "Kelsey Grammer Happy to Honor His Inspiration." *Fredericksburg (Va.) Free-Lance Star*, November 29, 1995.

"To Our Readers." *Time* (July 4, 1994): 4.

Tomlinson, Don E. "Legal and Ethical Ramifications of Computer-Assisted Photograph Manipulation." *Protocol* (1991): 4–6.

"Two Canadian Newspapers Snap Up High-Tech Cameras." *Straits Times Press* (Singapore), February 6, 1995.

Ubelaker, Douglas H., Erica Bubniak, and Gene O'Donnell. "Computer-Assisted Photographic Superimposition." *Journal of Forensic Sciences* (May 1992): 750–62.

Ubelaker, Douglas H., and Gene O'Donnell, "Computer-Assisted Facial Reproduction." *Journal of Forensic Sciences* (January 1992): 155–62.

U.S. Senate. "Soviet Deception and Disinformation." *Congressional Record*, vol. 125, no. 84, pt. 2 (December 20, 1979): S19536–S19539.

Van Riper, Frank. "Kodak Goes Digital." Weekend, *Washington Post*, June 7, 1996.

———. "The Truth About Fakes." On the Town, *Washington Post*, February 18, 1994.

"Verfälschte Bilddokumente Beriut." *Frankfurter Allemeine* (Frankfurt am Main), July 23, 1979.

"Viet War Photo Is Challenged." *Washington Post*, January 19, 1986.

Vogel, Steve. "At Fort Meade, Military Gears Up Media Machine." *Washington Post*, October 10, 1998.

Wagner, John. "MIA Families Fault Pentagon Research." *Washington Post*, July 24, 1992.

"Wal-Mart Leads Way in Cleaning CD Racks." *Fredericksburg (Va.) Free-Lance Star*, November 18, 1996.

Ward, Fred. "Images for the Computer Age." *National Geographic* (June 1989): 719–59.

Waxman, Sharon. "Wizards of Ah." *Washington Post*, July 5, 1996.

Wheeler, Linda. "Shocking Shots." *Washington Post*, August 12, 1984.

White, Larry, and Michael J. McNamara. "Computer Imaging: A Photographer's Guide." *Popular Photographer* (September 1993): 38–41.

Wiley, John P., Jr. "Cameras, Sonar Close in on Denizen of Loch Ness." *Smithsonian* (June 1976): 96–102.

Wills, Garry. "Twilight of the American Cowboy." *Civilization* (November/December 1995): 61–63.

Wilson, George C. "Is the Press Being Duped." *Washington Post*, September 25, 1983.

Witchell, Nicholas. "Unloching Ness's Secrets." *Geographical* (May 1944): 21–24.

"Wow! Car-To-Tiger Metamorphosis. A Jaw Dropper." *EXXON Company Marketing Exxpress*, no. 91–19 (September 10, 1991): 5.

"Wow! A Showcase for Spectacular Images and How They Are Made." *Popular Photography* (November 1994): 64–65.

Zito, Tom. "Panda Panic." *Washington Post*, September 2, 1981.

———. "Through a Lens Lightly." *Washington Post*, July 3, 1983.

INDEX

ABOUT THE AUTHOR

Dino A. Brugioni is a native of Missouri and attended schools in Bevier and Jefferson City. During World War II, he flew in sixty-six bombardment and a number of reconnaissance missions over Europe. After the war, he received B.A. and M.A. degrees in foreign affairs from George Washington University. He joined the Central Intelligence Agency in 1948 and became an expert on Soviet industrial installations. In 1955, he was selected as a member of the cadre of founding officers of the National Photographic Interpretation Center. As a senior officer of the Center, he was not only involved in the exploitation of U-2, SR-71, and satellite imagery, but also became the CIA expert in photo fakery and photo manipulation.

He is the author of *Eyeball to Eyeball*, which discusses the critical role aerial photography played during the Cuban Missile Crisis. He also discovered and analyzed World War II aerial photography taken of the Auschwitz-Birkenau death camp. Since his retirement from the CIA in 1982, he has written extensively on a variety of topics involving aerial and satellite photography. Mr. Brugioni is also a Civil War buff and has written a number of articles and a book dealing with the war in the West.

ALSO BY DINO A. BRUGIONI

Eyeball to Eyeball

The Civil War in Missouri

From Balloons to Blackbirds

*The Holocaust Revisited: A Retrospective Analysis
 of the Auschwitz-Birkenau Extermination Complex*
 (with Robert Poirier)